t3-30 2/92

Published by Ashford
1 Church Road
Shedfield
Hampshire SO3 2HW

British Library Cataloguing in Publication Data

Brooks, Stephen
Operation Overlord: The history of D-Day and the Overlord Embroidery.
1. English embroidery: Overlord Embroidery.
Special subject: World War 2.
Normandy campaign. D-Day, 1944
I. Title II. Eckstein, Eve.
746.44′5′0942

ISBN 1-85253-098-7

Designed by Jenny Liddle
Typeset by Acorn Bookwork, Salisbury, Wilts
Printed by Mateu Cromo, Madrid, Spain

CONTENTS

FOREWORD

There have been only two armed cross-Channel invasions in the last millennium and, by chance, the name of Montgomery features in both these crucial events in our island history. It is therefore with a mixture of pride and humility that I write this foreword to the definitive work on the Overlord Embroidery, now so happily housed in the D-Day Museum at Portsmouth.

Finding a home for the Overlord Embroidery has not been without difficulty. Conceived in the early sixties, commissioned in 1968 and completed in 1973, the famous Embroidery had a somewhat nomadic existence in its early life, while strenuous efforts were made by all concerned to find the ideal permanent location. The imaginative decision by Portsmouth City Council to create a museum to mark the fortieth anniversary in 1984 provided the opportunity for two great projects to combine, with the result that the Overlord Embroidery now forms the centre piece of the award-winning D-Day Museum.

There could be no more suitable destination, since Portsmouth was not only the focal point in the south of England for launching the great invasion on 6 June 1944, but also the headquarters of the Allied Expeditionary Force. The invasion of Normandy in 1944, the largest single military operation in the history of warfare, represented a massive effort in planning, co-ordination, leadership, courage and dedication to duty. It was the initiation of the last phase of the war, the liberation of France and the Benelux countries. Neither the Bayeux Tapestry nor the Overlord Embroidery glorifies war, but both record the struggles, in fascinating and most instructive works of art.

Many have contributed to the success of the Museum – officials and councillors of Portsmouth City, the Committee of the D-Day and Normandy Fellowship, the Trustees of the Overlord Embroidery – but no one more than Lord Dulverton. His imagination and extraordinary generosity created the Embroidery as a permanent tribute to a great historic endeavour, and as a memorial to the spirit and sacrifice of the people who made it possible.

Montgomery of Alamein
Isington Mill, Alton, Hampshire
June 1988

INTRODUCTION

This book tells the story of the Overlord Embroidery from the moment Lord Dulverton first conceived the idea of creating a 'Bayeux Tapestry in reverse' which would record and commemorate the Allied invasion of Normandy in 1944. Although the Embroidery deals with one of the great operations of the Second World War, the concept of commissioning it was 'historic rather than military', as Lord Dulverton once explained. It was intended as a permanent memorial and tribute to the efforts and sacrifices of the Allies, but above all to the 'national teamwork' here in this country which made D-Day possible.

So the Overlord Embroidery shows in the early panels the bombing and deprivations which everyone suffered. It shows the whole country pulling together to survive and fight back. It then records the long period of planning for the return to Europe, the build up of equipment and supplies and the training of the armed forces, which culminated in the launching of the biggest invasion of all time. It tells the story of the landings and the battles which led to the Allied break-out from Normandy, though in the Embroidery, as Lord Dulverton says, it is only possible 'to hint at the bitterness of the contest and the losses sustained'.

The book relates the fascinating story of the commissioning of the young designer, Sandra Lawrence, how she became totally absorbed in her enormous task, the early meetings of the Embroidery Committee, how the work gathered momentum, how unforeseen difficulties arose, how alterations were made and how the completed Embroidery wandered homeless and travelled thousands of miles before coming to its final purpose-built resting place at the D-Day Museum in Portsmouth.

Research has revealed the human stories and amusing anecdotes from the workroom of the Royal School of Needlework, and unearthed fascinating correspondence and memoranda from the archives of the Dulverton Trust and the Imperial War Museum. The workbook kept as a diary by Margaret Bartlett, head of the workroom at the Royal School, was found to contain a wealth of detail about types of material and silk used, the quantities and costs, and the many day-by-day difficulties of creating a modern counterpart to the Bayeux Tapestry.

Running alongside the story of the making of the Embroidery and the historical events it depicts are highlights of embroidery and appliqué technique, which would be helpful for anyone contemplating the creation of an embroidery on an historical theme. Consideration is also given to other historical and military tapestries and embroideries, including the Bayeux Tapestry, so that the Overlord Embroidery can be seen in its rightful place within the tradition of pictorial friezes.

Many people have helped in many ways with the writing of this book. The authors would first and foremost like to thank Lord Dulverton, who has supported the project, shared his recollections of the making of the Embroidery and given unrestricted access to the papers of the Overlord Embroidery Trust. We are also indebted to the Secretary of the Dulverton Trust, Major-General Mike Tomlinson, for assisting us as we delved into the archives.

Sandra Lawrence has been of invaluable help in the production of this book, providing many personal memories and essential information on the sources of inspiration for her designs. On the historical side, Admiral Sir Charles Madden and Lieutenant-Colonel Ben Neave-Hill have put life into the written record of the deliberations of the Embroidery Committee. Margaret Bartlett and Wendy Hogg from the Royal School of Needlework have, despite their natural modesty, provided

ample evidence to show how much the Embroidery owes to the School's skill and imagination.

The relevant files in the archives of the Imperial War Museum were made available to us by the Deputy Director, Robert Crawford, who, as the Museum's Research and Information Officer, drafted the first captions for the Embroidery panels in 1972. Thanks are due to David Bradshaw, who discussed the circumstances which led to the exhibition of the Embroidery in Whitbread's Porter Tun Room, and to members of staff of the Portsmouth Museums Service: Dan Chadwick, who provided information on the display at the D-Day Museum; Anne Cleave, who compiled the index; and Caroline Benham and Liz Burroughs, who typed the manuscript (twice!). Finally, we would like to thank Viscount Montgomery for contributing such an excellent foreword.

Stephen Brooks
Eve Eckstein

PART I
PLANNING AND PREPARATION

The Bayeux Tapestry in Reverse

The idea that he should take on the task of creating an embroidery on the theme of Operation Overlord crystallised in Lord Dulverton's mind over a number of years. The basic concept was founded on the fact that the Norman conquest of England in 1066 is vividly recorded in the tapestry which is preserved at Bayeux and bears that town's name. Since then there has been only one successful armed and opposed cross-Channel invasion – in the reverse direction, in 1944. Should that not be commemorated in a tapestry, too?

The person who first suggested the idea to Lord Dulverton was his land agent and friend, Bill Tyhurst. In the late 1950s, Lord Dulverton was concerned about the future of his family home, Batsford Park in Gloucestershire, and with the Overlord Embroidery in mind, Bill Tyhurst suggested turning the whole of the top floor at Batsford over to such a project, rather in the same way as in medieval times weaving and embroidery were done in long galleries. Lord Dulverton realised that it would not really be practicable to use Batsford in this way, but he was very taken with the idea of an embroidery to commemorate Operation Overlord. Sadly, Bill Tyhurst died in the autumn of 1964, so he was not to know that his suggestion had borne such magnificent fruit.

Lord Dulverton approached a number of people in high places about the project. The response was favourable, but no positive action was forthcoming. In the end he decided he would have to 'do it himself'. In the spring of 1966 a meeting was held in the office of Sir Arthur Drew, the Permanent Under-Secretary of State for the Army, at which Lord Dulverton outlined his scheme for a Bayeux Tapestry in reverse. Also present was General Sir John Anderson, the commandant of the Imperial Defence College in Belgrave Square. General Anderson quickly arranged a follow-up meeting with two distinguished colleagues representing the other services: Marshal of the Royal Air Force Sir John Slessor, a former Chief of Air Staff, and Admiral Sir Charles Madden, who had recently retired as Commander-in-Chief Home Fleet and NATO Commander-in-Chief Eastern Atlantic Command. They sought further guidance from Lord Dulverton as to what scale of cost he envisaged for the creation of the Embroidery and where he thought it might eventually be displayed.

In the following months, the question of a future home for the Embroidery was investigated. As a later chapter explains, Portsmouth Cathedral looked a real possibility at this stage. The Secretary of the Dulverton Trust, Sir Walter Coutts, corresponded with the Cathedral authorities, exploring the suggestion that the Embroidery might be incorporated into plans for the completion of the unfinished end of the Cathedral as a memorial to D-Day. In the course of the correspondence, Sir Walter was told that the Cathedral had been receiving first-class advice on the project from the Narrator in charge of the army historical section at the Ministry of Defence library, Lieutenant-Colonel Ben Neave-Hill, who knew a very great deal about Operation Overlord.

Colonel Neave-Hill was destined to play a very important part in the Overlord Embroidery project. General Anderson contacted him in March 1967 and explained the plan to create an embroidery to commemorate the Normandy landings. Colonel Neave-Hill later remembered thinking 'what a marvellous idea', and he set about reading up on the Bayeux Tapestry. General Anderson told Sir Walter Coutts that Colonel Neave-Hill was 'most interested and enthusiastic' about the proposed Embroidery and a meeting was arranged to see if progress could be made on the historical content of the Embroidery. In the course of his discussion with Sir Walter Coutts, Colonel

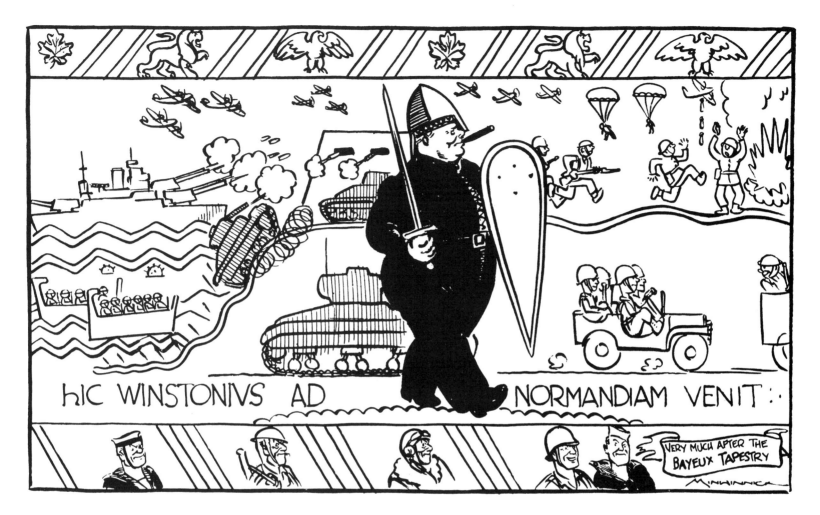

HIC WINSTONIVS AD NORMANDIAM VENIT

VERY MUCH AFTER THE BAYEUX TAPESTRY

A cartoon by Sir Gordon Minhinnick from the New Zealand Herald *of 14 June 1944. The parallels between Operation Overlord and the Norman Conquest were readily apparent in 1944. New Zealand Herald*

Neave-Hill said he needed guidance on two crucial questions. The first was how wide a period should be covered, and to what extent the preparations for and consequences of D-Day should be included. The other was where the main emphasis should be placed.

These points were put to Lord Dulverton, who replied with some initial thoughts which provided a marker for all the subsequent deliberations about the content of the Embroidery: 'I think the broad answer to both questions ... is that the theme should be *national* effort, and the involvement of so many people in so many ways, to produce the huge, complex and finally successful expedition.'

Colonel Neave-Hill set about converting the D-Day story into a simple series of episodes which could be narrated through the medium of embroidery. He first analysed the scenes in the Bayeux Tapestry – 32 in all – and then he began work, on the assumption that the

3

Overlord Embroidery would be similar in length (230 feet). However, he pointed out that as Overlord was a so much 'vaster and more complex achievement' than William the Conqueror's invasion, the 'leisurely style' of the Bayeux Tapestry would not be appropriate for its modern counterpart.

Colonel Neave-Hill divided the story into three main aspects: 'The beleaguered island, fortress and arsenal, becomes the main base for the invasion'; 'Cross-Channel assault'; and 'Liberation and victory in north-west Europe'. He went on to suggest 30 headings which would take the story from the Blitz to VE (Victory in Europe) Day. In addition he envisaged that, like the Bayeux Tapestry, the Overlord Embroidery would have upper and lower borders. The upper could contain flags, the insignia of the units involved, barrage balloons, aircraft and cheering crowds. The lower border might show, appropriately enough, minefields, submarines, casualties, underground organisations and the 'pipeline under the ocean' (PLUTO). Other suggestions for the borders included the medical services, chaplains, the press and the artificial 'Mulberry' harbours constructed by the Allies on the coast of Normandy.

As well as drawing up the first draft of a script for the Embroidery, Colonel Neave-Hill made a key contribution to the project in mid-1967 by putting forward the name of a young artist, Sandra Lawrence, as a possible designer for the Embroidery. In the next section the story is told of how this led to Sandra Lawrence's appointment to prepare the cartoons for the Embroidery a year later, in May 1968.

Once Sandra Lawrence had been given the commission, it was time to begin work on refining the Script for the Embroidery, and to bring together a team to oversee its execution. General Anderson had been succeeded as commandant of the Imperial Defence College by Air Chief Marshal Sir Donald Evans, and it was to him that Sir Walter Coutts turned for advice on forming a committee to guide Sandra Lawrence's efforts.

Admiral Madden, who had been involved at the outset, was very happy to continue to give advice. He was himself an artist and he happened to live near Sandra Lawrence, so that when work began in earnest they were able to meet for informal discussions if particular problems arose, as well as at the more formal Embroidery Committee meetings. As army representative, the name of General Sir Charles Jones was put forward by Air Chief Marshal Evans: 'At the time of the Normandy invasion, he was commanding the Royal Engineers in the Guards Armoured Division and was subsequently Chief of Staff of 30 Corps for the remainder of the campaign.' Donald Evans himself completed the team of senior officers, soon to be dubbed the 'Three Wise Men'.

Meanwhile Colonel Neave-Hill had contacted his opposite numbers in the air and naval historical sections, L.A. Jacketts and Rear-Admiral Peter Buckley. Between them they had agreed a synopsis for the Embroidery based on Colonel Neave-Hill's original draft script (see Appendix I). This was circulated in July 1968, together with a discussion paper in which the three service historians set out the situation as they saw it regarding the object of the Embroidery, its emphasis and scope, and how its production could best be supervised. They also asked for a ruling on whether the original ideas for upper and lower borders should be omitted at the behest of Sandra Lawrence, who had not found them satisfactory from a design point of view.

The various points were discussed at the first meeting of the Dulverton Embroidery Committee in September 1968. As the first step it agreed a statement on the aims of the project as a whole:

To produce a tapestry for public exhibition to commemorate the successful assault on Nazi-held North-West Europe, with particular emphasis on the national effort which enabled the Allied Forces, sea, land and air, to mount and launch successfully the invasion of Normandy.

As regards the scope of the Embroidery, Lord Dulverton had come to the conclusion that the time span would

have to be reduced. As he explained to Sir Walter Coutts, he was afraid that they would otherwise be 'attempting far too much and the result will be very, very bitty indeed'. So it was agreed that no more than four panels would be devoted to the early period of the war, under the heading 'The Beleaguered Island'; 23 panels would deal with the central theme, the cross-Channel assault; and a further three panels would take the story up to the break-out from Normandy, rather than right up to VE Day. It was also accepted that the borders should be dispensed with and certain topics planned for them – such as Mulberry harbours and the medical services – incorporated into the main scenes.

Colonel Neave-Hill was asked to form a historical subcommittee with Rear-Admiral Buckley and Mr Jacketts (succeeded in due course by Group Captain Haslam). Its task was to provide Sandra Lawrence with detailed technical advice on military matters and to make an initial examination of her sketches. At the first meeting of the Subcommittee in October 1968, the revised Embroidery Script was distributed (it is reproduced as Appendix II), and this formed Sandra Lawrence's main brief for the sequence of her designs.

The full Dulverton Embroidery Committee consisted of the 'Three Wise Men', the Secretary of the Dulverton Trust, Sir Walter Coutts (followed by his successor, Major General Douglas Brown), the three service historians and Lord Dulverton himself. At the meetings of the committee the main role of the 'Three Wise Men' was to give general advice on the subjects to be shown in the Embroidery and on the historical balance. The detailed vetting and research was left to the three service historians. After the first session of the full committee in September 1968, Air Chief Marshal Evans, who took the Chair, wrote to Colonel Neave-Hill thanking him for helping to make the meeting a success: 'I am only sorry that so much seems to have fallen on the plates of yourself and your colleagues,' he wrote, 'but I think it right that the experts should be

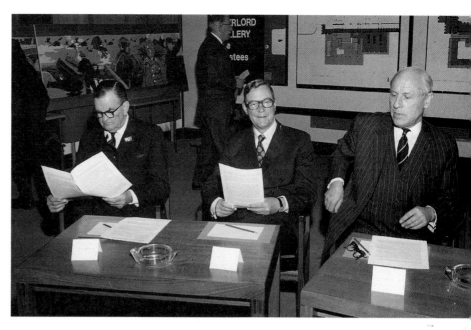

The 'Three Wise Men': left to right, General Sir Charles Jones, Admiral Sir Charles Madden and Air Chief Marshal Sir Donald Evans. The photograph was taken at the Imperial War Museum in May 1972, when plans for the new gallery to display the Overlord Embroidery were announced. Imperial War Museum MH 15952

the experts and that four-star officers should not set themselves up as such!'

Both Admiral Madden and Colonel Neave-Hill later recalled the pleasure they had derived from being members of the Embroidery Committee and how happily they had all worked together on the project. No inter-service wrangling disturbed the deliberations of the Committee, which met some twenty times between 1968 and 1973. Its discussions ranged widely over all matters connected with the Embroidery, including the thorny problem of its eventual home. Minutes were kept of every meeting and these are preserved in the archives of the Dulverton Trust. They provide a fascinating record of how the Embroidery grew until the seal of approval was given to the panel on the struggle for Caen and the project was finally complete.

Drawing Out the Past

Once Lord Dulverton had decided that he himself would commission a 'Bayeux Tapestry in reverse', he was faced with the problem of finding an artist who could be entrusted with the preparation of designs for the embroidered panels. In the spring of 1967 Lord Dulverton approached his friend Peter Scott, the noted ornithologist and wildlife painter, for advice on possible candidates. Peter Scott had served in destroyers in the Battle of the Atlantic and light coastal forces in the Channel during the Second World War. No reply was forthcoming until, after the synopsis had been sent to him, Peter Scott simply sent word that he hoped the Embroidery would 'contain enough horror to make the anti-war message plain'.

Lord Dulverton also approached Edward Seago, the Norfolk artist who had been involved in camouflage work during the war. He replied that he would not take on the job because he was intimidated by the thought of 'the time involved and an endless series of sleepless nights'. But a new possibility arose when Colonel Neave-Hill mentioned that his son, Charles, had a friend who was an artist. This was Sandra Lawrence, who was at that time studying at Signora Simi's School of Art in Florence.

She was only 21 when Lord Dulverton asked her if she would submit a sample sketch for a section of the Overlord Embroidery and was reluctant at first. Despite the fact that her father was a brigadier, she knew little about the subject of war. She did not take the matter seriously, as she felt that she was ill-equipped for the project. But gradually, with a little persuasion from Charles, she realised that perhaps she would 'never forgive herself if she didn't at least give it a try'. Besides, she very much wanted to prove to her father, who had just had an appalling stroke, that she was not just 'the parasite who did those dreadful daubs', and could really do something of which he would be proud.

Sandra Lawrence produced a thumbnail sketch for Lord Dulverton of soldiers struggling through water with rifles held above their heads. This reflected the fact that highly imaginative surreal paintings involving water and figures were important in her work at that time. She did not think for a moment that it would be accepted, but Lord Dulverton liked it and asked her to produce a sketch of George VI saluting the fleet. Having gone this far, she did so, and much to her surprise Lord Dulverton said, 'You are on.'

Colonel Neave-Hill had been giving Sandra Lawrence some initial coaching on the background to Operation Overlord. In a letter to him in October 1967 she admitted that 'it is such a vast project I have been wondering about where to begin'. She was very much aware that the undertaking would require 'the most tremendous amount of thought and knowledge'. So Colonel Neave-Hill arranged for her to borrow a selection of books from the War Office library on the Battle of Britain, the Blitz and the Normandy campaign itself.

Early in November 1967 Sandra Lawrence went for a preliminary discussion with Margaret Bartlett, the head of the workroom at the Royal School of Needlework. They discussed the likely size of the Embroidery as a whole and agreed that they would work on the basis that each panel would be 8 feet by 3 feet. Two days later Sir Walter Coutts confirmed the offer of the payment of a fee to Sandra Lawrence for her work up to the end of January 1968, and she set off for Cornwall where she had taken a studio with a friend on Porthmeor Beach, St Ives.

Cornwall in the late 1960s was a popular place for artists such as Ben Nicholson, Patrick Heron, Roger Hilton and Barbara Hepworth. Patrick Heron influenced Sandra Lawrence, particularly with regard to colour. Whilst in Cornwall she also saw slides of the work of

Elizabeth Allen, a lady in her eighties whose appliqué work had been exhibited at the Crane Kalman Gallery in the Brompton Road, London. The border which surrounds the Overlord Embroidery was directly influenced by Elizabeth Allen's work.

Sandra Lawrence now launched into her first 20 feet of design. Her full-sized cartoons were painted on cartridge paper using gouache in flat areas of colour, ideally suited to transposing into appliqué embroidery. Later she adopted the practice of always producing a thumbnail sketch first for the initial discussions with the Embroidery Committee. These sketches were on cartridge paper, 6 inches by 16 inches, with some shading indicated.

After only four weeks, Sandra Lawrence wrote to Sir Walter Coutts to say that she was returning to London wtih 20 feet of completed design for him to see. Unfortunately it proved impossible to arrange a meeting over the Christmas period. On the day she was due to return to Cornwall Sandra Lawrence took the cartoons to the Royal School of Needlework. Margaret Bartlett noted in her workbook, 'Drawing workable for embroidery.'

Back in Cornwall Sandra Lawrence wrote to Sir Walter and Lord Dulverton explaining that her work was with the Royal School. 'I do hope you will both like it', she wrote. 'I have tried to get as much colour into it as possible, and split up the various episodes in a fairly unconventional manner – so as to gain more originality.' She explained that it was easier to work in Cornwall and that she hoped to have further designs ready by the end of January to complete the section of the Embroidery dealing with 'the beleaguered island'.

Lord Dulverton and Sir Walter Coutts went to the Royal School early in January 1968 to see the cartoons. Sir Walter wrote to Sandra Lawrence, 'One particular panel depicting the anti-aircraft searchlight together with the balloon barrage was quite excellent and the sort of crowded atmosphere and action which we were trying to get portrayed.' But he added, 'There were one or two possible adjustments which might be made, but I think we had better wait until your next section.'

This rather understated the case as there were several aspects of the designs which Lord Dulverton did not like at all. When Sandra Lawrence came up to London at the begining of February with the next section of the cartoon, Lord Dulverton was not impressed. 'No, I don't think so. Forget the whole thing', he said. With the shock of this decision it dawned on Sandra Lawrence that, having put so much time and energy into the project, she felt that she was 'getting into it' and very much wanted to continue. In the outer office at the Dulverton Trust, she persuaded Sir Walter to go in to Lord Dulverton and explain that she had rushed the work he had seen so far. If he would give her another month, she would really like to try again, concentrating on just one 8-foot panel.

Fortunately Lord Dulverton agreed and Sandra Lawrence returned to Cornwall. Sir Walter Coutts informed the Royal School of Needlework that there would be a delay while the artist produced some new designs: 'I think Lord Dulverton would like to see some more detail put into the painting with perhaps slightly more traditional methods of depicting the figures, etc. This may mean that the finished product will not be so easy to follow for those who do the actual needlework as the type of painting she has so far produced.'

Meanwhile, in Cornwall, things progressed slowly. It took Sandra Lawrence some time to pluck up courage to start again from the beginning. It was not until early in May that she was ready to return to London with the completed cartoon (later to form Panel 3 of the Embroidery) to show Sir Walter Coutts. To her relief he liked it, and so too did Lord Dulverton. At a meeting at the end of May Lord Dulverton offered her the job of designing the Overlord Embroidery. 'I really am very thrilled to have the commission', she wrote.

Sandra Lawrence went straight round to the Royal School of Needlework. 'They saw my latest piece of work', she told Sir Walter Coutts, 'and said it was quite possible to execute. They seemed very happy about it and very eager to begin.' A monthly salary was agreed which gave Sandra Lawrence some vital security.

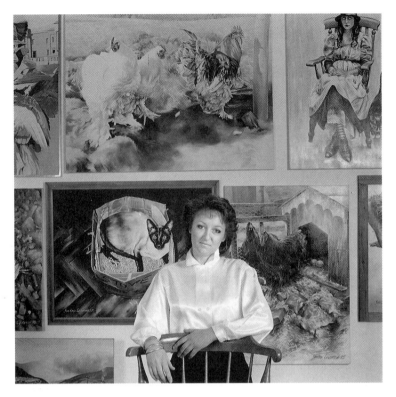

Sandra Lawrence in her studio with a selection of her recent work: portraits and 'fruit and veg., fur, fish, flowers'. David Whyte

She launched into preparing her cartoons with great enthusiasm. By this time a helpful friend had given her copies of the lavishly illustrated part work, Purnell's *History of the Second World War*. The magazines helped her to get a feel for the subject. It is worth noting that Sandra Lawrence's designs were not influenced by the Bayeux Tapestry, and the appearance of similar scenes in the two works is simply the result of the historical parallels between the cross-Channel invasions of 1066 and 1944. The vast range of wartime photographs available in Purnell's magazine and various other published sources were the main inspiration for Sandra Lawrence's designs.

Today Sandra Lawrence realises that in accepting the commission to design the Overlord Embroidery she simply had 'no idea of the enormity of the task. I just did one panel, then the next. I don't think it was until I was a quarter of the way through that it really hit me just what I had taken on. It was a challenge. To depict war or religion has been the task of many a painter, both past and present. What disenchantment I felt for the sheer lunacy of any form of war as I came near to the completion of the panels is another story.'

The designing of the Overlord Embroidery took over four years – 'four years out of my life', as Sandra Lawrence says. 'Whilst painting it, all I could think about was, just one more panel and I'm nearer completion. On completing it, I used to think, I'll go on a long holiday or just out and about and really celebrate. Instead of which I sketched a 4-foot canvas and began another painting. That's the way it always is: finish one, start another. I rarely ever look back, in spite of the fact that I have a great affection for the Embroidery and all the memories of the meetings of the Committe and the people who sat on it.'

Since those days Sandra Lawrence has had one-woman shows at various galleries in London, New York and Caracas in Venezuela, besides exhibiting extensively in group shows. She readily admits that the four years working on the Overlord Embroidery have had a great effect on her work since. 'Before my paintings were very imaginative, just out of my head, in spite of the fact that I had learned how to draw, in Italy, in the classical sense of the word. It forced me to come out and look at reality, to see things as they really are.' Looking at her work today, one is aware of the extreme realism in her oils, acrylics, water-colours and pastels. Whether she is painting portraits or 'fruit, veg., fur, fish or flowers', her subtle use of colour, seen so frequently in the Overlord Embroidery, appears again and again. Eighteenth-century Chinese vases complement her flower studies, or a Chinese lacquer screen forms a background to a portrait, picking up colours and shapes and suggesting a connection between the animate and the inanimate, reminiscent of seventeenth-century Dutch still life. Sandra Lawrence is currently working on a 'jungle series', reflecting her deep concern about continuing deforestation.

Embroidering the Overlord Story

To complete the team which was to create the Overlord Embroidery, Lord Dulverton had turned to the obvious place to undertake the embroidery work: the Royal School of Needlework. It had built up a world-wide reputation for its expertise in the field since its foundation nearly a hundred years before.

The Royal School of Needlework (or School of Art Needlework, as it was first called) was established in 1872, with Queen Victoria's daughter, Princess Christian of Schleswig-Holstein, as its president. It was originally based in Sloane Street, but it has moved four times since then. In 1875 it moved to premises in Exhibition Road, and in 1903 to a new building of its own nearby. In 1948, the high cost of maintaining the building in Exhibition Road necessitated a move to 25 Princes Gate, and it was there that the Overlord Embroidery was executed. The Royal School remained at Princes Gate until 1987, when lack of space made it necessary to move and divide the School between three centres. The workroom transferred to Hampton Court, the Youth Training Scheme to Rotherhithe and a shop was established in King Street, Covent Garden.

The original aim of the School was to provide training in what was considered to be a suitable occupation for gentlewomen, who learned how to create beautiful embroideries and to restore ecclesiastical and historic textiles. Today, as well as two-year apprenticeship courses for young people of 16 to 18, the School runs day and evening classes in all types of embroidery. It is a charitable educational institute, without any endowment of its own, but supported by many City Livery Companies and commercial firms.

The Overlord Embroidery was to be one of the Royal School's largest commissions, and the School's concern and support for the Embroidery continued long after its completion. Lady Mark Fitzallan Howard, successively Chairman and President of the Royal School of Needlework, was later to take over as Chairman of the Overlord Embroidery Trust. Once Lord Dulverton had approved Sandra Lawrence's revised cartoon for what is now Panel 3 in the summer of 1968, Sir Walter Coutts took it to the Royal School and arranged for a trial section to be worked. This sample piece, 36 inches by 46 inches, was presented to the first meeting of the Dulverton Embroidery Committee in September. The members of the Committee were 'unanimous in their approval'.

In December 1968, the Royal School produced its specification for the Overlord Embroidery, referring to the working of only 22 or 23 panels at this stage. 'The designs will be applied with suitable materials and worked up in embroidery using silk threads and cords, and every effort will be made to match the colours shown on the designs as nearly as possible, but no guarantee can be given.' The memorandum said that every endeavour would be made to complete the project within three years.

A cheque was sent to the Royal School for the first panel as confirmation of the terms in January 1969. When the Director of the School, David Lloyd, replied, he included a word of caution: 'I would like to point out that these are embroidered and appliqué panels, and the work should not be referred to as a "tapestry".' The incorrect usage was, of course, due to the Bayeux Tapestry, although that too is an embroidery, worked in wool on a linen background using a needle and various stitches. The original mistake in the name probably arose because tapestry, woven fabric made on a loom by means of a shuttle passing between the warp threads, was the usual method of creating a large piece of pictorial fabric.

It took some time for the correct name to be adopted in the case of the Overlord Embroidery. The 'Three Wise

Men' and their fellow committee members went on referring to themselves as the Dulverton Tapestry Committee right up until October 1970. (This name is not used elsewhere in this book, to avoid confusion.) At its meeting that month it was announced that, as the Royal School had again said that the work should be referred to as an Embroidery, the Committee would have to be renamed. There was some discussion about this, and the point was made that continuing to use the word 'tapestry' would make clearer the link between the new work and its eleventh-century predecessor. However, Bayeux Tapestry or no, it was the Dulverton Embroidery Committee which next met in January 1971.

The techniques used at the Royal School for appliqué embroidery were very old ones. The panels were made by first stretching strong calico on to a wooden embroidery frame. Next, the background Crestweave linen was placed on top, and sewn firmly to the edges of the cotton beneath to prevent the two layers of fabric moving independently. The first stage in the transfer of Sandra Lawrence's designs was the production of a tracing of her gouache cartoon. The designs were then transferred from the full-sized tracing to the linen by means of 'pricking and pouncing': thousands of tiny holes were pricked in the tracing paper along the design outline, and a fine powder (pounce) was rubbed through, leaving a trail of dots on the linen. These were then joined together with a thin painted line and the powder blown off. This method of transferring designs from tracings to textiles has been in use for almost 400 years.

Once the whole design had been marked on the background linen, paper patterns were made and suitable materials chosen. Silk and other fine or loosely-woven fabrics were backed with vilene to give body and prevent fraying. Then the required shapes were cut out. Work on sewing them down began on a 15-inch strip in the middle of the panel, the rest remaining rolled up. 'An eye for detail' was essential here, recalls Wendy Hogg, one of the senior staff at the Royal School of Needlework, because any movement in the pieces of fabric had to be avoided

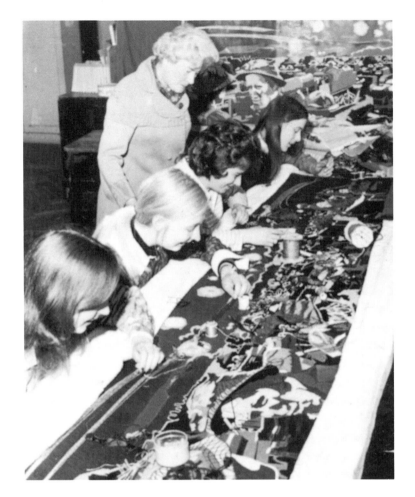

Margaret Bartlett supervising work on the Overlord Embroidery at the Royal School of Needlework in 1972. Twenty embroiderers and five apprentices worked on the project under Margaret Bartlett between 1968 and 1973. Fox Photos

otherwise everything became misplaced. Errors in the central area were magnified by the time the sides were reached.

As the needlework progressed the linen was unwound. Several seated embroiderers could work closely side by side on the same panel, working with one hand above the embroidery and one hand beneath. Both left- and right-handed girls apparently tend to work with their

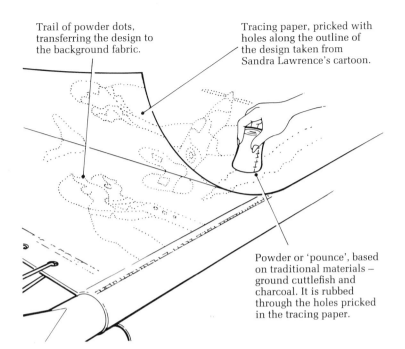

Trail of powder dots, transferring the design to the background fabric.

Tracing paper, pricked with holes along the outline of the design taken from Sandra Lawrence's cartoon.

Powder or 'pounce', based on traditional materials – ground cuttlefish and charcoal. It is rubbed through the holes pricked in the tracing paper.

The technique of 'pricking and pouncing'.

Embroiderers at work on the Overlord Embroidery. Note how they work side by side at both top and bottom of the frame.

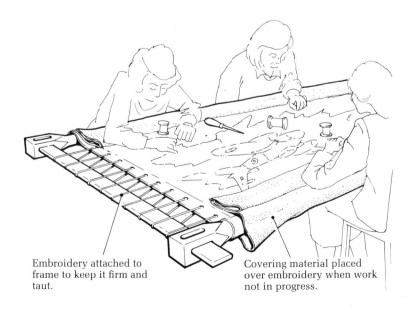

Embroidery attached to frame to keep it firm and taut.

Covering material placed over embroidery when work not in progress.

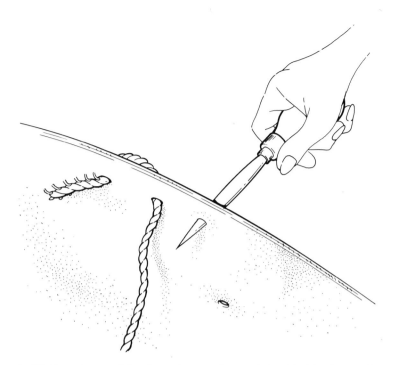

A stiletto being used to pierce layers of material so that lacing cord can be threaded through and secured neatly at the back of the panel.

left hands on top. The cartoon was placed at the end of the frame so that the embroiderers could see it easily while they worked. Once the pieces of fabric had been sewn to the background, they were edged with lacing cord or cotton couching thread for very small pieces.

For detail or for particular effects embroidery stitching was used. The stitches were mainly long and short to give shading to particular areas; satin stitch and French knots for a textured effect. Apart from a variety of needles, fine stilettos were the only needlework tools employed. These sharp, pointed instruments were used to pierce the appliquéd material, sometimes several layers thick, so that the lacing cord could be taken through to be finished off neatly at the back. Each completed panel was finally removed from the embroidery frame and mounted on wooden stretchers.

During the making of the Overlord Embroidery, David Lloyd, the Director of the Royal School, was re-

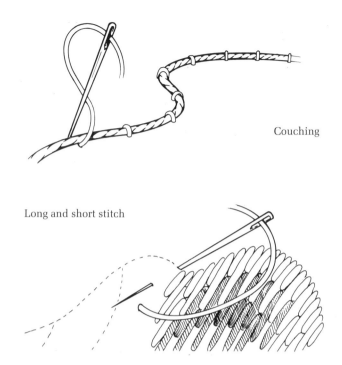

Couching

Satin stitch

Long and short stitch

French knots

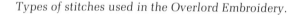

Types of stitches used in the Overlord Embroidery.

sponsible for all the administrative and financial arrangements with Lord Dulverton. A key role was also played by Margaret Bartlett, who was the head of the workroom. She had been trained at the Royal School before the Second World War. During the war, she served in the Auxiliary Territorial Service (ATS) and she was one of the girls sent on a course of car and lorry maintenance, a course which Princess Elizabeth later joined. She could herself remember the strict security regulations in force along the south coast prior to D-Day.

After the war, Margaret Bartlett returned to the Royal School, becoming head of the workroom in 1963. In this capacity she supervised work on the Hastings Embroidery, another example of appliqué work used with embroidery. It consisted of 27 panels showing landmarks in British history since 1066, and was commissioned to mark the 900th anniversary of the Norman Conquest.

Lord Dulverton saw reproductions of it before commissioning the Overlord Embroidery, and experience gained in the production of the Hastings Embroidery proved valuable during work on the Overlord project.

The most important of Margaret Bartlett's duties was the selection of the materials to be used in the Overlord Embroidery. All that remained of wartime uniform and other fabrics such as camouflage material and parachute silk were bought up. More than 50 different materials were used, including sateen, crêpe, silk, linen, chiffon, barathea, serge, rep, net, gold lurex for buttons (which tarnishes less than silver lurex) and a piece of lace for the Frenchwoman's collar in Panel 17. Medal ribbons were worked over strips of card to make them stand out. The main material used as backing for the panels was Crestweave, a purple-coloured, 100 per cent linen, which is described as 'good tempered', in that it responds to being stitched without stretching and can be handled easily. A

total of 102 yards was needed. The petersham border, in a plum colour to tone with the purple Crestweave, was specially dyed by Pilgrim and Payne: 204 yards were needed to edge the designs. And 350 yards of cording were used to edge the pieces of appliquéd material.

During the making of the Overlord Embroidery, Margaret Bartlett kept a workbook recording all the dates of meetings, when panels were started and finished, queries and alterations. The workbook is full of fascinating day-by-day details of the buying and costings of materials: a note that half a yard of Naval Best Superfine had been purchased from Gieves of Old Bond Street on 11 February 1970 at a cost of £3. 7s. 6d.; another that Pilgrim and Payne had been paid £1. 16s. 9d. for dyeing some khaki rep for the uniforms of the American officers in Panel 9; and a warning that one out of four 6-yard lengths of Crestweave bought on 1 May 1970 showed variations in colour.

Margaret Bartlett's workbook makes comprehensible, better than any other source, the vast effort and care which went into the creation of the Overlord Embroidery. And not only does it record all the details of the embroidery work, it also provides insights into the human side of the story: the occasions when 'Miss B' found herself in disagreement with 'Miss L' (Sandra Lawrence); the consternation when one of the cartoons went missing; and the great day when the Embroidery was displayed almost in its entirety for the first time at Lord Dulverton's home. Miss Bartlett noted simply in her workbook, 'Party at Batsford. V. happy day.'

Lord Dulverton in the arboretum, which he has himself created at his family home, Batsford Park in Gloucestershire. Dulverton Trust: Paul Kaye

14

PART II
THE OVERLORD EMBROIDERY
PANEL BY PANEL

Introduction

It is important to remember in reading what follows that the significance of Operation Overlord cannot be fully understood in isolation from the wider story of the war. Overlord was the culmination of years of planning and preparation by the Allies, but it could not have been mounted successfully without the enormous effort in other theatres of war which preceded it. The diverse lessons which were learnt from those campaigns, and the gradual reduction in the strength of the Axis powers which they brought about, were essential stepping-stones to D-Day. The Embroidery alludes to a few of these campaigns: the Battle of Britain, the Battle of the Atlantic and the bomber offensive against Germany. But the terms of reference of the Embroidery ruled out any mention, for example, of the conflict by land, sea and air in the Mediterranean theatre of war, the bitter battles between the German and Russian armies on the Eastern Front or the war against Japan.

Overlord owed an immeasurable amount to these struggles, but an understanding of what a 'world war' meant in terms of the military commitments faced by Britain and the Commonwealth also makes the concentration of forces achieved to secure victory in Normandy seem all the more remarkable. Lord Dulverton still regards the Allied assault on Normandy as one of the most memorable events of his lifetime:

'With all the setbacks of the first phase of the war, the Blitz and then the far-flung engagements around the world, I believe that it is nothing less than fantastic that Britain and its Commonwealth managed, even with the decisive help of the Americans, to mount and carry to success the vastly complex assault on Hitler's Fortress Europe, of which the Embroidery tells the story.'

This section of the book examines in detail the making of each of the Overlord Embroidery's 34 panels. It also explains and puts into context the scenes depicted in the Embroidery's 272-foot length. The creators of the Embroidery believed that an historical commentary on each of the panels would be essential to a proper appreciation of the work. As the Embroidery progressed, plans were made for an historian from the Imperial War Museum to draft suitable display captions and an illustrated brochure. There was also to be a full-scale book on Operation Overlord and the Embroidery, with an introduction by the distinguished historian, Sir John Wheeler-Bennett. A brochure with short descriptions of each panel *was* published (by The Readers Digest) in 1973, but the major book was never produced. Now that original intention of providing background information on the scenes in the Embroidery to give a balanced picture of Operation Overlord has, we hope, been fulfilled by this book.

Apart from the main Embroidery, three related special panels were created by the Royal School. In 1975, a reduced-size version of Panel 28 was made as a demonstration of the appliqué embroidery style, and this has been displayed at a variety of exhibitions. In 1978, Selina Winter worked a small-scale panel showing King George VI, on fine canvas (28 threads to the inch), for presentation to the Queen Mother when she opened the display of the Overlord Embroidery in the Porter Tun Room of Whitbread's Brewery, London. And finally, also in 1978, a display showing all the different stages in the working of a panel was made by Wendy Hogg from pieces left over from the Embroidery. This can be seen at the D-Day Museum.

A NATION AT WAR

Date: The First Year of War, 1939–40 Location: Wartime Britain and the surrounding seas

D-Day would be the main focus of the Overlord Embroidery, that was clear. But where should the story begin? Weeks, months or years before the launching of the invasion? Lord Dulverton's wish that the emphasis should be on Britain's 'national effort' prompted Colonel Neave-Hill to include in his first synopsis for the Embroidery an introductory section on how this country, 'the beleaguered island, fortress and arsenal', became the base for the invasion of north-west Europe four years after the

Dunkirk evacuation. He suggested that this might cover 'the factories, air raids and ARP (Air Raid Precautions), firemen and merchant navy, barrage balloons, radar.'

The first panel Sandra Lawrence designed was, in fact, the one that is now Panel 3, in which she dealt with the Blitz. For Panel 1 she picked out various other ideas from Colonel Neave-Hill's draft script. In her initial cartoon she also included American landing craft, but at its first meeting the Historical Subcommittee of the Dul-

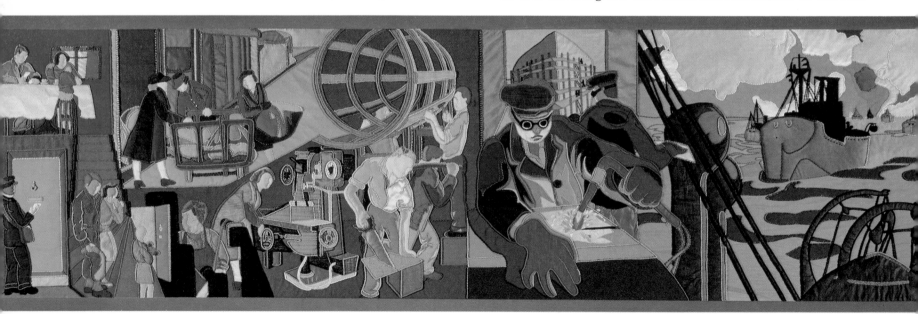

The piece of machinery in Panel 1, worked in grey materials of six different textures.

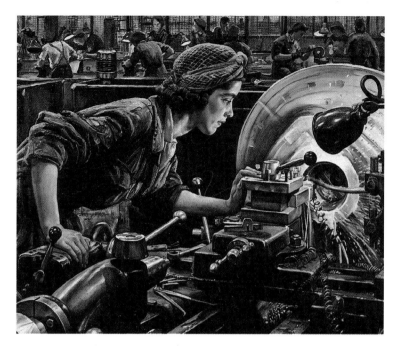

Laura Knight, Ruby Loftus Screwing a Breech-ring, oil on canvas, 1943. Ruby Loftus was one of the outstanding machinists responsible for screwing breech-rings for Bofors guns at the Royal Ordnance Factory in Newport. The painting was reproduced as a poster and widely displayed 'on the factory front'. Imperial War Museum

verton Embroidery Committee suggested that a convoy would be a more appropriate topic for this stage in the story. So Sandra Lawrence incorporated one into the final part of the panel, using for reference a photograph of a North Sea convoy of colliers and merchantmen from Purnell's *History of the Second World War*.

In the six scenes in this crowded panel, Sandra Lawrence has succeeded in giving an impression of concentrated activity and effort. In the first scene, she manages to convey the difficult idea of the passing of time. Father, mother and daughter appear twice on the left of the panel. A postman delivers a letter. Upstairs the father, in his civilian clothes, studies it at the breakfast table. When he appears again at the foot of the stairs, he is in

army uniform: the letter contained his call-up papers. His wife wipes away her tears and the child clutches her teddy bear. The door is open, waiting for the soldier to depart. This compact scene tells the viewer within a very small area that the war has begun.

The most eye-catching character in the panel is the welder, who is reminiscent of the figures in the official war artist Stanley Spencer's painting *Burners*, one in his wartime series on shipbuilding on the Clyde. The welder's huge, gloved hand reaches out to the forefront of the panel, involving the spectator in the act of welding. The size of the hand is increased by the deep blue shadow on one side and the light grey metal on the other. The effect of the glove reflecting the brightness of the flame is created by light brown strips of material, edged with orange lacing cord.

Stanley Spencer, Shipbuilding on the Clyde: Burners (detail), oil on canvas, 1940. Protective gloves, as worn by these workers, are the most prominent feature of Sandra Lawrence's design for Panel 1. Imperial War Museum

Once Sandra Lawrence's cartoon had been approved by the Embroidery Committee, a tracing was made and the design transferred to the background material by the Royal School of Needlework, using the pricking and pouncing method described earlier. It was then Margaret Bartlett's responsibility to select suitable material on the basis not just of colour but also of texture and bulk. This was a highly skilled task, though also at times a matter of trial and error. In this panel, the piece of machinery below the aircraft fuselage is a good example of Margaret Bartlett's selection of fabrics. At least six types of grey material of varying tones and textures have been used to give the 'feel' of the metallic surfaces as light falls on them from different angles. In many parts of the Embroidery, several layers of material are applied one on top of another. Here two layers of net have been placed over much of the sea around the convoy to create a really textured effect.

While the Royal School were working on the first panel (actually Panel 3), it was felt that the Embroidery lacked a three-dimensional quality when the shapes of material were simply applied without any edging. Sandra Lawrence herself agreed with this: 'Miss L did not like panel at first visit when no cording had been done', Margaret Bartlett noted in her workbook. So Margaret Bartlett suggested that they try lacing cord, which they had used successfully for the Hastings Embroidery. This immediately gave the extra depth that was needed, as the cord was bulky enough to throw a shadow.

In Panel 1, the Royal School has used great imagination in the choice of different thicknesses and colours of lacing cord. It is used particularly successfully on the framework of the aircraft fuselage and the welder's gloved hands. The lacing cord is normally held down to the edge of the material by being sewn into it, rather than couched down, so no stitching can be seen. Lacing cord is also used for features such as the door knocker on the left of this panel, and the poles of the stretcher in Panel 3.

GEARING UP FOR WAR

The Call-Up

On the left of the panel, a civilian receives his call-up papers and is given a tearful send off by his wife and

A scene from the Hastings Embroidery. Techniques which had proved successful in the Hastings Embroidery were used again by the Royal School of Needlework for the Overlord Embroidery. Hastings Borough Council

The Battle for Production

In the centre of the panel, work goes on round the clock in aircraft factories and shipyards; women take over many jobs previously done by men, working as porters on the railways and in machine shops. Mobilisation for a 'total war' meant much more than the call-up to the armed forces. It involved deploying all the nation's available resources – people, raw materials, transport services, industry, the land – to support the war effort.

There was an enormous expansion in the production of war materials. In the aircraft industry, for example, the workforce grew from 973,000 in 1940 to a peak of 1,678,000 in 1943, and production of planes rose from 8000 to 26,000 a year. As men went into the armed forces and the demands for labour grew, women played an increasingly important role. In the aircraft industry, women made up 40 per cent of the employees by 1943. Winston Churchill wrote, of the battle on the 'factory front', 'Men and women toiled at lathes and machines until they fell exhausted on the floor and had to be dragged away and ordered home, while their places were occupied by newcomers ahead of time.'

The Battle of the Sea Lanes

On the right of the panel a convoy of merchantmen and colliers moves vital supplies. After the fall of France in 1940, seaborne supplies were essential to Britain's war effort. On 17 August 1940, Hitler declared a total blockade of the British Isles, warning that neutral shipping would be sunk on sight. The greatest threat to Britain's ocean trade came from the German U-boats, now able to operate from bases on the coastline of western Europe from Norway to the Bay of Biscay. But merchant ships were also at risk from German surface raiders, bomber aircraft and mines. The battle of the sea lanes was to be a long and hard struggle for the Allied navies and merchant fleets, but it was one which was vital to Britain's survival and ultimate victory.

child. In contrast to the beginning of the First World War, it was clear in 1939 that service in the armed forces could not be left to volunteers. In April 1939, conscription was first introduced in Britain in peacetime when young men aged 20 became liable for military training. During August, telegrams went out to recall reservists, and on the outbreak of war in September the National Service (Armed Forces) Act made all men aged 18 to 41 liable to be called up. During the war, a total of 5,900,000 men and women served in the British armed forces.

THE BATTLE OF BRITAIN

Date: Summer 1940 Location: Wartime Britain, factories, farms and fighter stations

In this panel the Embroidery Committee suggested that Sandra Lawrence should continue with the theme of the 'beleaguered island', by completing the section showing the effect of the war on civilians and then moving on to some well-known images of the Battle of Britain, such as fighter pilots 'scrambling' to their aircraft. The Women's Land Army, the Women's Auxiliary Air Force and the Auxiliary Territorial Service also feature in this panel. Admiral Madden later recalled that he got into trouble for allowing the Embroidery to be completed without a reference to the Women's Royal Naval Service. The omission was also pointed out to Lord Dulverton. Margaret Bartlett recorded in her workbook the occasion in February 1973 when Lady Dulverton visited the Royal School with her husband: 'Lady Dulverton wants to have the Wrens and ATS represented in other panels. Miss B agrees.' But when Lord Dulverton did add another panel it dealt with the battle for Caen and not with the Wrens.

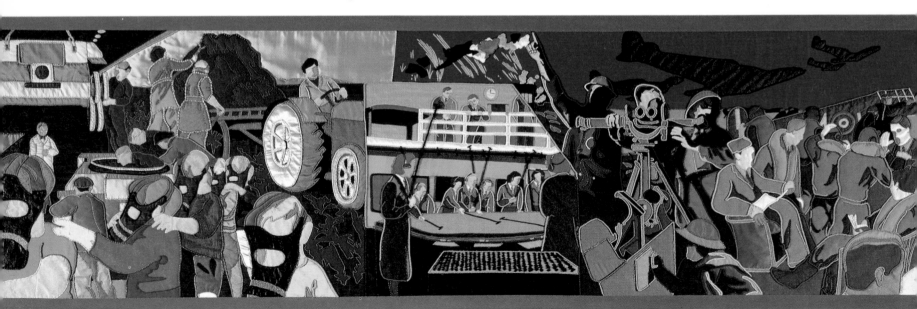

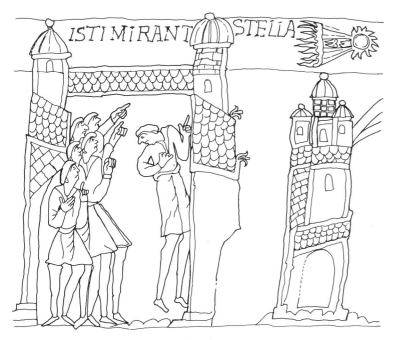

Halley's comet causes consternation in 1066.

German bombers overhead.

The call to 'scramble'.

The Royal School of Needlework were not very happy with some aspects of Sandra Lawrence's early designs: for example, the very bright colours, the blank faces and certain 'pop-art' features like the welder's hand in Panel 1. Margaret Bartlett felt that both the nature of

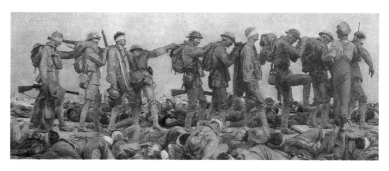

John Singer Sargent, Gassed (detail), oil on canvas, 1918–19. British soldiers temporarily blinded by mustard gas on the Western Front during the First World War make their way to a casualty station. Like the boys in Panel 2, they hold the shoulder of the person in front for guidance. Imperial War Museum

the subject and the medium demanded a more traditional and conservative approach.

In the photograph on which Sandra Lawrence based the group of children practising gas mask drill, the leading figure was wearing a striped pullover. In her cartoon Sandra Lawrence gave him a striped orange T-shirt. The Royal School did not think this worked at all well, so Margaret Bartlett substituted the plain turquoise T-shirt which can be seen in the panel. When Sandra Lawrence next visited the Royal School she asked why the alteration had been made without consulting her. A lively discussion then ensued. According to her workbook, Miss Bartlett pointed out that the Royal School felt that various aspects of the designs were stylistically wrong for an historical embroidery. 'Discussed lines to be drawn which were omitted', she wrote. 'Miss L did not want to put detail in of uniform, etc. Miss B insisted that this must be done in future.'

Sandra Lawrence took the cartoon with her when she left, but David Lloyd, the Director of the Royal School, retrieved it so that the problems could be discussed at the next meeting with Lord Dulverton. To a very great extent Lord Dulverton shared the Royal School's misgivings, and indeed the Embroidery does become more detailed and more sober, particularly as military uniforms are increasingly in evidence. Sandra Lawrence herself later

felt that the 'bright, almost primitive style' of the early panels was perhaps a mistake. 'Should I have commenced in the middle and worked out both ways', she wondered, 'instead of starting at the beginning (or nearly so) and working through?'

Sandra Lawrence has included a number of interesting features in the design of this panel. First, there is an example of looking into a scene – the operations room – from behind a silhouetted figure. This has the effect of concentrating the viewer's attention on a particular area, like trying to look over the shoulders of people in a crowd to see what is going on, and is a useful technique to incorporate into an embroidery which involves the use of figures.

Then, on the extreme right, note the use of a hand gesture to reinforce the significance of the open mouth of the officer who is shouting at the pilots to scramble. This is very reminiscent of the Bayeux Tapestry, where gestures are frequently used. For example, in the Bayeux Tapestry a look-out puts his hand to his eyes, and pointing fingers direct the viewer's attention to the most important part of a scene.

Hair is used in this panel and throughout the Embroidery as a way of adding colour to a scene. Bright orange is used for the child on the left and orangey brown, edged with orange lacing cord, for the airman on the right. The hand of cards on the right adds another eye-catching detail to the panel. Cards appear again as a highlight in Panel 31.

The Royal School has used various ways of edging the pieces of applied material in this panel. Both silky and more woolly varieties of cording can be seen. For the shirt of the child in front of the tractor wheel, the yellow lacing cord is sewn through, rather than couched down, to give a smooth finish. For the land girls, the thick edging is couched down to give a more 'rugged' look befitting their working clothes. Margaret Bartlett remembered Lord Dulverton saying that the object of their attentions looked nothing like any muck heap he had ever seen, but let it pass!

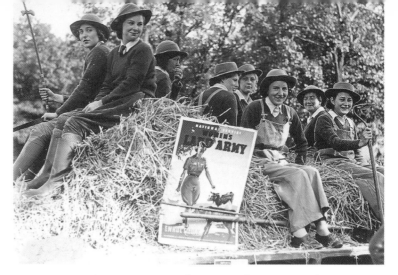

Recruiting for the Women's Land Army in the Portsmouth area during the Second World War. Portsmouth and Sunderland Newspapers

Particularly thick, black lacing cord has been used on the gas mask of the boy in the yellow shirt to thrust it out towards the spectator. The crocodile of children with their gas masks echoes the First World War painting *Gassed* by John Sargent, in which soldiers blinded by gas stumble across the canvas. There is a strange 'sightless' quality about the children in the Embroidery. The gas masks seem not to be positioned correctly in relation to their eyes. This is not surprising, as Sandra Lawrence based this disturbing scene on a photograph in Purnell's of *blind* children getting used to moving in their gas masks. The image serves to remind us that gas blinds as well as chokes. But the children do not have that extra harm to fear: the fate inflicted by gas on the men in Sargent's painting has already been inflicted on these children by nature.

ON THE LAND AND IN THE AIR

The Women's Land Army

On the left of the panel, tanks roll off the assembly lines and land girls work in the fields. Increased production of food was vital to save on imports. The Women's Land

Army was formed in June 1939, and by 1943 there were nearly 90,000 land girls. Despite a contemporary description of them as 'this young, sun-tanned, green-sweatered, cord-breeched army', war work on the land was by no means a romantic existence. In wartime Britain, the number of acres under cultivation rose from twelve to eighteen million.

Children at War

No age group escaped the impact of war. A simple illustration of this was the universal distribution of gas masks to civilians. Inspired by the terrible memories of the western front in the First World War and the fear of air attack with gas bombs, the authorities had issued 38 million gas masks by the time of the Munich Crisis in 1938. All-enveloping gas helmets were provided for babies, and red and blue 'Mickey Mouse' masks for toddlers. As the evacuation of over a million children from danger areas began on 1 September 1939, lines of boys and girls could be seen at railway stations, all carrying one essential possession – their gas masks.

Women in the Services

In the centre of the panel, as the Battle of Britain develops, information on German air raids is fed to Fighter Command operations rooms where members of the Women's Auxiliary Air Force (WAAFs) plot them on map tables. Alongside, members of the Auxiliary Territorial Service (ATS) operate the range-finder and predictor on an anti-aircraft gun site. In December 1941, a new National Service Act made women aged 20 to 31 liable for military service. By 1945, the armed forces of Great Britain numbered 4,680,000, of whom 437,000 were women serving in the Women's Royal Naval Service, the WAAF or the ATS.

The first ATS were deployed with men on anti-aircraft guns in so-called 'mixed batteries', near London in the late summer of 1941. The commander of the first mixed battery to shoot down a German plane – near Newcastle in December 1941 – declared:

As an old soldier, if I were offered the choice of commanding a mixed battery or a male battery, I say without hesitation I would take the mixed battery. The girls cannot be beaten in action, and in my opinion they are definitely better than the men on the instruments they are manning. Beyond a little natural excitement which only shows itself in rather humorous and quaint remarks, they are quite as steady if not steadier than the men.

The Battle of Britain

Before Hitler's plan to invade England, Operation Sealion, could be carried out, the German air force had to gain mastery of the skies over the Channel. Its attempt to do so in the Battle of Britain began in earnest on 13 August 1940 – 'Eagle Day'. Between 24 August and 6 September, the Luftwaffe carried out 33 major raids, concentrating on attacking the opposing fighter airfields. Fighter Command's reserves of aircraft and pilots were steadily being depleted. Then, on 7 September, Hitler ordered a switch to bombing attacks on London, relieving some of the pressure on the RAF.

In his war memoirs, Churchill describes how he visited the operations room of No. 11 Fighter Group at Uxbridge, on 15 September. With his wife, he was taken 50 feet below ground to a room like a small theatre, about 60 feet across, with two storeys. 'We took our seats in the Dress Circle', Churchill wrote. 'Below us was the large-scale map table, around which perhaps twenty highly trained young men and women, with their telephone assistants, were assembled.' After quarter of an hour the raid-plotters, like those shown in the Embroidery, began to move about as an attack developed, pushing the discs which showed the paths of the enemy aircraft. The resources of No. 11 Fighter Group were soon stretched to the limit and casualties were heavy on both sides. But it was clear that command of the air still eluded the Luftwaffe. Two days later, on 17 September, Hitler postponed Operation Sealion 'until further notice'. The Battle of Britain was over.

PANEL 3

THE BLITZ

Date: September 1940–May 1941 Location: London and many other
British cities

Work began on this panel, the first to be produced by the Royal School of Needlework, in July 1968. In her design, Sandra Lawrence included five very compacted scenes, which through the vivid colours and aggressive shapes show the unpleasant experiences to which everyone was subjected in the Blitz: danger, discomfort, the noise of guns firing as searchlights probed the sky, the crackle of flames, the smell of smoke, choking dust from falling buildings and always the dreadful possibility of finding your home destroyed when you emerged from your shelter. The areas of black, pinkish mauve and purple form a wonderful background against which to silhouette the shapes of the aircraft, the barrage balloon, anti-aircraft gun, searchlights, sound locators and falling masonry. When the Royal School of Needlework accepted the commission to work the Overlord Embroidery, Margaret Bartlett was rather concerned that the young staff of the workroom would not find a military subject of very great

interest. But the inclusion of Home Front scenes such as the ones shown here aroused their curiosity. Much discussion ensued as Margaret Bartlett explained the significance of barrage balloons, gas masks and taking shelter on tube station platforms.

Images of civilian suffering in wartime are common to both the Overlord Embroidery and the Bayeux Tapestry. In the Tapestry, just before the battle of Hastings begins, two soldiers are shown setting a torch to a house as a woman and her son escape. Her hand gesture seems to express resignation at this wanton act. In this panel of the Overlord Embroidery, the burning buildings symbolise the terrible destruction caused by incendiary bombs in many cities during the Blitz. The scale of the civilian suffering in the Second World War is symbolised even more strikingly by the image of Caen devastated by Allied bombing in Panel 30.

Until the very last part of this scene, the action takes place at night, but imaginative use has been made of a number of different light sources. The beams of the

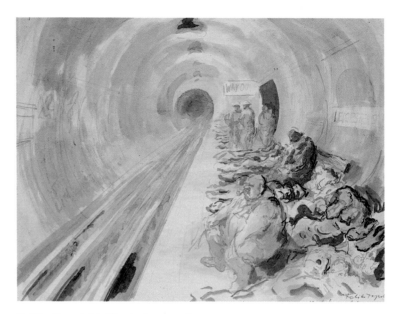

Feliks Topolski, The Tube, October 1940, *wash. Londoners take shelter on the platform of Leicester Square tube station during the Blitz.* Imperial War Museum

Shelterers descending to the tube station platform in Panel 3. The blind man's stick is made from white lacing cord.

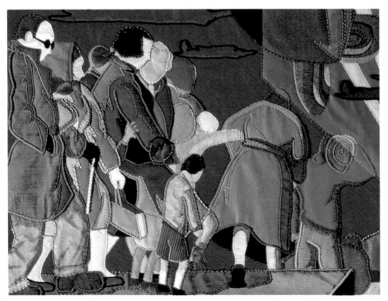

searchlights in the distance are shown in two colours, as we look at them in part through the beam from the searchlight in the foreground. The searchlights flicker across the German bombers, some of which are shown in silhouette and some caught in a beam as they seem to pass in and out of the light. Silver-grey embroidery silk in long and short stitch, worked in the direction of the beam rather than of the plane, is used to create the effect of light striking the metallic surface of an aircraft.

The diagonal of the firemen's hose and jet of water carries our eyes to the upstairs window of the house, where incendiary bombs have done their work. The fierce heat and light from the flames are shown by the edging of the clothing of the firemen and rescue workers with orange and yellow lacing cord, and of their faces with cotton couching thread. Strands of yellow lacing cord, placed side by side on the coat of the woman carrying the potted plant, create a larger area of reflected 'glare'.

In her workbook, Margaret Bartlett recorded that she

27

bought the following materials to begin work on this panel:

Material		Colour	Quantity	Price
Morvel	No. 3	Plum	2 yards	23/6
	No. 5	Autumn Leaf	2 yards	23/6
	No. 6	Apricot	2 yards	23/6
Turkana	No. 4	Thailand Pink	–	31/9
	No. 6	Autumn Leaf	–	31/9

In this and the other early panels, before military uniforms start to predominate, there was greater scope for the use of a variety of materials for clothing: some matt and woolly in texture, some of finer weave and smoothness. Note in particular the use of corduroy for the trousers of the little boy descending into the Underground.

The Bayeux Tapestry: '. . . the widow and orphan, eternal victims of war.' They flee from their blazing home as the Normans lay waste to the English countryside.

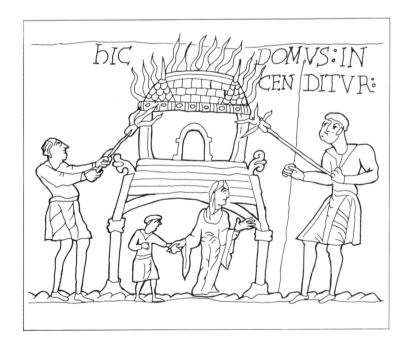

BRITAIN CAN TAKE IT

Civilians in the Front Line

The chaotic scene epitomises the contemporary slogan: 'Britain can take it.' Civilians in London are shown descending to take shelter at a tube station as the Blitz begins. As German bombers fly overhead above the balloon barrage, numerous searchlights and sound locators attempt to find targets for the anti-aircraft guns and night fighters. Firemen, rescue squads and nurses deal with the results of an air raid, while bombed-out civilians salvage a few precious possessions.

Although not as bad as anticipated by those in the 1930s who feared a 'knock-out blow' from the air, the Blitz, when it did come in 1940, put the whole population in the front line. After concentrating on London at first, the Germans extended their bombing to the provinces in October 1940, and in the final phase, from March to May 1941, they attacked the ports. During the war as a whole, bombing killed 60,595 civilians and seriously injured a further 86,000 in Britain. Damage to property was worse than expected: 200,000 homes were destroyed and over four million damaged. Yet war production was not crippled and morale was heightened, if anything, under the German bombs.

Take Cover

Between 7 September and 13 November 1940, there was only one night when London escaped bombing. At first the government tried to ban the use of the London Underground for sheltering, but once heavy raids began, people simply ignored this prohibition. By 27 September, some 177,000 men, women and children were using the tube as their nightly refuge, descending to their favourite positions, taking food, drink and bedding with them. Yet though the scenes in the tube are some of the most famous images of the Blitz, only a minority sheltered there. Of the three million people remaining in inner London in November 1940, over half used no shelter at all, preferring to take their chances in their own homes.

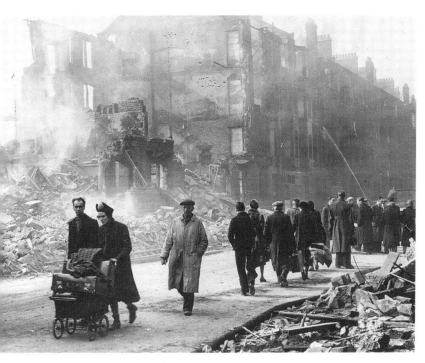

Glasgow: the aftermath of a German bombing raid. Imperial War Museum HU 36232

Ack-Ack

The Anti-Aircraft Command, headed by General Sir Frederick Pile throughout the war, was initially short of both troops and equipment, but by the time the Blitz ended in May 1941 it deployed 1691 heavy guns, 940 light guns and 4532 searchlights. Radar was introduced to direct the anti-aircraft fire ('ack-ack') in October 1940, although the system was not complete until after the end of the Blitz. Up till then the gunners had to rely on sound locators, which were inaccurate under ideal conditions and became hopelessly confused during mass raids. But almost as important as their effect on the German bombers was the boost which the sound of anti-aircraft guns gave to the morale of those suffering under the Luftwaffe's attack.

Air Raid Precautions

In 1937, the Air Raid Precautions Act required local

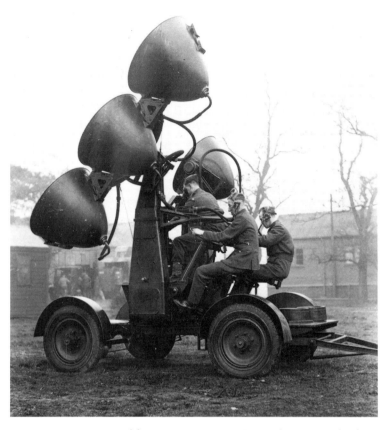

Troops manning sound locators attempt to detect the approach of German aircraft. Portsmouth and Sunderland Newspapers

authorities to submit plans for emergency services in the event of war. By the end of 1938, some 1,400,000 adults had volunteered to serve in the ARP. In the Blitz, the ARP became a civilian army acting as fire watchers, air raid wardens, first aiders, rescue squads and drivers, and in numerous other capacities. ARP workers often went almost straight from their daily jobs to their nightly duty posts in all the cities in Britain. Places like St Paul's Cathedral had a complicated network of workers so that the maze-like geography of the whole building could be covered to the best advantage. In September 1941, the ARP was officially superseded by the Civil Defence, incorporating the new National Fire Service.

THE WORLD AT WAR

Date: 1940–2 Location: The Atlantic Ocean and British ports

At the first meeting of the Embroidery Historical Subcommittee in October 1968, the cartoons which Sandra Lawrence had already completed were examined. Then the Subcommittee asked her to prepare the next one to 'illustrate planning (a map?), and the Americans landing, perhaps from a passenger liner at the dockside'. The following month they met to look at the result and decided that it would be better to replace the map by a 'scene to show the Battle of the Western Approaches'.

The Subcommittee suggested that this might involve a U-boat attacking a merchant ship, or a destroyer or RAF Sunderland flying boat attacking a U-boat. But there were clearly practical problems in depicting such a scene. 'It was appreciated that some artist's licence might be desirable to create the desired impact of such a scene involving a U-boat.' Sandra Lawrence wisely decided not to attempt to show the U-boat at all, but based her design on a photograph of an escort sloop using depth charges.

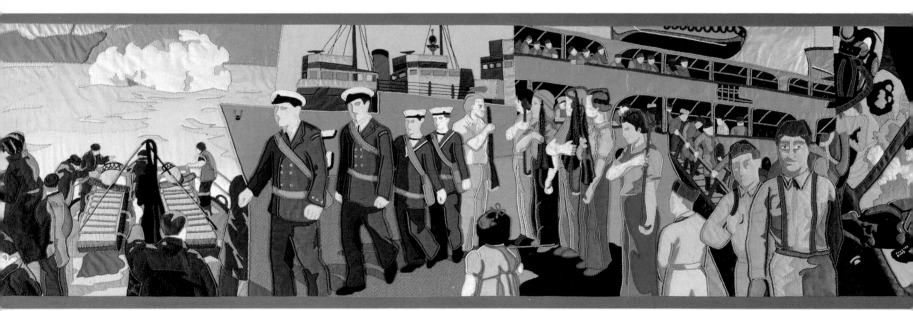

The design finally arrived at by Sandra Lawrence is tightly packed with activity, but it somehow lacks dramatic effect. The figures seem too far removed from us. Compare the impact made by the leading American soldier in the braces in this panel with that of the tug boat captain in Panel 8 or the German prisoner in Panel 26. We look in over the head of a child watching the Home Guard, but we are not really drawn in and involved. The vignette symbolising the ill-equipped state of the Home Guard in 1940 sits uneasily with the two dockside sequences. It seems to form part of the scene showing the arrival of American troops in Britain, which did not begin until January 1942.

The horizon line where sea and sky meet is broken by a hard line above the head of the leading Canadian sailor and the harsh red of the dockside breaks the continuity of the foreground. On the extreme right the image is that of a leather-helmeted, oxygen-masked member of a bomber crew, his gloved hand pressing the bomb release mechanism. The disconcerting change of scale makes it very difficult to comprehend, despite the small lettering saying 'bomb release'. The significance of the scene — based on a photograph from a wartime book about the American bomber offensive, called *Target: Germany* — is explained under Panel 5.

OUT THERE AND OVER HERE

The Defeat of the U-Boats

The scene on the left of this panel is based on a photograph of HMS *Starling*, an escort sloop launched in October 1942. As leader of the Royal Navy's Second Support Group, it was the most successful U-boat destroyer of the war. Alongside are men of the Royal Canadian Navy, which played an important role in the battle of the Atlantic.

The United States entered the war after the Japanese bombing of Pearl Harbor in December 1941. The battle of the Atlantic, the dominating concern of the Royal Navy, assisted by the Royal Canadian Navy, took on an even

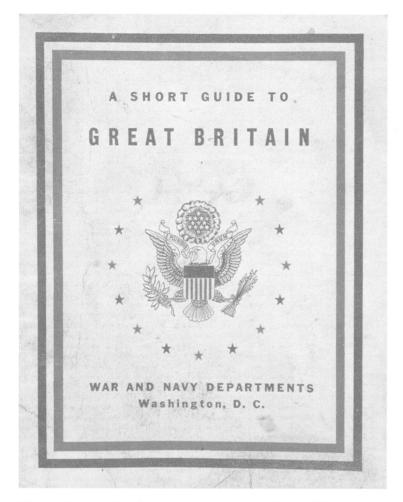

The booklet issued to American servicemen in Britain. D-Day Museum: Dominic Fontana

greater significance. The advantage in the struggle gradually went to the Allies, as the combination of escort vessels, very long-range aircraft, and short-range aircraft operating from escort carriers, became increasingly effective against the German submarines. The turning point came in May 1943, when the Germans lost some 40 U-boats. The defeat of the U-boat menace opened the way for the concentration in Britain of the men, weapons and supplies required for the invasion of Europe.

Members of the Home Guard practise with their newly-acquired rifles in the summer of 1940. Portsmouth and Sunderland Newspapers

The Home Guard

In May 1940, the Secretary of State for War, Anthony Eden, appealed for men to join a new force of Local Defence Volunteers. Men between the ages of 17 and 65 were eligible. By July, over a million men had volunteered and, at Churchill's insistence, the name was changed to the Home Guard. Armed at first only with clubs, pitchforks and shotguns, German propaganda reacted to them by using the term 'the Broomstick Army', in derision. However, the Home Guard was soon equipped with weapons shipped over from North America. Women could join as auxiliaries but were not officially supposed to carry arms, although a number of 'private' armies with names like the Women's Amazon Defence Corps were formed. In the spring of 1944, the Home Guard played a valuable role in the build-up to Overlord when it took on many security and movement control duties, thus freeing the regular troops for invasion preparations. The Home Guard was stood down in November 1944.

The Friendly Invasion

American troops began arriving in England in January 1942. By June 1944, 1,527,000 Americans had been brought across the Atlantic. An important part was played by the great liners, *Queen Mary* and *Queen Elizabeth*. Each was adapted to hold 15,000 men, and between them they brought over more than 425,000. The arrival of the Americans brought to war-deprived Britain a ray of hope and excitement, which were not always appreciated by the male population as the more glamorous and smartly uniformed GIs, with their supplies of nylons and chocolate, became familiar in every part of the country.

The American GIs were issued with a booklet entitled *A Short Guide to Great Britain* to prepare them for the differences they would encounter in character, customs and language:

> If Britons sit in trains or buses without striking up conversation with you, it doesn't mean they are being haughty and unfriendly. Probably they are paying more attention to you than you think ... To say: 'I look like a bum' is offensive to their ears, for to the British this means that you look like your own backside ... Keep out of arguments. You can rub a Britisher the wrong way by telling him 'We came over and won the last one.'

The booklet urged the troops to remember the slogan, 'It is always impolite to criticize your hosts; it is militarily stupid to criticize your allies.'

Nevertheless, there was a considerable degree of culture shock awaiting GIs like those shown in the Embroidery when they first set foot in Britain. David K. Webster of the 101st Airborne Division found everything he saw an almost incredible contrast to his base back at Fort Bragg:

The last image in Panel 4 was based on this photograph of a bomber crewman pressing the bomb release switch. D-Day Museum

'Welcome to the land of mild and bitter.' American servicemen acclimatise themselves to English beer outside The Fox in the village of Catworth near Huntingdon. D-Day Museum

When I woke up the next morning, I thought I'd passed out on a Hollywood movie set. All around the area were fairy-book cottages with thatched roofs and rose vines on their sides. Vast horses shaking long manes stomped down narrow winding cobblestone lanes. A soft village green, soon to be plowed by GI vehicles, set off a weathered old grey church whose clock's bell chimed the hours just like Big

Ben, and five ancient public houses, their signboards swinging in the breeze, bade us welcome to the land of mild and bitter. I asked the name of the place and was told it was Aldbourne, in Wiltshire County.

THE BOMBER OFFENSIVE AGAINST GERMANY

Date: 1942–3 Location: The skies over Europe; air bases in Britain

This panel covers an aspect of the war against Germany which played an important part in ensuring the success of Operation Overlord: the Allied strategic bombing offensive. The heading in the Embroidery Script was 'softening up by air attack', but Sandra Lawrence has succeeded in adding an important human element to the strategic picture by including the waiting ground crew and the airmen returned from their mission.

When the Embroidery Committee discussed Sandra

Lawrence's initial design, they made a number of points. They asked that the aircraft in the top left should be changed to RAF Lancaster bombers (rather than American B-17 Flying Fortresses) to represent night-time bombing. A formation of B-17 bombers was to be added in the background of the air battle to symbolise daytime bombing operations of the kind carried out by the Americans. The Committee also suggested that the air battle scene on the left should be more clearly divided from the returning

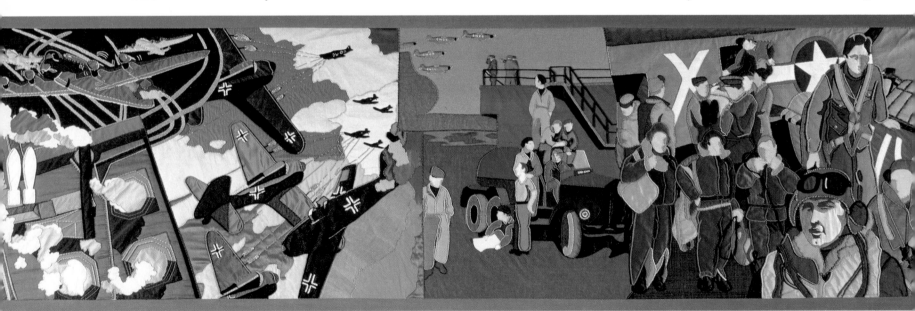

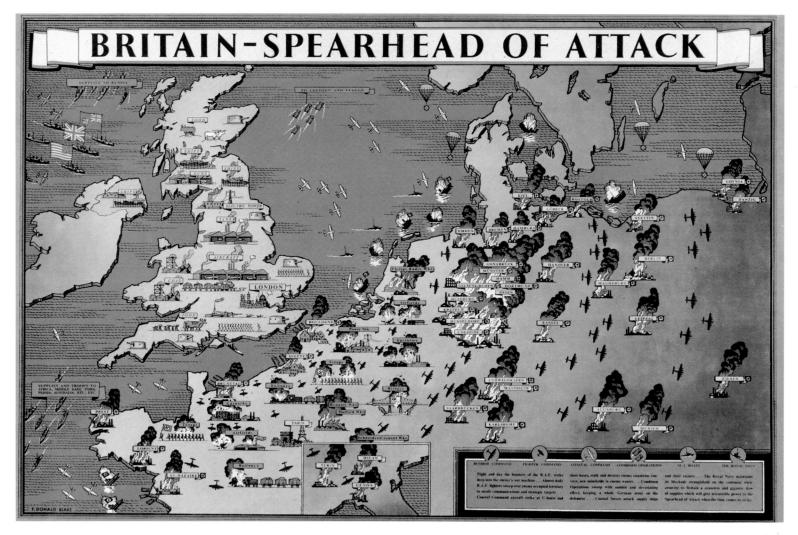

A wartime poster celebrating Britain's contribution to the fight against Nazi Germany before the opening of the Second Front.
Imperial War Museum

aircraft and crews on the right. Sandra Lawrence incorporated these amendments into her design.

Two years later, however, the Embroidery Committee had another look at some of the completed panels. Two comments about Panel 5 appear in the minutes of their meeting in May 1972. The first was rather mysterious:

'The Artist will give the Royal School of Needlework a new sketch for the face of the airman shown in the bottom right hand corner.' It is apparent, however, from the photograph of the first version of the panel that the airman had originally been given a magnificent handlebar moustache. Margaret Bartlett remembers explaining what a handlebar moustache was to her young embroiderers, but sixteen years on, no one can now recall exactly why it was decided to give the airman a shave.

35

The original version of the right-hand side of Panel 5, before the leading airman's magnificent moustache was removed.

The second comment in the minutes was more straightforward. The Committee reversed its earlier suggestion about including the American Flying Fortresses. These aircraft, 'which appear to have their own sky around them, should be deleted and the cloud beside them extended to cover the area concerned.' An additional piece of material was placed over the unwanted aircraft. Somewhat confusingly, brochures about the Embroidery continued to include in the caption to Panel 5 a reference to 'unescorted formations of American Flying Fortress bombers', but even the most keen-eyed spectators could not penetrate the 'cloud cover' to see them.

Perhaps because of the Embroidery Committee's request for a clearer distinction to be made between the air and ground sequences, there are hard dividing lines in the centre of the panel, which cause an abrupt stop as one's eye is prevented from carrying on easily to the next scene. A better flow could have been achieved by bringing the waiting ground crew with their vehicle closer to the front of the panel. As in Panel 3, we again see the use of unusual but extremely dramatic background sky colours for the aerial sequences, where all is furious activity. But there is a lack of subtlety about the sudden change to a turquoise sky – an effect which is not seen again in the whole Embroidery.

In this panel, the vapour trails and the paths of the tracer bullets form an interesting contrast in the way they are executed. The vapour trails on the left are embroidered in continuous bands of long and short stitch. Each tracer line, on the other hand, is made of one length of gold lurex flat cord actually sewn in and out of the background material, giving a wonderfully staccato interpretation. The blasts where the bullets leave the guns are also made of gold lurex, looped round into an oval shape to indicate the burst of flame and explosive force.

Another noteworthy feature of the panel is the treatment of the goggles of the leading airman, who seems to look past us, as though so preoccupied with his last mission that he is not yet part of our world. One eyepiece of the goggles is covered with net and the other is not, to give an indication of light glinting on one side only. The effect is picked up by a piece of white lacing cord on one edge of the frame.

THE FRONT IN THE SKIES

The Strategic Bombing Campaign

The aim of strategic bombing in the Second World War was to bring the enemy to their knees by striking directly at their homeland from the air, destroying both their ability and their will to resist. The Embroidery's treatment of this controversial subject begins at the end of Panel 4, where a member of a bomber crew is seen activating the bomb release mechanism to send two 500-lb bombs on to a German power station shown at the start of Panel 5. (This is based on a photograph of a raid on a Cologne power station on 12 August 1941.) In the night sky above are Lancaster bombers of RAF Bomber Command. Bomber Command found early on in the war that it was suffering such heavy losses by day that it was forced to

switch to area bombing of enemy cities by night to disrupt and wear down the German war effort. Lancasters went into service in March 1942 and became the mainstay of Bomber Command's strategic offensive against Germany. During the war, Lancasters made 156,000 sorties over Europe and dropped 600,000 tons of bombs.

In the next part of the panel, RAF Spitfires are engaged by German Focke-Wulf FW 190 fighters with their four 20 mm cannon. In the original version of this panel, a formation of American B-17 Flying Fortress bombers was shown far in the distance, heading towards a target in Germany. The scene was intended to depict how the American Eighth Air Force tried to operate by day with their heavily armed bombers in order to be able to carry out precision bombing of specific targets in Germany. But Allied fighters did not have the range to protect them all the way to their targets, and the unescorted American bombers suffered heavy losses over Germany from fighters like the Focke-Wulf FW 190.

Nevertheless, the strategic bomber offensive did provide the Allies with a means of striking directly at the heart of Germany. As the Russians struggled on the Eastern Front, the Allies could point to the fact they had opened a 'second front' in the skies over Germany long before they were ready to mount a cross-Channel invasion.

American B-17 Flying Fortresses on a daylight bombing raid; around them are the vapour trails of escorting fighters. The Flying Fortresses included in Panel 5 were later covered by a cloud. Imperial War Museum NYF 14138

A Wellington bomber and crews of No. 149 Squadron of the Royal Air Force after a raid on Berlin in August 1940. Imperial War Museum HU 44271

The salvation of the American daytime offensive was the development in 1943 of an effective long-range fighter – the Mustang. In the next sequence in Panel 5, Mustangs are shown returning to base as the ground crew waits to begin its vital work of servicing and repairing the aircraft. In the first half of 1944, Germany's air strength suffered a critical blow through bombing raids on aircraft factories and through combat with the long-range fighters accompanying the bomber force. The strategic bombing offensive had played a key role in ensuring that Allied mastery of the air on D-Day was complete.

The Air and Ground Crews

In the combined British and American bomber offensive against Germany, the ground crews had a vital role to play in keeping the aircraft serviceable and preparing them for their next mission. As a wartime Air Ministry pamphlet put it: 'The success of the attack and the lives of the flying crew depend in the last resort on their [the ground crew's] labours.' On the right of the panel, a casualty is brought out of an American bomber strapped to a stretcher. An RAF bomber crew climb down on to the tarmac, having survived another mission, to make their way to a debriefing session with an intelligence officer. Some 55,000 British and Commonwealth airmen of RAF Bomber Command were killed in the course of the war.

37

PREPARING FOR THE RETURN TO EUROPE

Date: 1942–3 Location: Combined Operations Headquarters; troop training areas 'somewhere in Britain'

The basic idea behind this panel was to show aspects of the long-term planning and preparation for D-Day. In her draft design, Sandra Lawrence sketched a map of north-west Europe on the left-hand side of the panel. The Embroidery Committee suggested that it would be more in keeping with the style of the Embroidery if there were three senior officers representing the British army, navy and air force, together with an American officer, studying the map. Sandra Lawrence added these figures, basing her

design on a photograph of General Eisenhower talking to General Montgomery and Air Chief Marshals Tedder and Leigh-Mallory. In each case, however, she left the figures 'faceless'.

Even so, much trouble was occasioned by the medal ribbons and insignia of the anonymous officers. When work was in progress on the panel, Major-General Brown, the Secretary of the Dulverton Trust, and Air Chief Marshal Evans called in at the Royal School. After the visit

Douglas Brown wrote to Lord Dulverton, 'Both Donald and I noticed that the Air Force officer viewing the map (he represents nobody in particular) had gold-coloured wings on his uniform and a row of quite unknown medals which would suggest he was a member of the MCC.' So Air Chief Marshal Evans sent in his own *silver* wings and his medal ribbons as a guide to the Royal School in making the necessary corrections.

But this was only the beginning of the story. Early in 1972, the question was raised with the Embroidery Committee whether some reference should not have been made in the Embroidery to the very early stages of preparation for the return to Europe, in particular the role of Lord Louis Mountbatten and Combined Operations. Lord Dulverton had, in fact, mentioned the inclusion of Combined Operations at one of the early meetings of the 'Three Wise Men'. So it was decided that the subject should be included, and that Panel 6 was the most logical place.

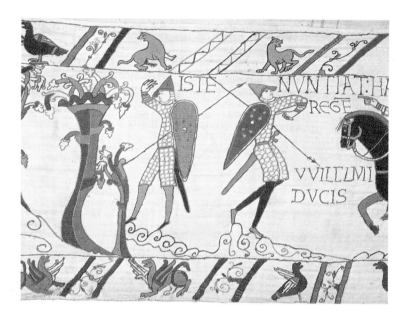

The Bayeux Tapestry: the use of link figures. An English scout spies the approach of William's army and hastens to inform King Harold, so that the two scenes are linked in a continuous narrative. Michael Holford

Lord Louis Mountbatten: one of the best portraits in the Embroidery.

Sandra Lawrence broke the news to the Royal School that one of the completed panels might have to be altered. Margaret Bartlett was not amused. 'Miss B unhappy with idea', she noted in her workbook. Later in the day, Major-General Brown telephoned Margaret Bartlett from the Dulverton Trust. He caused confusion by saying that Panel 5, rather than 6, was the one to be altered. Shortly afterwards David Lloyd, Director of the Royal School, contacted him to say that a way had been found to amend Panel 5, only to be told that it was a section of Panel 6 ('faceless officers looking at an orange map') that had to go.

The Embroidery Committee had suggested that the new end section should show 'Lord Mountbatten in profile looking at a wall diagram depicting some of the amphibious equipment he had advocated. Lord Mountbatten would be shown flanked by a soldier, sailor and airman and the wall diagram would carry the Combined Operations badge.'

Sandra Lawrence followed these suggestions for her revised design. Mountbatten is shown in conversation with three officers. As Mountbatten's face obviously had to be a recognisable portrait, Sandra Lawrence has opted to show more detail in these versions of the three 'faceless officers'. It is possible to see that a photograph of Montgomery was the model for the soldier on the right, but he was still not intended to be recognisable. On the blackboard are pinned diagrams of Hobart's 'Funnies' (see below). These are depicted in black embroidery silk, which is a more effective way than appliqué of translating line drawings into embroidery. Note how cleverly the shadows of the three officers fall on the light background.

The profile of Lord Louis Mountbatten is considered to be one of the most accurate portraits in the whole Embroidery. It is clear and striking, with most realistic hair worked in embroidery thread. The face has few shadows and the features are simple. The whole profile of the head and chest, silhouetted against the light area of the diagrams, works exceptionally well.

The likenesses of the well-known wartime figures, or VIPs as they were dubbed, are a remarkable aspect of the Embroidery. They were the work of Ruby Essam, who had been at the Royal School of Needlework for over 50 years. She could remember when Queen Mary, herself an accomplished needlewoman, came to visit and would cause consternation by jabbing at pieces of embroidery with her umbrella! Ruby Essam worked the VIP faces separately on a small square frame in order to obtain the greatest tension. Flesh-coloured silk material was used, and a variety of flesh-toned embroidery silks in long and short stitch to create the superb three-dimensional effect of the faces. When each VIP face was completed it was then incorporated into the appropriate panel.

This is the last panel to have hard dividing lines running from top to bottom, accentuated in this case by the replacement of the left-hand section. The use of a 'link figure' occurs for the first time in this panel in the form of the soldier clutching his rifle; he appears to be moving from the American to the British exercises, carrying the spectator's eye with him as he does so. Link figures appear frequently in the Bayeux Tapestry, although they are used rather differently: there a figure standing between two scenes indicates by the angle of his profile — either facing back to the previous scene or looking forward — whether spectators should 'slow down' in their appreciation or hurry on to the next scene.

In the central section, the assault course shows the use of lacing cord, sewn down where it intersects, to make a really textured climbing net. The bulky, wrinkled effect on the hanging dummies is realistic but fortuitous. Puckering tends to occur throughout the Embroidery where there is a large area of vilene-backed material not held down in the centre. In this panel there may well also have been an overall loss of tension when the left-hand section was removed and replaced by the scene with Mountbatten. At a meeting in May 1972, the Embroidery Committee asked if the Royal School could try to take the crinkles out of the material in Panel 1. 'If the material on this panel can be smoothed out, others will be considered for this treatment.' Presumably the treatment was not successful, as puckering is visible throughout the Embroidery.

When the Royal School began work on this panel, they were still unhappy about some of the colours Sandra Lawrence was using in her cartoons. David Lloyd and Margaret Bartlett both had words with her on the subject. Sandra Lawrence eventually agreed that khaki could be used for the uniforms of the British soldiers in the foreground, but she insisted that the ones in the background had to remain pale brown. She was also persuaded that the beach was shown in too bright a yellow and should be more of a buff colour.

The right-hand side is perhaps the least successful part of the panel. The four landing ships have a rather strange appearance. The photograph in Purnell's magazine on which Sandra Lawrence based this scene has above it the caption, 'A host of men and vehicles had been loaded into ships . . . Soon they would be spewed up like Jonahs upon an alien shore.' Is it possible that Sandra

Lawrence had whales rather than landing craft in mind when she designed this end of the panel?

DEVELOPMENT AND TRAINING

Combined Operations

The real start of the preparations for the invasion of Europe came with the appointment of Lord Louis Mountbatten as adviser on, and then Chief of, Combined Operations in March 1942. Among his most important contributions was the impetus he gave to the development of specialised assault craft and artificial 'Mulberry' harbours, and his advocacy of Normandy rather than the Pas de Calais as the target for the invasion. The raid on Dieppe mounted by Combined Operations Headquarters in 1942, though the Canadians suffered heavy losses in it, provided valuable lessons, particularly on the need for overwhelming fire support for an amphibious assault.

When, in the spring of 1943, Lieutenant-General Sir Frederick Morgan took over primary responsibility for planning the cross-Channel assault as the Chief of Staff to the (as yet unappointed) Supreme Allied Commander (COSSAC), he acknowledged an enormous debt to the groundwork in inter-Service and inter-Allied co-operation accomplished by Combined Operations Headquarters. On 12 June 1944, when Churchill visited the scene of the successful Normandy landings, he and his companions sent a special message to Mountbatten, by then Supreme Allied Commander in South East Asia: 'We wish to tell you at this moment in your arduous campaign that we realise that much of this remarkable technique, and therefore the success of the venture, has its origins in developments effected by you and your staff of Combined Operations.'

Hobart's 'Funnies'

The raid on Dieppe in 1942 showed the need for special armoured vehicles to overcome beach obstacles. These were developed by the 79th Armoured Division under Major-General Sir Percy Hobart. The three 'Funnies' shown

An amphibious Sherman tank with its canvas screen lowered. When the screen was raised, as in the diagram on the blackboard behind Mountbatten's head in Panel 6, the tank could float – but only just. Imperial War Museum MH 3660

on the blackboard are: on the left, a type of AVRE (Assault Vehicle, Royal Engineers), consisting of a large bobbin on a Churchill chassis which could lay a 10-foot wide canvas carpet over soft sand; bottom right, an armoured bulldozer; and top right, an amphibious Sherman with its canvas flotation screen raised. Other devices in Hobart's 'siege train' included mine-clearing, flame-throwing and bridge-laying tanks.

Forging the Weapon

The men of the invasion forces had to be fit for battle both physically and mentally. Months of arduous training were organised. In the Embroidery, men are shown learning to disembark from ships using climbing nets and practising with the bayonet. Full-scale exercises for the British, Canadian and American contingents were held just prior to D-Day. One American exercise of the type shown in this panel, carried out in April 1944, ended in tragedy. During Exercise Tiger at Slapton Sands in Devon, nine German torpedo boats mounted a night attack on an exercise convoy. Two tank landing ships were sunk and a third badly damaged. At least 749 Americans lost their lives.

41

FORTRESS EUROPE

Date: 1943–4 Location: Occupied France and the Atlantic Wall

This panel represents two aspects of what was going on before D-Day in occupied France: German preparations to resist the Allied invasion and French efforts to ensure its success. These particular topics were not included in Colonel Neave-Hill's original Embroidery Script, but at the meeting of the Embroidery Committee in December 1968, Lord Dulverton raised the question of whether there was sufficient coverage of the background operations which were essential to the success of Operation Overlord. 'He had in mind', say the minutes of the meeting, 'such things as air and sea reconnaissance, dropping of agents in occupied territory, contact with the Maquis and combined operations generally.' General Jones added that the planning and production of landing craft was another important factor.

The Committee agreed with Lord Dulverton that the landing of agents and air reconnaissance should be fitted into the next six cartoons. One of them might portray

what was happening on the other side of the Channel, 'for example beach reconnaissance, obstacles and the activities of SOE (Special Operations Executive).' Another could cover the softening up process and include air attacks on railway systems and radar installations (this was incorporated into Panel 9).

With these points in mind, Sandra Lawrence embarked on her design for the panel. For inspiration she drew on photographs accompanying articles in Purnell's magazine entitled 'Fortress Europe', 'Europe's Secret Armies' and 'Helping the Resistance'. These included a German colour photograph of a coastal defence gun showing the rust-red ring of metal at its mouth, which Sandra Lawrence incorporated as a distinctive feature of her cartoon. When the draft design was examined by the Historical Subcommittee, only one small embellishment was suggested: 'Add cigarette to a member of French Resistance.'

Rommel inspects the beach defences which he had ordered to be constructed. Note the nails in the Maquisard's boot.

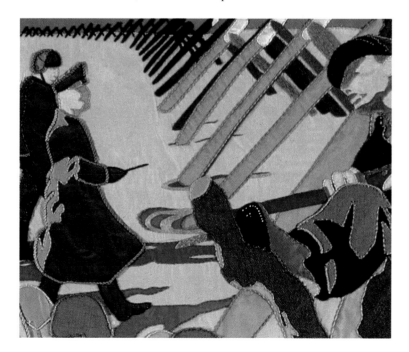

Looking at the design of this panel, it is clear that Sandra Lawrence is beginning to tackle problems encountered in earlier panels with much greater assurance. Its scenes are more skilfully organised, with none of the hard dividing lines to interrupt the dramatic flow. Our eyes follow the progress of Field Marshal Rommel as he inspects first a concrete emplacement and then, in the centre, a row of beach obstacles. He is distinguished in the two scenes by his swirling coat and his baton, a symbol of authority in the tradition of William the Conqueror's mace in the Bayeux Tapestry. Our eyes return with the marching column to the red-ringed mouth of the coastal defence gun. On the right, the passage of time is conveyed as the figures in the French Resistance group melt away into the moonlit night, and we see the results of their sabotage efforts in the destruction of a bridge in the distance.

The panel is full of movement and of contrasts. The distinctive scenes showing Rommel's high-profile defence inspections and preparations and the clandestine activity of the French Resistance are cleverly linked by the Maquisard look-out watching from the tree. The faceless efficiency of the marching Germans contrasts with the very human depiction of the Maquis — complete with cigarette — receiving firearms instruction. The portrayal of Rommel, in his leather greatcoat and upswept cap, captures perfectly the image of German military might.

When Margaret Bartlett began to look at the fabrics which would be needed for this panel, she was still unhappy about some of the colours used by Sandra Lawrence, in this case to portray the uniforms of the German soldiers. She telephoned the artist, and in the course of conversation it was agreed that in Panel 6 the colour of some of the uniforms of the British soldiers could be changed to khaki. But Sandra Lawrence was adamant about not changing the uniforms in this panel to 'normal German uniform colouring'. As Margaret Bartlett recorded in her workbook, 'Miss L said *No* – must be kept to her coloured drawing for Panel No. 7.'

Once work did begin, the Royal School used various

Aerial reconnaissance photograph of Rommel's 'devil's garden' taken on 19 May 1944. An intelligence officer has ringed the slots on the stakes where mines could be placed. D-Day Museum: L E R Bentall

ping timbers, catching the sun, however, are worked in light-coloured appliquéd material.

The texture of the materials, including brown corduroy, used for the shadowy areas on the gun emplacement, and the dark areas of the soldiers' boots, the Lysander aircraft and the look-out, add depth and interest to the panel. Little touches such as the nails in the soles of the look-out's boots show the care taken over the smallest detail in the Embroidery.

THE DEVIL'S GARDEN

Rommel and the Defence of the Beaches

The 'double exposure' of Rommel in this panel and the fact that he is the only identifiable German depicted in the Embroidery (apart from Vice-Admiral Ruge at his side) reflect the key role he played in the German preparations to resist the Allied invasion. Field Marshal Rommel was given the task of inspecting the German coastal defences in the west and suggesting ways of strengthening them, in November 1943. He chose Vice-Admiral Ruge to advise him on the naval side of the problem. The Embroidery captures the determination and sense of urgency Rommel brought to the job. Ruge wrote that Rommel 'got up early, travelled fast, saw things very quickly and seemed to have an instinct for the places where something was wrong.'

Rommel found much that was wrong. German propaganda photographs might show huge guns and massive concrete emplacements, but except in the Pas de Calais this was largely a myth. Fortifications were incomplete and the garrisons were composed of second-grade troops – the young, the old, foreign 'volunteers' and men invalided out of the Russian campaign. The Embroidery shows an anti-aircraft gun with silhouettes of downed Allied planes painted on the shield, but anti-aircraft defences in the west were generally weak, as many units had been recalled to defend the German homeland.

At the beginning of 1944, Rommel was given command of Army Group B, comprising the German forces

materials with their customary skill to interpret the subtle range of mauvey-greys and browns in the cartoon, contrasted with the light sandy beach and the moonlit night sky on the right. Rommel's greatcoat swings out in a most three-dimensional swirl, its edge picked out in light grey cord. The accentuation of the mouth of the gun by the red ring worked in short and long stitch, and the way in which the seashore defences darken as they curve away from us, give perspective to the panel. The technique used to show Rommel's improvised beach obstacles is a mixture of embroidery stitches and appliqué work. The dark tree trunks are embroidered, as are the supporting timbers nearest to us: stitching is often used in the Embroidery to give the effect of wood. Some of the slo-

from the Netherlands to the Loire. He set about the task of strengthening the beach defences to impede the approach of Allied invasion craft. Rommel believed that the Allies would have to be stopped in the first 24 hours and on the shoreline. He told his aide-de-camp, Captain Lang, on 22 April 1944, 'The war will be won or lost on the beaches. We'll have only one chance to stop the enemy and that's while he's in the water.' Once the Allies were established ashore, Rommel's view was that their superiority in the air would make a successful German counterattack impossible.

So a variety of metal and concrete obstacles was constructed, some with mines on them, and, where nothing else was available, logs were cut and erected on the beaches (as shown in the Embroidery). By mid-May 1944, despite the shortages of materials and labour and the disruption caused by Allied air attacks, over four million mines had been planted along the French coast, and a further 517,000 foreshore obstacles composed Rommel's 'devil's garden'. Rommel wrote to his wife on 15 May 1944: 'It's quite amazing what has been achieved in the last few weeks. I'm convinced that the enemy will have a rough time of it when he attacks and ultimately achieve no success.'

The French Resistance

Before D-Day the French Resistance supplied the Allies with valuable intelligence about the German defences and troop movements. During May 1944, 700 wireless reports and 3000 written reports on German positions were sent from France. The aircraft shown here in the Embroidery is a Lysander, which, because it was ideal for short landings and take-offs over bumpy fields, was used to transport agents of the British Special Operations Executive (SOE). Their job was to make contact with Resistance groups, help direct their sabotage and guerrilla operations and arrange the reception of arms and equipment drops. In the foreground, men and women of the Resistance receive training in the use of the Sten gun, perhaps from one of these agents. Between February and May

Field Marshal Erwin Rommel. In North Africa Rommel had won the respect of his adversaries and almost legendary status as the 'Desert Fox'. After being wounded in Normandy, he was forced to commit suicide to save his family from harm when he came under suspicion of involvement in the plot to kill Hitler in July 1944. Imperial War Museum RML 14

1944, the Allies dropped more than 76,000 Sten guns to the Maquis. The group breaks up and in the distance a bridge is destroyed. The damage and disruption of rail, road and telephone communications by the Resistance, and ambushes of German convoys, provided valuable help to the Allies before and after D-Day.

PANEL 8

THE FORCES GATHER

Date: Spring 1944 Location: Marshalling areas in southern England

Sandra Lawrence has now reached the heading 'The Assembly' in the Embroidery Script. There is hardly any unfilled space in this panel, which symbolises the gathering of immense forces by land, sea and air for the invasion. Sandra Lawrence has massed the landing craft and gliders right to the upper edge of the Embroidery, precluding any sea or sky, to convey the idea of the huge numbers involved. There is an interesting comparison between the fullness of this panel and the sequence in the

Bayeux Tapestry showing William's invasion fleet crossing the Channel. For the only time in the Tapestry, the upper border dissolves completely, and William's ships fill that area too.

The tug boat captain is the key figure in this panel. He is based on a photograph of a tug skipper reproduced in the British naval official history of the Second World War, in a section simply headed 'Some Types of the British Maritime Services 1939–45'. The staff of the work-

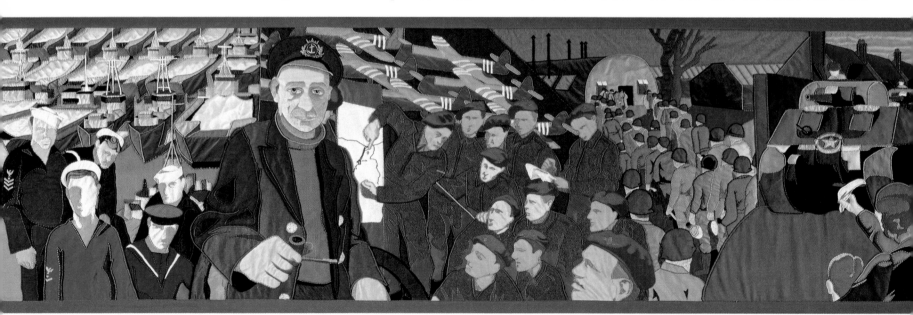

room at the Royal School of Needlework nicknamed him 'Sid James'. He seems to typify, the solid, dependable, pipe-smoking imperturbability of the merchant navy tradition. He looks out from the Embroidery at us, challenging our doubts and fears.

On the right of the panel, American troops carrying their mess tins line up for food. We look over their shoulders and feel we are part of the queue. In the final scene, a woman waves as a column of Sherman tanks passes down her street, and we join the group as they watch and wait. A row of terraced chimney stacks picks up the regimentation of the convoy.

The range of different techniques used to create eyes in the Overlord Embroidery is very well illustrated in this panel. On the extreme left we see five sailors, who have either only facial shadow made of appliquéd material or fairly basic indications of eyes. The eyes of 'Sid James', on the other hand, were skilfully embroidered in great detail by Ruby Essam, so that the pupils, irises and whites are clearly seen.

The tug boat captain, who was nicknamed 'Sid James' by staff at the Royal School of Needlework.

A wartime poster expressing the country's gratitude to the men of the Merchant Navy. Imperial War Museum

Perhaps the most interesting technique is the one used for the eyes of the paratroopers in their red berets. It is an example of the skilled use of embroidery silks of two

Sherman tanks head for their point of embarkation shortly before D-Day. Portsmouth and Sunderland Newspapers

The Bayeux Tapestry: the main action fills the upper border as William's great fleet crosses the Channel. Viewers would have been familiar with the convention that objects placed higher in the scene were further away.

different colours – gold and red. The silks were first unravelled and then, using a ratio of two strands of gold to one of red, they were retwisted before being used to embroider the paratroopers' eyes. This has created a far more subtle effect than either colour would have done on its own, and blends well with the overall khaki and red of the uniforms.

MARSHALLING THE FORCES

Landing Craft

On the left of the panel there is a group of British and American sailors, together with the merchant navy figure. They represent some 113,000 British sailors, 53,000 American and 5000 from other Allied navies, as well as an estimated 25,000 from the merchant navies, who took part in Operation Neptune, the naval side of Overlord.

Behind them are various types of landing craft which packed the ports of southern England before D-Day. The invasion of Normandy would not have been possible without the development and production of specialised landing craft. These ranged from the ocean-going Landing Ship Tank (LST) to the Landing Craft Assault (LCA), which carried troops to the beaches. There were also landing craft equipped with anti-aircraft guns, and others firing banks of 5-inch rockets.

It was the shortage of landing craft above all which led the Combined Chiefs of Staff to postpone the target date for Overlord from 1 May to 31 May, in order to allow another month's production. It was also agreed after much debate that the planned simultaneous landing in southern France – Operation Anvil – would have to be postponed to release the landing craft for Overlord. By these means over 4000 landing craft and ships were made available for the invasion of Normandy on D-Day.

Briefing the Paras

In the centre of the panel, men of the British 6th Airborne

48

Division are being briefed about their landing zones north-east of Caen. In the background are some of the Division's Horsa gliders, painted with their D-Day recognition stripes so that they can be readily identified by friendly forces.

For the airborne forces, which were likely to be required to act quickly in unexpected situations, the pre D-Day briefing was particularly important. As the commanding officer of the 6th Airborne Division, General Sir Richard Gale, later wrote:

> In all airborne operations we go in for very detailed briefing of the troops ... The men were told everything, not only the details of what was to be expected of them, but also the larger plan. They were allowed to discuss among themselves their tasks and how they were going to carry them out. It was quite a sight to watch them in groups talking their problems over, their officers moving about among them to answer their eager questions.

An Armed Camp

On the right of the panel, American troops stand in line for their rations, while civilians wave as a column of Sherman tanks head for their embarkation point. From the beginning of April 1944, a coastal strip ten miles deep from the Wash to Land's End was closed to visitors, and movement for the inhabitants was strictly controlled. This tight security was deemed essential as southern England became a vast armed camp. Finally, on 26 May, the troops were sealed into their camps. This caused mixed reactions: Gunner Ernie Brewer wrote to his mother on 28 May:

A forest camp at Denmead, near Portsmouth. Sergeant Docherty of the 1st Battalion, King's Own Scottish Borderers, writes home to Dumfries. Imperial War Museum H 37989

Well it looks as though I've well and truly had it now. We are all confined to this dump we have moved into; the camp is sealed so they say. It seems a rotten trick not to tell us beforehand so that we could let you know that it might be our last time at home. ... We are, so far as I can understand, kept here for security reasons though I myself can't see what we could give away, we don't know anything.

THE OVERLORD COMMANDERS MEET

Date: Spring 1944 Location: Supreme Headquarters, London; the skies over western Europe

This panel shows the Allied commanders meeting together at the headquarters of the Supreme Commander, General Eisenhower, at Norfolk House, St James's Square, London, in February 1944. The seated figures are (left to right): Lieutenant-General Bradley, Commander US First Army; Admiral Ramsay, Commander Allied Naval Expeditionary Force; Air Chief Marshal Tedder, Deputy Supreme Commander; General Eisenhower, Supreme Commander Allied Expeditionary Force; General Mont-

gomery, Commander 21st Army Group and overall ground forces commander for Overlord; Air Chief Marshal Leigh-Mallory, Commander Allied Expeditionary Air Force; and Lieutenant-General Bedell Smith, Chief of Staff.

In this panel, Sandra Lawrence successfully uses the classical composition of framing the central area with 'wings'. In eighteenth-century classical painting, these often took the form of trees which channelled the eye into

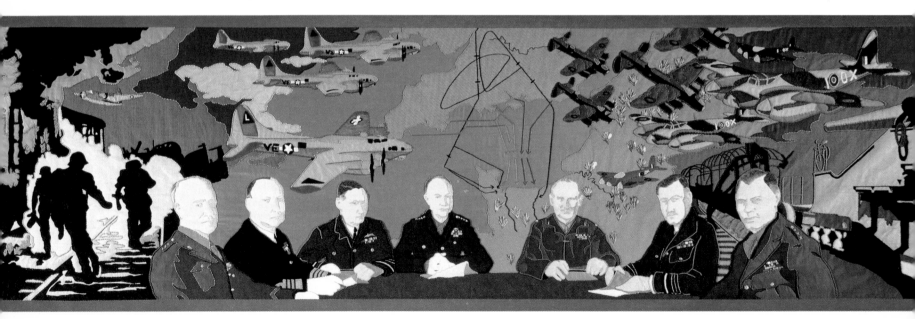

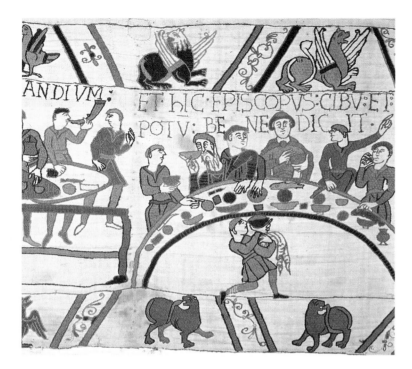

The Bayeux Tapestry: Bishop Odo blesses the food and drink on high table. Odo's prominent position in several scenes in the Tapestry indicates his likely role as its patron. Michael Holford

the central area. The team of Allied commanders is reminiscent of the scene in the Bayeux Tapestry in which William, Bishop Odo and two Norman knights sit feasting and conferring at a horseshoe-shaped table before the battle of Hastings.

When Sandra Lawrence produced her initial design for the panel the scenes on either side of the commanders showed children with soldiers on the way to ports of embarkation and minesweepers at work in the Channel. However, at the Embroidery Committee meeting in July 1969 when this cartoon was discussed, Air Chief Marshal Evans felt bound to 'put aside his chairman's hat', as he described it, and point out that important topics relating to the use of air power before D-Day had been entirely omitted. The Allied armada was about to sail and yet there had been no mention of air reconnaissance or the

bombing of railway communications, airfields and radar stations in France.

Lord Dulverton came up with a solution which was that these subjects should form a revised background to the table of Allied commanders. The central group in the panel is therefore framed and backed by images which show examples of the aircraft which carried out the Allied bombing campaign and symbolise its effects. The Royal School has given the flames on the left a decidedly explosive character by using large and jagged embroidery stitches in orange, red and yellow. The running figures on the railway tracks are very effectively silhouetted against clouds of smoke. In the sky above, it was a happy coincidence that, in the photograph on which Sandra Lawrence based the B-17 Flying Fortress bombers, the aircraft had as their squadron code the letters VE – 'Victory in Europe'.

There were two problems which made this panel one of the most troublesome in the whole Embroidery from the point of view of achieving visual and historical accuracy: Montgomery's likeness and the commanders' decorations.

How Monty's Face was Saved

The story began when Sandra Lawrence's first version of the panel was considered by the 'Three Wise Men' in July 1969. Admiral Madden commented that the drawing of Admiral Ramsay, second from the left, could be improved. Then General Jones said that Field Marshal Montgomery's face was not a very good likeness either, and that he should be slighter in build.

Sandra Lawrence amended the faces a little and the cartoon went off to the Royal School of Needlework. But in June 1970, after a visit from Sandra Lawrence, Margaret Bartlett noted in her workbook that the artist was working on a better likeness of Montgomery and the existing version, which had already been embroidered, was not to be used. The new drawing duly arrived and immediately created a problem because it was smaller than the original one, which was marked on the panel. But in any case,

The Overlord plan, showing the disposition of the Allied invasion forces.

when Lord Dulverton called in at the Royal School in July he did not like Sandra Lawrence's latest version either.

Margaret Bartlett now decided to have a go herself, and began an embroidery version direct from a photograph of Montgomery in his book *Normandy to the Baltic*. When Major-General Brown visited the Royal School in August 1970, he was shown the new embroidered head, and took it away with him to show Lord Dulverton. Lord Dulverton replied that Montgomery's right eye seemed to be higher than the left one, but once this was corrected, the latest version of the Field Marshal's head was incorporated into Panel 9.

But it was only a temporary appearance for Margaret Bartlett's Monty. In January, Lord Dulverton visited the Royal School with his daughter and looked again at Panel 9. 'Lord D. does not like Monty's face', wrote Margaret Bartlett. 'We are to alter.' So Sandra Lawrence produced yet another drawing, which Lord Dulverton thought was an improvement.

Now it was the turn of the Royal School to feel uneasy with the way this sixth version of Montgomery's face was turning out. As Margaret Bartlett noted, 'Sandra Lawrence coming in to see this tomorrow morning. Shadows too dark.' Sandra Lawrence arrived and suggested that the Royal School should use 'dark on light silk' to overcome the effect. It worked, and at long last Monty's face was finished. Sadly, Montgomery himself was housebound by the early 1970s, and though he lived until 1976, he never saw the Overlord Embroidery or heard the story of the problem he had caused.

Ribbon Development

The second difficulty in this panel was the accuracy of the medal ribbons worn by the commanders. This was a problem which arose at many points in the making of the Embroidery. Early on, the Embroidery Historical Sub-committee asked Sandra Lawrence to put the correct decorations in her cartoons wherever possible. They gave her a copy of *Ribbons and Medals* by Captain H.T. Dorling, RN, the bible of medal researchers, as a guide to the correct designs and colours. But it was to prove no easy matter to track down precisely which decorations should be shown at a particular date – in the case of this panel, February 1944.

When the Royal School began work on this panel in February 1970, the famous medal suppliers, Spink's, agreed to research Montgomery's decorations and make up a correct set as a guide to the embroiderers in creating their version. But no reply was forthcoming when an equivalent American firm, Lautersteins of San Antonio, Texas, was contacted about Eisenhower's decorations. Unfortunately the colour photograph of the group of commanders was not distinct enough. So by August 1970 the Royal School were anxiously waiting to complete the panel, but had nothing to put above the breastpockets of the three Americans.

David Lloyd, the Director of the Royal School, raised

the matter of Eisenhower's decorations with Colonel Neave-Hill, who arranged a meeting with Colonel Trevor N. Dupuy, an American military historian and executive director of the 'Historical Evaluation and Research Organisation'. When he returned to the United States, he wrote to the Eisenhower Library at Abilene, Kansas, and in November 1970 their listing of the Supreme Commander's decorations was relayed to the Royal School. The following March, Colonel Neave-Hill had to contact Colonel Dupuy again to ask him if he could now help out over Bedell Smith and Omar Bradley. According to Miss Bartlett's workbook, it was July 1971 before Bedell Smith's decorations could be finished, and then finally, in January 1972, Bradley's ribbons completed the set.

CONVERGING ON NORMANDY

The Commanders and their Plan

The Allied commanders shown in this panel came together as a team in January 1944, giving them a bare five months to complete the planning and preparations for Overlord, on which Lieutenant-General Morgan and his staff had been at work since March 1943. At the outset Montgomery insisted that the resources would have to be found to expand Morgan's invasion plan, so that the initial assault could be made not on a three-divisional front but by five divisions with airborne landings on the flanks. The lines on the map of western Europe behind the commanders' heads show the scope of the new plan. The black lines mark the paths of the airborne divisions – the American 101st and 82nd to the west, the British 6th to the east. The red lines represent the British and Canadian seaborne assault and the green lines the American.

The Transportation Plan

The second main feature of this panel is Allied airpower in the months leading up to D-Day. This had a direct role to play in the success of Overlord. On the left of the panel there are American aircraft – a single B-26 Marauder and B-17 Flying Fortresses. On the right are RAF Lancasters

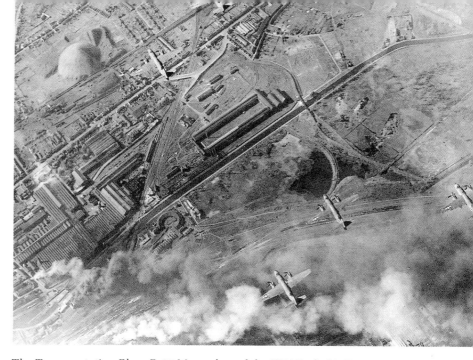

The Transportation Plan: B-26 Marauders of the US Ninth Air Force bomb railway yards at Valençiennes in northern France in May 1944. Imperial War Museum EA 21615

and Mosquitoes. In the run-up to D-Day, Allied aircraft attacked enemy coastal defences, radar stations and airfields. But most important of all was the campaign against rail and road communications in western Europe – the Transportation Plan – aimed at isolating the invasion area and preventing the Germans moving men and equipment quickly to Normandy. As the spread of 'explosions' on the map of France shows, the commanders had to be careful that the pattern of bombing did not alert the Germans to the fact that Normandy was to be the invasion target. German troops guarding marshalling yards flee for cover as the bombers attack on the left of this panel. Between 9 February and 6 June 1944, Allied aircraft dropped more than 76,000 tons of bombs on 80 rail and road targets.

On the right-hand side of this panel, perhaps symbolically blocking the way, is a giant German railway gun, a number of which were deployed on the Channel coast.

FINAL INSPECTIONS

Date: May/June 1944 Location: The coastal areas of southern England

For this particular panel, Sandra Lawrence drew her inspiration not from Purnell's magazine, but from a sequence of photographs in the classic *Daily Express* publication, *Invasion: The D-Day Story*, which first appeared in 1954. But though the idea of the three inspections – by an officer, by Montgomery and by the King – is a good one, the panel is lacking in drama. No one looks out and engages our attention, although this effect could easily have been achieved. There is also a return to the hard dividing lines between scenes, which could have been linked together with less rigidity.

The King's gold braid, buttons and medal ribbons, and the white stripes in short and long stitch on the sailors' blue collars, form highlights in this panel. Otherwise it shows the subtle use of different tones of khaki and brown. In particular, the legs of the officer inspecting his men's kit are a wonderful example of appliquéd material shaped to show the light catching on his uni-

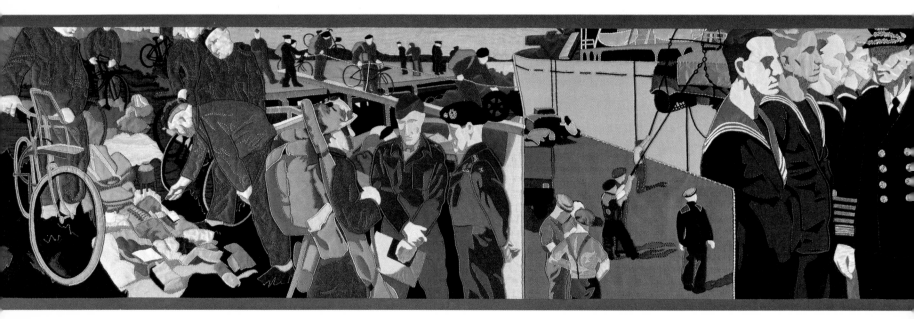

A celebration of royal leadership in an earlier age. This tapestry, woven in Dublin by a Huguenot refugee, John van Beaver, shows King William III leading his army to victory at the battle of the Boyne in 1690. Bank of Ireland, Dublin

The Bayeux Tapestry: provisioning an eleventh-century invasion fleet. Weapons, armour and supplies, including a cask of wine, are taken on board ship. Michael Holford

form. Subtle choice of colour is shown in the variety of flesh coloured silks selected for the sailors' faces on the right, blending so successfully with their different hair tones. These give individuality to the uniformed men.

The portrayal of Montgomery in this panel gave rise to some problems, though fortunately not nearly as many as in Panel 9. The face is not perfect, but the famous black beret, with the two badges, and the familiar stance make him quite recognisable. In the photograph on which Sandra Lawrence based her design, Montgomery, wearing spectacles, was inspecting a list of the kit a soldier would be carrying on D-Day. The man in front of him was in full kit as a demonstration.

In her preliminary sketch, Sandra Lawrence tried to re-create the scene, but evidently had some difficulty over

Montgomery's spectacles. The Historical Subcommittee wondered why he was wearing dark glasses, and the Embroidery Committee requested that 'Montgomery should not be reading orders or wearing goggles. Instead he should be looking at the man he is talking to.' There was some suggestion later that he might even be shaking hands with the soldier in full kit, but this idea was not adopted.

The King's medal ribbons also caused some problems. In December 1969, Major-General Brown wrote to Sir Michael Adeane, the Queen's private secretary, asking for advice about the correct decorations for King George VI in 1944. Sir Michael replied enclosing a note from the Secretary of the Central Chancery of Orders of Knighthood, Major-General Peter Gillett. The latter provided an

analysis based on comparing a list of known decorations in 1951 with those which appeared to be shown in a 1944 painting of the King by Sir Oswald Birley.

This, however, was presumably not thought to be definitive. The Royal School began work on the panel in March 1970, but in June Margaret Bartlett noted in her workbook that they could not complete it because the

General Montgomery wears spectacles to check the list of kit a soldier from the Royal Ulster Rifles will carry with him to Normandy. Sandra Lawrence was asked to modify her first sketch based on this photograph to show Montgomery in a more typical pose. Imperial War Museum H 38628

King's medal ribbons were not yet confirmed. In fact it was not until October 1970 that Major-General Gillett wrote again, with a list based on the examination of 'correspondence held in Buckingham Palace, a personal inspection of coloured photographs held in the photographic library of the Imperial War Museum, a personal inspection of the late King's Orders, Decorations and Medals and an interview with his personal valet.' Not surprisingly after these exhaustive enquiries, the list was gratefully accepted, and the panel completed.

A problem that emerged later was that of the scar-like shadow on the King's face. At the request of the Queen Mother, the lighting was changed at Whitbread's Porter Tun Room to reduce this unfortunate effect.

CHECK-UPS AND SPEECHES

The Officer's Inspection

On the left of the panel, commandos have a final kit inspection by their officer, and they are then shown with their folding bicycles going on board their assault craft. The troops sealed in their camps had plenty to occupy their time. As Brigadier Lord Lovat, commander of the 1st Special Service (Commando) Brigade, recalled:

> Officers busied themselves with final arrangements and the check-ups that save lives – dinghies were inflated, bayonets sharpened, automatic springs tested, magazines oiled, waterproof wrapping wound round all weapons, escape maps were issued together with ammunition, rations and first aid kits.

The commandos in this panel have been issued with folding bicycles, which were specially made with a very strong oval-shaped frame and large, easy to unscrew wing nuts to join the two parts together. Some commandos spent a good deal of time trying to master the art of riding a bicycle when heavily laden with kit; but within hours of arriving in Normandy they were ordered to leave their bikes, and never saw them again.

Monty's Inspection

In the run-up to D-Day, Montgomery saw his most important task as being to raise the morale of the invasion forces. He believed it was a question of giving them confidence in their commander. The men, wrote Montgomery, 'must know that the battle is safe in his hands, that he will not sacrifice their lives needlessly, that success will always crown their efforts'. In contrast to the First World War, when soldiers were committed to costly offensives by generals they had never seen, Montgomery set out to visit as many of the invasion contingents as possible. Standing on the bonnet of his jeep, he addressed huge gatherings. In his diary for 9 February 1944 he wrote, 'My general theme was – the war has gone on long enough; together we will see it through and finish it off; it can be done and we will do it.'

The King's Inspection

On the right of the panel King George VI inspects sailors of the invasion fleet. Although the days were long passed when kings of England led their troops into battle, it provided an important boost to morale for the sovereign to see and be seen by men and women 'fighting for King and Country'. The conduct of King George VI and Queen Elizabeth won the universal respect and affection of the British people during the Second World War. Before D-Day, the King travelled widely inspecting the invasion forces. On 15 May 1944, he attended the final briefing for senior commanders at St Paul's School in London and gave a surprise speech: 'absolutely first-class, quite short, and exactly right', Montgomery wrote in his diary.

The King had himself served in the Royal Navy during the First World War and valued his contacts with his old Service, so it is most appropriate that the scene in the Embroidery should be based on a photograph of his visit to HMS *Scylla*, the flagship of the Eastern Naval Task Force on D-Day. Of his naval career the King said, 'It has been my privilege to serve as a Naval Officer both in peace and war: at Jutland, the greatest sea battle of modern times, I saw for myself traditions which are the inheritance of British seamen.'

Supplying the Invasion

In the centre of the panel a lorry is being loaded on to a cargo ship. The invasion of Normandy required enormously complex arrangements to ensure that hundreds of thousands of tons of equipment, munitions and stores would be speedily unloaded in the right order, and that the transport would be available to take them to their proper destinations. It was planned that 20,000 vehicles would accompany the 176,000 men who were scheduled to land in the first two days of the invasion.

A practice session at riding a folding bicycle when wearing full kit. Imperial War Museum H 37689

WAITING FOR THE OFF

Date: 3/4 June 1944 Location: Ports and harbours around the coast of southern England

On board their landing craft, British troops wait for the invasion of Normandy to be launched. Because of bad weather, Eisenhower had to postpone D-Day for 24 hours, and many men had to endure a very unpleasant wait on a heavily pitching sea. For this panel, Sandra Lawrence set out to capture the comradeship and the tension of the hours of waiting.

The inspiration for the left-hand side of the panel was the well-known photograph of a group of men from the Royal Electrical and Mechanical Engineers studying the guidebook to France issued to the invasion forces. This is almost the only occasion in the Embroidery where humour is in evidence, in the laughing faces of the men as they read the good advice contained in the small volume.

The humorous mood does not last, however, and we are brought back to the reality of the situation by the grim, if somewhat ghostly, faces of the soldiers on the right. Great care has been taken again in this panel with the

facial tones of the soldiers. Some puckering has occurred, but because of the elasticity of facial flesh this enhances rather than detracts from the lifelike quality of the faces.

As far as colour was concerned, Sandra Lawrence could have produced a rather drab panel, in as much as she had to depict a mass of khaki-clad soldiers. But subtle combinations of lighter and darker shades of brown are used to create variety and a truly three-dimensional effect for the uniforms. The choice of green and black for the berets and the inclusion of the formation signs worn by the troops all help to create points of colour and interest.

There was a good deal of discussion, while the panel was in production, about the possibility of incorporating the text of Montgomery's personal message of good luck to the invasion forces into the scene. In the end, the Embroidery Committee decided that a copy might simply be framed and hung alongside the panel. The space was filled by the inclusion of an extra landing craft. The result is that for the first time the panel is a single entity, rather than a composite of separate scenes.

READY AND WAITING

Embarkation

For men such as those shown in this panel, embarkation was the culmination of months of training and preparation for the invasion. The moment of going on board ship was described by Lieutenant Hugh Bone of the 2nd Battalion, East Yorkshire Regiment, who sailed in HMS *Glenearn*. In a letter dated 4 July 1944, he wrote to his mother:

> By this time, after all our exercises, we and the ship's crew were great friends. Almost without orders or arrangements everyone found their way to their cabins and mess decks. All the customary things happened, 'cooks to the galley', rum issues, cheap cigarettes. Drinks for the officers in the wardroom. And on the wardroom notice-board a timetable of events. No question about D-day and H-hour now,

only the 24 hrs prior confirmation to come and then the issue of real maps in place of the bogus ones we had learned by heart with all their bogus names.

Passing the Time

Most of the soldiers are grim faced as they wait packed into their landing craft. But the group on the left is finding light relief in the guidebook to France issued to the invasion forces. The preface to the booklet reminded the troops that 'this book has nothing to do with military operations. It deals only with civilian life in France and with the way you should behave to the French civilian population.' It described all aspects of French life and gave some useful words and phrases, but perhaps the most important section was a simple list of dos and don'ts. Some were quite serious: 'Don't get into any arguments about religion or politics. If a Frenchman raises one of the points which have strained Anglo-

Barnett Freedman, The Operations Room, Southwick House, Portsmouth, 6 June 1944. Imperial War Museum

General Montgomery's personal message to the invasion forces, which it was initially thought might be included in Panel 11. D-Day Museum

French relations since 1940, drop the matter. There are two sides to every question, but you don't want to take either.' Others might well have struck the men as humor-

ous: 'The French are more polite than most of us. Remember to call them "Monsieur, Madame, Mademoiselle", not just "Oy".' One wonders how far all this sound advice was put into practice in the weeks after D-Day.

Insignia

Badges of various units figure prominently in many panels of the Embroidery. Identification for troops going into battle has always been important, both for practical reasons of knowing friend from foe and also for morale. Here the troops are wearing the formation signs of the 3rd Division (an inverted red triangle) and the 27th Armoured Brigade (a yellow seahorse). As the British official history of the Normandy campaign noted, 'To foster regimental pride and the fellowship of larger formations, regimental and formation badges were to be worn

Men of the Royal Electrical and Mechanical Engineers amuse themselves by reading the official guide book as they wait to sail for France. Imperial War Museum B 5207

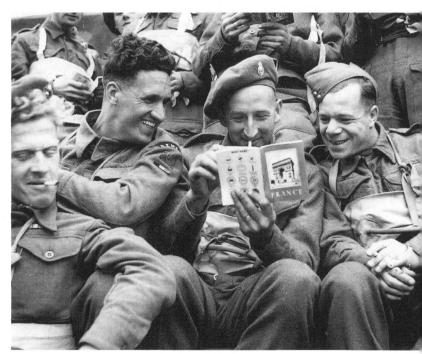

in battle, contrary to the recent practice and despite the risk that the enemy might thereby obtain useful information.'

THE ULTRA SECRET

While the men shown in Panel 11 study their guide book to France, the Allied commanders were gathered at Southwick House on the outskirts of Portsmouth. Through the brilliant stroke of breaking the codes from the German cipher machine 'Enigma' they were able to decipher German wireless signals, thereby gaining vital and accurate information about what awaited the troops on the other side of the Channel. This coup continued to provide the 'Ultra' secret intelligence information which was invaluable to Allied planners and commanders throughout the remainder of the war. There is no reference to this in the Overlord Embroidery because the secret of Ultra was not revealed until 1974, but once the first Ultra messages were released in 1977 it was possible to see the extent to which Ultra had provided vital details of German strengths and dispositions, logistical problems and operational plans in Normandy.

Knowing what was happening 'on the other side of the hill' in this way enabled the Allies to check on the effectiveness of their deception plans before D-Day, and on the extent to which pressure around Caen in June and July was drawing in German armoured divisions to the British and Canadian front. They received warning of many German operations, such as the offensive towards

Royal Engineers embarking for Normandy from South Parade pier at Southsea in Hampshire. Portsmouth and Sunderland Newspapers

Avranches on 7 August 1944. In July 1945, Eisenhower wrote to the Chief of the British Secret Service, Sir Stewart Menzies, that the intelligence with which he had been provided 'saved thousands of British and American lives and, in no small way, contributed to the speed with which the enemy was routed and eventually forced to surrender'.

THE ALLIED ARMADA SAILS

Date: 5/6 June 1944 Location: The English Channel

At its meeting in July 1969, the Embroidery Committee studied Sandra Lawrence's latest cartoons up to Panel 11, and then had a general discussion about the next stage in the production of the designs. So far the various activities leading up to D-Day had been depicted 'in vignette form'. The Committee strongly urged that consideration should be given to at least the sea crossings being shown 'in panoramic style'.

Taking this as her cue, Sandra Lawrence produced one of the most memorable portions of the Embroidery. For the first time, the theme does not just cover one panel but continues to a second and then on to part of a third, to give a tremendous impression of the immense size and variety of the Allied naval and air forces. The two and one-third panels which share the same horizon line give a wonderful sense of perspective and purpose, aided by unity of colour throughout. When viewed at the D-Day Museum, the panels are displayed in such a way that the

spectator feels drawn into the very scheme of things, seeing far more of the invasion than could have been seen by any of the participants at the time. The minutes of the Embroidery Committee meeting in March 1970 record that the members were 'unanimous in their appreciation of this panorama'.

The Frieze Technique

The Overlord Embroidery follows one of the oldest traditions in art – that of telling a story in a series of images in a long, narrow frieze. Beginning with the prehistoric cave paintings of southern France and Spain, which show animals being killed by hunters, friezes depicting feats of arms have been created in many different forms. In the 2nd century AD, for example, the triumphal columns erected by Trajan and Marcus Aurelius in Rome used spiral pictorial strips to celebrate the military victories of the two emperors. Trajan's Column may form a link to the Bayeux Tapestry, as a comparison of scenes in the two friezes suggests that the 11th century designer may have visited Rome and been influenced by what he saw there.

Although the Bayeux Tapestry was in many respects the inspiration for the Overlord Embroidery, Sandra Lawrence did not adopt similar design features for the latter. First, as has been mentioned in Part I, the inclusion of pictorial borders in the Overlord Embroidery was mooted but rejected at an early stage, mainly on the grounds that they would be too distracting. The question whether explanatory inscriptions, such as dates and place names, should be embroidered in the panels was also discussed, and it was thought they might well be needed. In the end, although the possibility of putting the names of the Allied contingents in abbreviated form on the map behind the commanders' heads in Panel 9 was examined at length, it was decided that captions should remain outside the Embroidery frames.

The most important difference between the Bayeux Tapestry and the Overlord Embroidery is that, although the former is physically constructed out of eight separate pieces of linen sewn together, its designer created a continuous narrative. There are no interruptions in the story, except those created by trees, buildings and figures. The complexity of Operation Overlord was such that an unbroken narrative spanning the entire Embroidery was

never even considered. Yet some of the most impressive and effective portions of the Embroidery, such as Panels 12–14, 18, 19, and 22–25, are those where Sandra Lawrence spreads her design beyond the confines of a single eight-foot panel, and shows us events 'in panoramic style'.

'OK, LET'S GO'

The Neptune Armada

On 4 June, it seemed possible that more than a year's careful planning and preparation for the invasion of Nor-

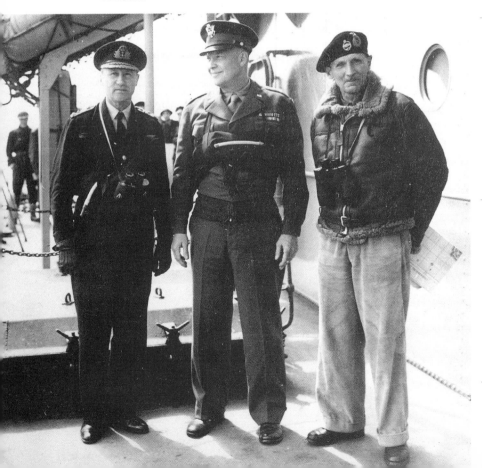

Admiral Ramsay, General Eisenhower and General Montgomery meet on board HMS Apollo off the Normandy coast on 7 June 1944. Their expressions show their relief at knowing that the gamble on the weather forecast for D-Day has paid off and that the Allies have established their beachhead in France. Imperial War Museum A 23929

mandy would be ruined by the simple fact of bad weather. That Sunday evening General Eisenhower, the Supreme Commander, convened a meeting of his senior commanders and their staffs in the library of his headquarters at Southwick House, Portsmouth. Earlier in the day he had been forced to put back the start of the invasion by 24 hours. Approaching low cloud and strong winds would otherwise have rendered the preliminary naval and air bombardments ineffective and made the landings themselves hazardous.

Now, at 9.30 PM on 4 June, any further delay would almost certainly mean postponing Overlord until 19 June, when tidal conditions on the Normandy beaches would again be suitable. But this would put at risk the secrecy of the operation, the morale of the troops and the whole timetable of the most complex amphibious assault in history. In this tense situation it was the Chief Meteorological Officer, Group Captain J.M. Stagg, who offered the meeting a glimmer of hope. He declared that he could forecast 24 hours of settled weather from late on 5 June, with reasonable conditions for the remainder of the week. Eisenhower consulted his commanders, but the final decision was his alone. 'OK, let's go', he said. Overlord was on.

Vessels of all shapes and sizes are shown in the Embroidery – destroyers, landing craft, 'corncobs' (old vessels destined to be used as blockships in the Mulberry harbours), Liberty ships and armed trawlers. In the sky can be seen the barrage balloons used by the ships as added protection against low-level enemy air attack. The statistics of the forces involved in Operation Neptune – the seaborne assault phase of Overlord – are staggering. Official records show that the total came to nearly 7000, made up of 1213 warships, 4126 landing ships and landing craft, 736 support ships of all kinds and 864 merchant ships. Two days after D-Day the Allied Naval Commander-in-Chief, Admiral Sir Bertram Ramsay, wrote:

One can honestly say that the naval side of this great operation, so far as it has gone, has been very suc-

cessful, and for this I am most grateful to Providence, to my staff for their excellent planning and meticulous care of details, and to all those to whom the actual carrying out of my orders was entrusted. It will certainly go down to History as a very great achievement and I have reason to be proud at being the head of it.

The Far Shore

What was it like to be part of this vast armada? Here are two contemporary descriptions. The first comes from a letter of 12 October 1944 written by Sub-Lieutenant Don Bonfield, RNVR, whose landing craft, carrying No. 45 Royal Marine Commando, sailed on the morning of 5 June:

> It was the most moving moment of my life. As we sped down the Solent towards the sea, thirty small ships in one long line, bugles sounding and the Marines yelling their war cry, we suddenly heard cheering coming from hundreds of ships around us who were waiting for their turn . . . Just as we passed round the Isle of Wight the Admiral signalled 'Good Luck. Drive on.'

The second comes from a letter dated 4 July, written by Lieutenant Hugh Bone of the 2nd Battalion, East Yorkshire Regiment, who sailed in HMS *Glenearn* at 10 PM, on 5 June. The colonel had called the officers together for a briefing:

> We learned for the first time then exactly where we were to assault. The ship's Captain then detailed for us all the naval plans and we were issued with innumerable maps and air photographs. The bar was closed and everyone got themselves ready for action stations. On both sides of the ship could be seen other, slower convoys moving out past the boom, one after another, all so familiar to us, yet this time just a little more exciting. There were shouts from the local people we worked with, a wail of bagpipes, multi-coloured signal flags, new paint, and our own Divisional sign on every vessel . . . a memorable sight.

Allied Airpower

On the left in this double spread is a squadron of Spitfires from the Air Defence of Great Britain (Fighter Command), whose job it was to protect the armada near the British coast. The total of 11,000 aircraft available for Overlord included 1890 RAF fighters and fighter bombers and 2300 American. On the right are Lancaster heavy bombers of RAF Bomber Command, on their way to pound the German coastal defences prior to the landings. During the night of 5/6 June, 1056 Lancasters, Halifaxes and Mosquitoes dropped more than 5000 tons of bombs on enemy strong points on the Normandy coast.

PANEL 14

SWEEPING THE SPOUT

Date: 5/6 June 1944 Location: The English Channel

The first part of this panel completes the panorama of the invasion armada, and we then see a British sailor keeping watch while two fleet minesweepers begin their work. The two parts of the panel, with their slight difference in horizon line and sky colour, are separated and linked by the metal ladder and the sailor. Although we come to the minesweepers after the main fleet, these vessels, of course, preceded the streaming armada, and the white horses remind us of the rougher seas on 5 June when the

minesweeping began. The overall colour harmony achieved by the close proximity of blues, greys and greens is very effective.

The sailor with the binoculars forms an excellent link between the vast panoramic view of the invasion and the minesweepers. The sailor, like the 'Sid James' figure in Panel 8, is a very lifelike character, with his elbow practically breaking into the spectator's space. The appliqué technique on the bent elbow is so three-dimensional

in its effect that you feel you could touch his arm and ask him what he can see through his binoculars. Extra care had to be taken here by the Royal School of Needlework, because where a considerable bulk of material in layer upon layer of fabric was attached to the Crestweave background there was a greater risk of movement. The whole effect is greatly enhanced by the subtle use of different colours of lacing cord. Along the top of the right arm, for example, light, medium and dark lacing cords have all been used.

The Channel plays a key role in both the Overlord Embroidery and the Bayeux Tapestry. The designer of the

The variety of Channel seascapes shown in the Overlord Embroidery.

The sailor with the binoculars is another good example of the use of a link figure in the Embroidery. His coat shows skilful use of appliqué technique and different colours of lacing cord.

Bayeux Tapestry has used a simple technique for portraying the waters of the Channel. A series of embroidered wavy lines are shown, which become more bumpy in mid-Channel. These lines are embroidered in a simple stem or outline stitch in one colour, and it is the colour which changes as the waves are shown flowing past a boat.

Contrast the amazing variety of wave forms Sandra Lawrence has used to show the sea in all its moods. There is an immense range of colours from warm blue to cold and stormy green. Cream, white and grey waves, in simple curves or complex patterns, indicate rough water, the wake of a ship or rolling breakers. Extra emphasis is given to the wave shapes in these panels by the use of two rows of lacing cord where the waves touch the sides of the ships.

SWEEPING THE PATH

A British sailor keeps careful watch while two 'Bangor' class fleet minesweepers begin their work. The 672-ton Bangors were the largest single class of fleet minesweepers involved in Operation Neptune, 45 of them taking part. The minesweeping component of Neptune com-

The Bayeux Tapestry: Harold's return to England. A watchman shades his eyes as Harold's ship crosses the Channel. Michael Holford

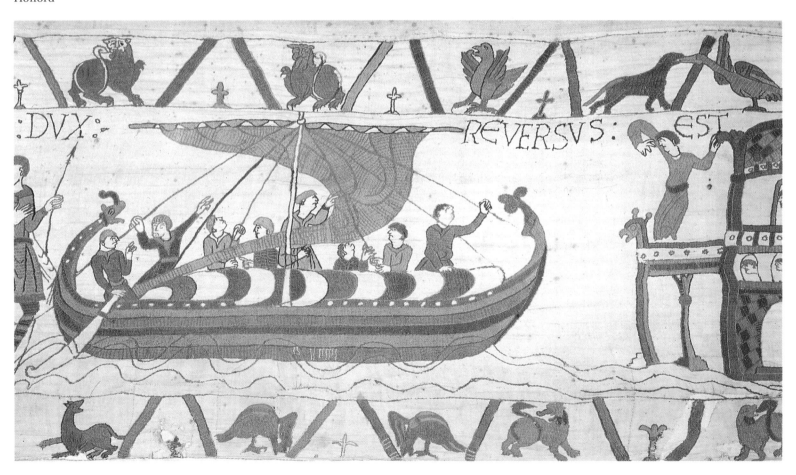

prised twelve flotillas of fleet minesweepers: ten British, one American and one Canadian. There were another ten flotillas of auxiliaries – a total of some 300 minesweepers. This was the greatest force of minesweepers ever assembled for a single operation, a reflection of the critical part the clearing of German mines played in the Neptune plan.

The aim of the operation was to 'give our ships the maximum of freedom with the minimum of loss'. Carried

Tristan and Isolde: detail from the Sicilian quilted embroidery, dating from around 1400. The sea is indicated by undulating lines of quilting and swimming fish. The story of Tristan and Isolde is told in another example of a frieze-like format, with sixteen panels arranged round the border of the coverlet. Victoria and Albert Museum

out in part under cover of darkness, in choppy seas with strong cross tides, great skill was required. The first task was to sweep ten channels from the assembly area south of the Isle of Wight, known as 'Piccadilly Circus', to form 'the Spout' down which the invasion forces could pour towards the Normandy beaches. The minesweepers began their work early on the afternoon of 5 June; during the evening, flotillas actually came within sight of the French coast, but they were either unobserved or disregarded by the German defenders.

After the successful clearance of the Spout, the minesweeping flotillas had to sweep the area off the beaches where the bombarding ships and assault forces would be deployed. One man who took part in this phase of the operation off Utah Beach in the early hours of D-Day was Joseph Newbold, a member of the crew of motor minesweeper (MMS) 261 in the 132nd Minesweeping Flotilla. In his diary he wrote:

At 2 o'clock we were ready to start sweeping . . . It's hard to describe the feelings one has when starting on such a risky enterprise. No one spoke much and the atmosphere was tense from the beginning of the operation to the end. It's not a pleasant feeling that you may be blown to bits any moment . . . It was a tribute that everyone kept his head and nerve despite great nervous tension.

Later in the day, MMS 261 came under fire from the German guns at St Vaast and 60 rounds fell within a quarter of a mile of it. 'The nearest shell to our own ship', Newbold recorded nonchalantly, 'was about 15 yards away and we had a little shrapnel about the decks without hurting anyone.'

The minesweepers successfully completed their role despite many difficulties. As the American commander of the Western Task Force, Rear Admiral Alan G. Kirk, wrote in his report, 'The minesweepers were the keystone of the arch and their task was one of unprecedented complexity.'

THE AIRBORNE TROOPS PREPARE

Date: The last hours of 5 June 1944 Location: Bases of British and American airborne forces in southern England

This panel, covering the topic 'parachute troops emplane' in the Embroidery Script, proved to be one of the more straightforward ones to produce. Sandra Lawrence found two first-class photographs on which to base her design – Eisenhower giving some last-minute words of encouragement to men of the American 101st Airborne Division, and four members of the British 6th Airborne Division synchronising their watches. Sandra Lawrence followed the photographs faithfully in portraying the two groups,

with a few embellishments such as putting a Supreme Headquarters' badge on Eisenhower's sleeve. This addition was made at the suggestion of the Embroidery Committee after a viewing session for completed panels in May 1972.

The resulting two-part, dual-nationality panel is a particularly successful one, with its backcloth of gliders and the silhouetted church spire which establishes the Englishness of the scene. The British paratroopers'

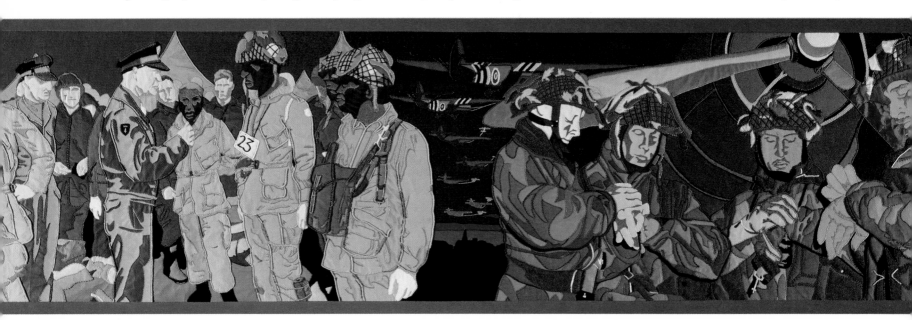

clothes – their appliquéd Denison smocks and sleeveless leather jerkins – look extremely realistic, with details of buckles on chin straps and harnesses picked out in embroidery thread. The sleeves of the British paratroopers are another example of the way in which the Royal School has used different coloured lacing cord, in this instance short lengths of yellow, green, brown and orange, to complement the pieces of appliquéd material.

In turn, the American group shows the skilful use of varying thicknesses of lacing cord to increase the effect of perspective. The different thicknesses of the same colour were simply obtained by unravelling the cores of the lacing cord. The nearest paratrooper has the full thickness of cord on his pocket flap and jacket outline. The middle figure wearing the number 23 has two-core cord, and the man behind Eisenhower's right arm has single-core cord. This clever technique greatly enhances the feeling of depth in the panel.

The badge of the Supreme Headquarters Allied Expeditionary Force (SHAEF), which was added to Eisenhower's sleeve in Panel 15. The design symbolises the flaming sword of justice piercing the black of Nazi oppression; above the sword is the rainbow of hope and the blue of peace to come.

The American paratroopers' pockets in Panel 15, where lacing cord of different thicknesses has been used to enhance the perspective effect.

THE BIG HOP AND JUMP

Ike and the 101st Airborne Division

In the photograph on which the embroidered image of Eisenhower is based, the Supreme Commander is talking to men of the 101st Airborne Division located at Greenham Common in Berkshire. The figure bound for planeload number 23 is identified as Lieutenant Wallace C. Strobel. In his diary, Eisenhower's naval aide, Harry Butcher, described the scene:

We saw hundreds of paratroopers, with blackened and grotesque faces, packing up for the big hop and jump. Ike wandered around them, stepping over packs, guns and a variety of equipment such as only

71

paratroop people can devise, chinning with this or that one. All were put at ease.

One of the men seen off by Eisenhower that evening, Sergeant Thomas Buff, wrote:

He was not a stranger to our Division, nor was it to him. This was his second or third visit to the 101st.

General Eisenhower gives a final pep talk to the US 101st Airborne Division as they prepare to take off for Normandy. Imperial War Museum EA 25491

This time, though, there was no Division review, no bands, no speeches. Yet there was no grimness; everyone was cheerful, inconceivably lighthearted. For as long as time permitted the General went from plane to plane, his hands in his pockets, chatting pleasantly with almost every member of each plane's stick of jumpers.

Eisenhower felt particular concern for the fate of the two American airborne divisions – the 82nd and 101st – taking part in Overlord, as he had rejected the advice of

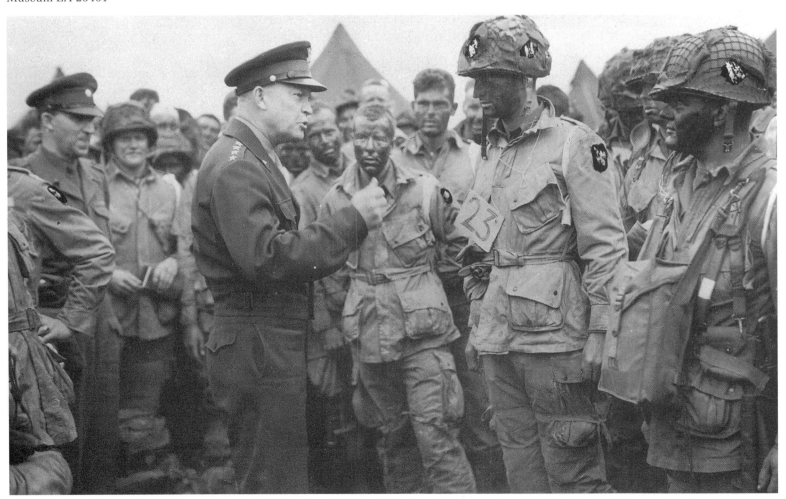

Men of the 6th Airborne Division check their watches. Imperial War Museum H 39070

his Allied Expeditionary Air Force Commander-in-Chief, Air Chief Marshal Sir Trafford Leigh-Mallory, that the plan to deploy them at the base of the Cotentin Peninsula was too hazardous. Eisenhower decided that the role of the airborne divisions – guarding the western flank of the landing beaches and ensuring that the seaborne troops could get across the areas behind the beaches flooded by the Germans – was vital whatever the risks. Fortunately his gamble was to pay off.

The 6th Airborne Division

The right-hand half of the panel shows four officers of the 22nd Independent Parachute Company in the 6th Airborne Division checking their watches, just before taking off in Albermarle aircraft from their base at Harwell. It is based on the famous photograph of (from left to right)

Lieutenants Robert de Latour, Donald Wells and John Vischer and Captain Bob Medwood, who were among the first airborne officers to set foot on French soil at 20 minutes past midnight on D-Day. They were among 60 members of the 'pathfinder' force, whose job it was to mark out the three zones for dropping and landing by glider of the 6th Airborne Division. Like the American airborne divisions, the 6th Airborne Division had a vital role to play in Overlord. It had to secure the eastern flank of the invasion, including seizing the bridges over the Caen Canal, the River Orne and River Dives and destroying the German coastal battery at Merville.

The officer on the right, Captain Bob Medwood, has the distinction, unexpected for someone other than a VIP, of being portrayed twice in the Overlord Embroidery; he is the same officer seen briefing his men in Panel 8, and it is to the very spot at which he was pointing on the map that they will shortly be parachuted.

73

THE GERMANS CAUGHT UNAWARES

Date: Early hours of D-Day Location: The Normandy coast

This panel shows the last hours of tranquillity on the 'far shore'. The headings in the Embroidery Script which guided Sandra Lawrence were 'the submarines mark the beaches' and 'the enemy sleeps'. The former referred to the use of two midget submarines, or X-craft, which acted as beacons off the Normandy coast for the Allied invasion forces.

Sandra Lawrence chose to focus more on the scene within the German bunker, which symbolises the fact that the defenders were caught unawares by the Allied assault. She used artistic licence in basing the image of the two Germans at the front of the panel on a photograph of a French soldier and a British Tommy sharing a drink on the Maginot Line in 1940. The composition was right, as was the image of comradeship, so the helmets and uniforms were changed and the men started new lives in another part of France four years later.

The use of the exterior/interior composition works

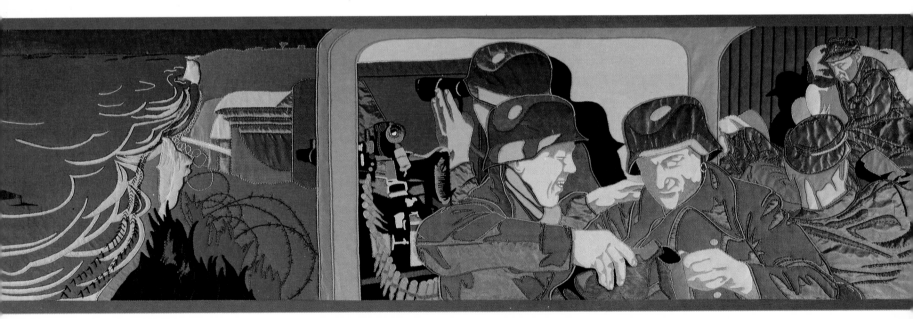

A German gun position overlooks the quiet seaside village of Arromanches in Normandy. D-Day Museum

shadows created by an unseen light source in the bunker. Note the care with which the ends of the cartridges in the machine gun belt have been embroidered.

The aspect of the panel which caused most difficulty was the midget submarine. In Sandra Lawrence's original cartoon there was only a spot of light to represent the submarine. The Embroidery Committee first asked that the conning tower or some part of the submarine should be shown too. When they looked at the amended cartoon some time later they still felt that the submarine, 'midget' or not, should be larger, with a beam of light showing out to sea.

The Royal School began work on the panel, but when Lord Dulverton saw the embroidery version of the X-craft he was still unhappy about it. So David Lloyd, the Director of the Royal School, produced an alternative sketch of his own, in which both the midget submarines appeared. The Embroidery Committee approved the outline of the submarine, but preferred to stick at including only one. In the end, the submarine is not a particularly successful feature of the panel. Historical accuracy required that it should be showing a green light, and neither this nor the submarine itself shows up against the dark blue of the sea.

RELAXATION AND ATTACK

The Deception Plan

During the early hours of 6 June, in a bunker on the Normandy coast, German soldiers of the Seventh Army share a drink (calvados, perhaps), relax and sleep, unaware of the Allied armada approaching. The Allies had taken elaborate steps to keep the Germans guessing about the time and place of the invasion. The overall deception plan was codenamed 'Bodyguard' and the most important element – convincing the Germans that the main invasion would be in the Pas de Calais – was called Operation Fortitude. By means of various schemes, including the creation of fake radio traffic and dummy tanks and landing craft in south-east England, the Germans were fooled into thinking there was another invasion army waiting to

well, enabling us to imagine that we are both attackers and defenders of the bunker. The fortifications outside and the relaxed, off-duty atmosphere inside are linked by the figure on watch with the binoculars. In this panel, and earlier in Panel 14, the binoculars are a useful device for reinforcing the role of the look-out. In the Bayeux Tapestry, the designer had to make the look-out's arm bend round awkwardly, so that his hand was shading his eyes, in order to tell us what his duties were.

At the Embroidery Committee's request, the informal image of men off duty resting within the bunker replaced a separate scene of a billet with bunk beds. The interior of the bunker has been created with great skill. Lacing cord has been used to produce the wooden boarding behind the sleeping German, and great depth is given to the scene by the black shadows of the helmets and the peaked cap,

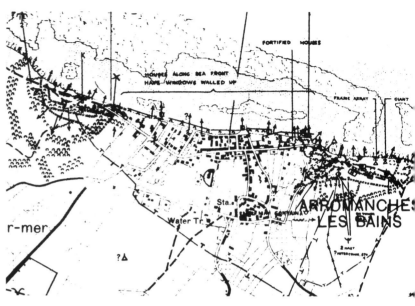

German defences around Arromanches were described in detail on this map issued to British troops assaulting Gold Beach on D-Day. Arromanches had been chosen by the Allies as the site for the construction of one of their two artificial Mulberry harbours once a foothold on the continent had been established. D-Day Museum

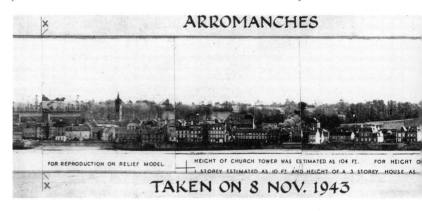

Arromanches as shown in the 'coastal silhouette' of the entire Normandy coastline, built up by the Allies from aerial reconnaissance photographs. D-Day Museum

Warning poster issued on 17 May 1944, forbidding people from using or carrying cameras, binoculars or telescopes in Arromanches. By then Allied reconnaissance and reports from the French Resistance had provided extensive information on German defences. D-Day Museum

go into action. Such was the success of Fortitude that when the German Fifteenth Army in the Pas de Calais, at 10 PM on 5 June, heard the Allied signal to the French Resistance that D-Day was imminent, and went on the alert, the Commander-in-Chief West, Field Marshal von

Rundstedt, decided that it was not necessary to alert the Seventh Army in Normandy for what was in any case probably a false alarm.

The key reason why the Germans had let down their guard was the weather. There had been excellent weather in May, but no invasion had come. Now, at the beginning of June, the weather had broken up. There was a general feeling that for the time being the Allies had 'missed the bus'. German radar stations had been bombed heavily, and because of the weather patrols by land and sea were in abeyance. Rommel's chief-of-staff, General Speidel, informed all units that the troops could stand down after the long period of tension in May, and officers could take local leave. As one historian has commented, after all the elaborate Allied measures 'the weather had proved to be the decisive instrument of deception'.

The Germans Relax

The scene of the Germans relaxing in the bunker symbolises the general relaxation on the far shore. Rommel himself was absent from Normandy when the Allies landed. The weather and the state of the tides had, he assumed, ruled out an Allied landing. So on 5 June he left his headquarters at the Château de la Roche Guyon to drive to his home at Herrlingen to celebrate his wife's birthday, and then to keep an appointment for an audience with Hitler at which he hoped to persuade the Führer to send additional reinforcements to France. In Rommel's absence, the headquarters of the Seventh Army had arranged to hold a Kriegspiel ('war game' or indoor exercise) at Rennes at 10 AM on 6 June, and a number of officers were on their way to take part when the invasion began. Ironically, the scenario for the exercise was to have been 'enemy landings in Normandy, preceded by parachute drops'.

Operation Gambit

On the left of the panel a midget submarine is shown flashing a green light to symbolise a small but important part of the Neptune plan – Operation Gambit. To assist

Midget submarine X23 photographed from headquarters ship HMS Largs on D-Day. D-Day Museum: W O Neal

the invasion craft in locating the correct points for their assaults, two midget submarines had been designated to act as floating 'lighthouses'. These were the X20, commanded by Lieutenant Ken Hudspeth of the Royal Australian Naval Volunteer Reserve, off Juno Beach, and the X23, commanded by Lieutenant George Honour of the Royal Naval Volunteer Reserve, off Sword Beach.

These two X-craft taking part in Operation Gambit left Portsmouth on the evening of 2 June. The postponement of the invasion by 24 hours meant that the operation became not only a test of skill and courage but also of endurance for the crews (five men in each for this operation), who had to spend 64 hours submerged in their tiny craft. Finally, shortly before midnight on 5 June, they surfaced and received the message that the invasion was going ahead next day. The Embroidery captures the moment when, at about 5 AM on 6 June, they surfaced, checked their positions in the dawn light and then began to flash a green light to the waiting naval task forces.

THE AIRBORNE LANDINGS

Date: D-Day Location: Airborne landing zones north of Caen and at the foot of the Cotentin peninsula; Pegasus Bridge

This panel picks up from Panel 15 the theme of the fortunes of the airborne forces on D-Day. We are confronted here by four dramatic scenes, full of colour and striking geometric shapes. The first two scenes capture one of the most memorable moments on D-Day, when French civilians realised that the Allied invasion was under way and they could look forward to the beginning of a new life. We are drawn in to share their excitement and anxiety in the early hours of 6 June 1944.

In Sandra Lawrence's first sketch for this panel, only the man was shown at the window. He was, in fact, based on a photograph in Purnell's magazine of a *Danish* newsagent. Whether or not they knew this, the Embroidery Committee thought he did not look very French, so Sandra Lawrence added a goatee beard. The realistic quality of his moustache and beard is achieved by the skilful use of grey and brown embroidery thread. The fact that he is not just looking through the glass, but is actually craning

his neck out of the window, is emphasised in the Embroidery by the subtle placing of his ear in front of the window frame.

The Embroidery Committee also asked for the Frenchman's wife to be added to the scene. This was done, but the 'Three Wise Men' did not realise that a mistake had been made in the depiction of her hair. Here Margaret Bartlett's personal memories of the war years proved useful in preventing an error slipping into the Embroidery. In Sandra Lawrence's cartoon, the Frenchwoman was shown wearing rollers. After checking with her hairdresser, Margaret Bartlett was delighted to be able to enlighten the members of the Embroidery Committee

French civilians witness the 'vertical invasion' of Normandy. Great care has been taken over the working of the man's beard and moustache and the woman's hair net and pin curls.

on one of their visits to the Royal School. 'May I', she said, 'as a mere female, point out that rollers did not exist in 1944?' As mere males, the Committee had not spotted this anachronism. So thanks to Margaret Bartlett the rollers were replaced, when the panel was embroidered, by a hairnet and the correct type of pin curls.

The figure of the piper on the right of the panel represents Bill Millin, the personal piper of Brigadier Lord Lovat, commander of the 1st Special Service Brigade on D-Day. Piper Millin's portrait caused problems from the outset. Sandra Lawrence initially depicted his pipes with a buff-coloured bag, such as Irish pipers used. Lord Dulverton, knowing that the bag ought to be shown in a Scottish tartan, consulted Lord Lovat, who was able to supply a piece of the correct 'Hunting Fraser'. So Bill Millin's pipes were changed to their proper 'uniform'.

When the Embroidery Committee looked at Sandra Lawrence's cartoon they were also not happy with the way that the drones of the pipes were shown. The Royal School began work on the panel, but when Lord Dulverton inspected it he felt that the configuration of the pipes was definitely wrong. So arrangements were made for a young Scottish piper, 'blushing puce with embarrassment', to come to the Royal School so that David Lloyd, the Director, could make a new sketch.

This, however, was only the start of the amendments to the piper. As photographic reference for the figure, Sandra Lawrence had used a picture of a piper of the 7th Seaforth Highlanders leading men into action on 25 June 1944. The only trouble was that he was wearing a steel helmet, whereas on D-Day Bill Millin was wearing his green commando beret, as were all his comrades under Lord Lovat's command.

When the Embroidery went on public display at Whitbread's Brewery, London, in 1978, at the opening ceremony Lord Dulverton noticed Lord Lovat and Bill Millin 'looking very glum' in front of Panel 17. They pointed out to Lord Dulverton that the helmet should have been a beret. They were undoubtedly correct, so at the earliest opportunity Bill Millin was 'beheaded' from

Piper Bill Millin as he appeared in Panel 17 until 1978, incorrectly shown wearing a steel helmet rather than a green beret.

the Embroidery and the section returned to the Royal School. Sandra Lawrence produced a new sketch and a commando beret was obtained, on which was worked the regimental badge of the Lovat Scouts as worn by Piper Millin on D-Day. Parachutes disguised the outline of the steel helmet and shading on the face replaced the chinstrap. And so, in January 1979, Bill Millin reappeared in the Embroidery with his authentic headgear.

CHAMPAGNE AND BAGPIPES

The Airborne Landings

The panel shows airborne troops parachuting from trans-port aircraft and being brought to earth in Horsa gliders. On the left the tightly packed complement of a Horsa, some thirty men, seem to be in good spirits as they come in to their landing zone. No doubt they are hoping that their first point of contact will not be with one of the stakes, nicknamed 'Rommel's asparagus', which the Germans have erected on the open fields. Later in the panel, American paratroopers are shown unloading a glider that has crashed. Both the British and American landings were widely scattered and there were many casualties, but their objectives were in the main accomplished.

The Gondrées

The two figures at the window represent the French civilians who were roused from their beds by the D-Day 'vertical invasion' of Normandy. The most famous couple were Georges Gondrée and his wife Thérèse, who ran the café by the swing bridge over the Caen Canal, which was renamed 'Pegasus Bridge' after the insignia of the 6th Airborne Division, the winged horse Pegasus. The Gondrées peered nervously out of their window when they heard the crash landing of Major John Howard with a *coup de main* contingent of Oxfordshire and Buckinghamshire Light Infantry and Royal Engineers at about 20 past midnight. The contingent's task, successfully accomplished, was to seize the bridges over the Caen Canal and the River Orne. The Gondrée family took refuge in the cellar, but once they were convinced that this really was the long awaited invasion, Monsieur Gondrée unearthed a hidden consignment of nearly 100 bottles of champagne and proceeded to toast the liberation with the airborne troops.

After the war, the interior of the café at Pegasus Bridge was kept as it was in 1944, and it has been the scene of celebrations and reunions for many men of the 6th Airborne Division. Madame Gondrée died in 1984, just after the fortieth anniversary of D-Day, but she would have been delighted that after many years her café at Pegasus bridge has been awarded the status of a '*monument historique*'.

The Linkup at Pegasus Bridge

On the right of the panel, the moment is captured at which the first contingent from the seaborne landings made contact with the 6th Airborne Division. This feat was accomplished by commandos of the 1st Special Service Brigade commanded by Brigadier Lord Lovat. They had landed on Sword Beach at about 8.40 AM and fought their way inland to link up with the airborne troops at the Caen Canal at around 1.30 PM.

The sound of the bagpipes being played by Lord Lovat's piper, Bill Millin, was heard as the commandos moved down the road from Saint Aubin d'Arquenay. Captain Ritchie of the 12th (Yorkshire) Battalion of the Parachute Regiment wrote to his sister:

> I remember that one lot had a piper with them, which was the first thing we heard of them, and a very pleasant sound it was and I have taken a better view of bagpipes ever since! I remember thinking it was like the siege of Lucknow; I believe they heard bagpipes too, didn't they?

Lord Lovat – who was to be badly wounded six days later – describes in his memoirs how he ran across the Caen Canal bridge under fire with a handful of men, but then, when they got to the bridge across the River Orne, Piper Millin played them across: 'Several other ranks became casualties, but the good music drowned the shooting and we managed to stride over in step – almost with pomp and circumstance!'

The commander of the 6th Airborne Division, General Sir Richard Gale, later bore witness to the effect of the commandos' arrival – and also the true nature of their headgear: 'A grim battle had been fought for close on twelve hours and the sight of the green berets was tonic which invigorated the troops.'

THE PEOPLE'S WAR

Panel 17 typifies a very important aspect of the Overlord Embroidery – the depiction of great events through the eyes and actions of ordinary men and women. The French civilians here represent all those who had to endure the German occupation. The Embroidery does not set out to shock us with the extremes of brutality (as Goya did when depicting the horrors of the Napoleonic occupation of Spain, for example) but rather to show us scenes which strike a chord in the viewer's own experience or imagination. The heroes of the events depicted in the Embroidery are not the statesmen and generals (though they could not, of course, be omitted altogether), but the thousands of individuals who contribute and suffer so much in wartime. Some of the Bayeux Tapestry's most fascinating scenes are those showing aspects of everyday life, but there is no doubt that it is the kings, lords and noble knights who occupy the centre of the stage. The minstrel, Taillefer, who rode before the Norman army singing the song of Roland, and perished at Hastings, is not depicted in the Bayeux Tapestry. In contrast, it is the piper, Bill Millin, who takes pride of place, together with the Gondrées, in Panel 17. It is this approach to the telling of the Overlord story that allows the spectator to identify with and become emotionally involved in these panels. This audience involvement is the true secret of the Overlord Embroidery's great success.

THE SEABORNE ASSAULT BEGINS

Date: D-Day Location: Off the Normandy beaches

In this double spread, Sandra Lawrence depicts the beginning of the run in to the beaches for the Allied assault forces – the Americans to the west, British and Canadians to the east. The use of two panels emphasises the width of the assault and the open and exposed position of those heading for the beaches.

The American and British troops frame the central action of the landing craft and the launching of the amphibious tanks. When the Embroidery Committee studied the cartoons for these panels, there was evidently something wrong with the appearance of the tanks. The Committee suggested that the amendment which would mean least alteration to the cartoon was to take out three tanks shown in the sea at the rear. The two remaining ones that have already been launched were to be made smaller and shown deeper in the water to emphasise the precariousness of their position.

In these two panels, the very rough sea looks cold,

green and menacing. Dark brown is an unusual choice for the colour of the sky, but despite the puckering caused by the use of such a long unbroken area of material, it certainly gives the effect of a dull and threatening dawn and sets off the muted greens, blues and greys used here so successfully.

THE AMPHIBIOUS TANKS

In the centre of the two panels, the Embroidery depicts a key element in the assault plan: the launching of the Sherman DD (Duplex Drive) amphibious tanks. These were developed in 1943 by the 79th Armoured Division under Major-General Sir Percy Hobart. A Sherman tank was first waterproofed and then fitted with a collapsible canvas screen which, when erected, acted as a flotation device. Duplex Drive meant that the tanks could move on tracks on land as normal, but also by means of propellers in the water. Once the tank had swum to the shore, the screen was lowered and the tank could deal with enemy strong points.

The tanks are shown in the Embroidery being launched from a Landing Craft Tank (LCT). On D-Day

The Bayeux Tapestry: the Norman ships are beached broadside, then tipped so that the horses can jump out. Michael Holford

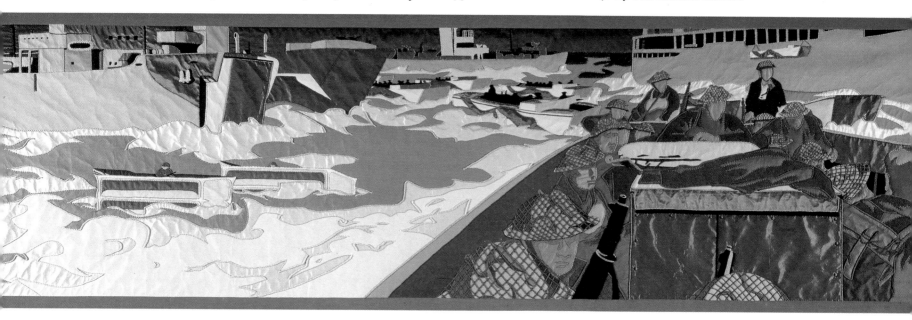

The wreckage of an amphibious Sherman tank, with its canvas flotation screen hanging in tatters, is pushed on to a landing craft by a Beach Armoured Recovery Vehicle during salvage operations after D-Day. D-Day Museum: Martin Waarvick

morning, there were crucial decisions to be made: whether conditions were suitable to launch the tanks (and if so, how far out) or whether an LCT should attempt to carry them right in to the beach. The tanks were easily swamped or damaged if there was a collision. The canvas screen could collapse inwards, trapping the crew, and if the tanks sank quickly the suction effect would close the hatches, sealing the crew inside, or drag down anyone trying to get clear.

Generally the DD tanks proved their worth on D-Day, but disaster struck those of the American 741st Tank Battalion on the eastern end of Omaha Beach. Launched too far out in rough seas – some 6000 yards from the shore – they rapidly came to grief. Of the 32 tanks that were available, only five survived: two which managed to

swim in and three others which were taken in by an LCT. One of those which sank was the first tank off LCT 600. The crew attempted to brace the canvas screen but to no avail. Within a hundreds yards of the LCT it began to sink. Three of the crew went down with it, including Corporal Wardall Hopper, who later described the experience:

> As I felt it settle on the bottom, I thought I was lost as my cigarettes worked out of my pocket and floated up past my face. I gave up hope as I saw that and started to breathe water. Before much longer I opened my eyes again and saw the water getting lighter. I finally did reach air ... One rocket boat passed me on its way to the beach and the commander saluted me, which didn't help my feelings any.

Eventually he was rescued by the crew of his own LCT 600 who succeeded in throwing him a line: 'I had to wrap it around my arms as my hands were too cold to hold onto it. They pulled me aboard and wrapped me in blankets and I passed out.'

As well as causing death to the troops inside, sunken tanks also became an obstruction and hazard to landing craft which followed.

THE THREADS OF HISTORY

When Lord Dulverton commissioned Sandra Lawrence and the Royal School of Needlework to create the Overlord Embroidery, he was continuing a tradition of the aristocratic patronage of textiles which was over 900 years old. The patron of the Bayeux Tapestry was almost certainly Bishop Odo, half-brother of William the Conqueror. His prominent role in the Tapestry – giving a blessing at the feast, advising William and encouraging young knights in battle – lends weight to this attribution. Odo was a powerful figure in both the ecclesiastical and political worlds until he fell out of favour in 1082, and he is known to have had a liking for fine wall hangings. During the Middle Ages luxury textiles were an essential

feature of any noble household. They provided a display of warmth, colour and grandeur for the kings, princes and churchmen who commissioned them and took them with them as they moved from place to place. They were a status symbol and were also given as presents.

From the fifteenth to the end of the eighteenth century, war was depicted in many tapestries. Notable examples were the Flemish tapestry *The Battle of Roncevaux* and the Franco-Burgundian tapestry *The War of Troy*. The great age for military tapestries was from 1643 to 1715, the period when Louis XIV of France commissioned a series of fourteen panels entitled the *Histoire du Roi*, and generally made such tapestries fashionable amongst European royalty and nobility. A set similar to the *Histoire du Roi* was commissioned by Frederick William of Brandenburg to commemorate his victories over the Swedes, and Charles XI of Sweden celebrated his own victories at Malmö, Lund and Landskrone in similar style. Visitors to Blenheim Palace can see the magnificent tapestries commissioned by the Duke of Marlborough to commemorate his victorious battles and sieges against the French in the War of the Spanish Succession.

The great period of tapestry patronage in England was the first half of the seventeenth century when James I, spurred on by Henry IV of France, who had established a royal tapestry workshop in Paris, recruited Flemish weavers to come to Mortlake to start a factory. Charles I followed in his father's footsteps with even more liberal patronage in support of the Mortlake venture, which, during the years 1625–35, produced some of the best work in Europe. The Duke of Buckingham was also generous in his financial backing, but by the time Charles II came to the throne, the factory at Mortlake was financially unstable. Without enthusiastic royal patronage, the tapestry making industry in England collapsed and royalty turned its attention to commissioning painters instead.

It was not until 1878, when William Morris attempted to improve the Royal Windsor Tapestry Manufacture and set up the Merton Abbey Tapestry Workshops, that tapestry flourished again in England. Between 1881 and 1927 sixty sets of hangings and panels were woven at Merton Abbey. In the early twentieth century, the fourth Marquis of Bute opened the Dovecot Studio at Corstorphine, Edinburgh, and under his patronage several workers came from Merton. All the large tapestries from the Dovecot Studio remained the property of the fourth Marquis of Bute. When the factory closed in 1940, it seemed to mark the end of a period when a 'devoted patron of the arts could afford to commission great hangings which reflected all that was best and most noble in the "elegant art"' (F.P. Thomson, *Tapestry*). However, it has since been reborn by becoming incorporated in the Edinburgh Tapestry Company, now one of the most noted international producers of hand-woven tapestry.

When Lord Dulverton first exhibited the Overlord Embroidery at his home in Gloucestershire in 1972, a local newspaper commented that the creation of the Embroidery amounted to a 'happily patriotic question of patronage on a lordly scale'. In an interview with the newspaper, Lord Dulverton said, 'I felt there must be a Bayeux Tapestry the other way round. I just happened to be the chap with a bit of history who was in a position to put his ideas into operation.' When asked about the cost, he modestly said, 'Oh, I haven't added it up – I don't really think I want to be asked about that.' In fact, Lord Dulverton paid £1000 to the Royal School of Needlework for each of the first eight panels as they were completed, and then, after the embroiderers had been given a pay rise early in 1970, £1100 each for the remainder.

The commissioning of the Overlord Embroidery links Lord Dulverton with those kings, princes, lords and churchmen who, in earlier times, encouraged and financed the production of fine textiles. But where Lord Dulverton broke with the tradition of Bishop Odo, Louis XIV and the Duke of Marlborough was that the Overlord Embroidery was not created to glorify war as a noble art nor in a spirit of triumphal celebration. Lord Dulverton's aim was to commemorate and pay tribute to all those civilians and servicemen who played their part in the 'national team' during the Second World War.

PANEL 20
THE FLEET OPENS FIRE
Date: D-Day Location: Off the Normandy beaches

This panel shows the next phase of the D-Day naval plan – the bombardment of the German defences from the sea. The most striking feature of the panel is the smoke from the ships' guns, a very effective three-dimensional mass composed of grey, brown, black and off-white fabrics cut in complex shapes. There is some ambiguity, however, as regards which way the wind is blowing, if you look on the one hand at the billowing smoke and on the other at the flag.

The panel is full of smoke, action and imagined noise, but it somehow lacks a conclusive feeling. Is this because the gun in the foreground seems to be pointing the wrong way, taking our eyes back against the flow of the assault craft, aeroplanes and smoke? Imagine reversing the whole image of the gun and the gunners and putting it on the left of the panel – would it not make more sense?

Equipment on the deck of the ship on the left shows a very careful use of different colours, brown and two tones

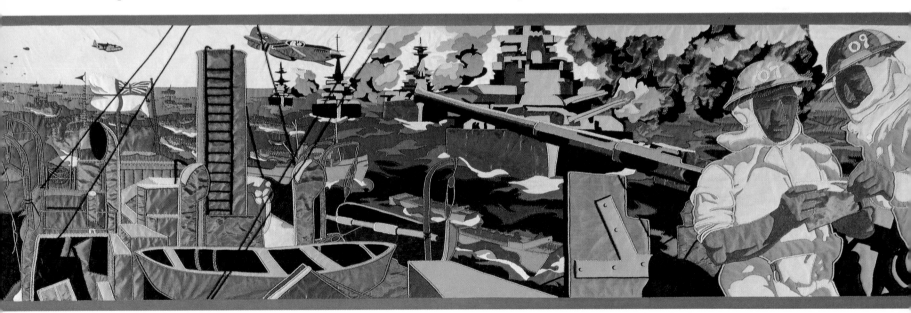

Norman Wilkinson, Seaborne landing on the Normandy beaches, D-Day, 6 June 1944, oil on canvas, 1965. Landing craft head for the beaches, while HMS Rodney *and HMS* Warspite *(top left) bombard inshore targets. Norman Wilkinson witnessed the landings from HMS* Jervis *(right centre). Southwick House, HMS Dryad*

of grey, so that the eye can easily pick out which surfaces are horizontal and which vertical. Note how the white waves breaking against the ships and landing craft are made up of embroidery thread in long and short stitches, which creates the effect of flecks of foam far better than pieces of appliquéd material would have done. The feeling of depth in the panel is enhanced by details such as the outlining of the Y-shape on the gunshield partly in black cord and partly in white; even the rivets have half crescents of black embroidery to make them stand out.

When the Embroidery Committee examined the thumbnail sketch for this panel, they requested some small but important additions: 'A Sunderland of Coastal Command should be shown in the distance on the left, and air reconnaissance in the form of a lone Mustang over the Fleet should be included.' In a letter to Dr Noble Frankland, the Director of the Imperial War Museum, Air Chief Marshal Sir Donald Evans referred to this as a good example of a panel where the captions which were planned for the Embroidery would have a very important role to play:

It dawned on me too late that ... there had been no representation of the part played by the air recce forces or by Coastal Command during the build-up to D-Day. So belatedly in a D-Day panel entitled 'The Fleet opens Fire' we crammed in a Mustang spotting

for the bombardment forces, and in the distance a Sunderland. At the time, I made a mental note that the caption to the panel should say that they were symbolic of the very significant air recce and coastal contribution.

In discussing the panels, the 'Three Wise Men' became increasingly aware that attempting to include references to as many aspects of the D-Day story as possible would inevitably require a good deal of compression and symbolism. In the case of this panel, Admiral Madden later remembered commenting that the position of the

The Allied assault on Normandy, 6 June 1944.

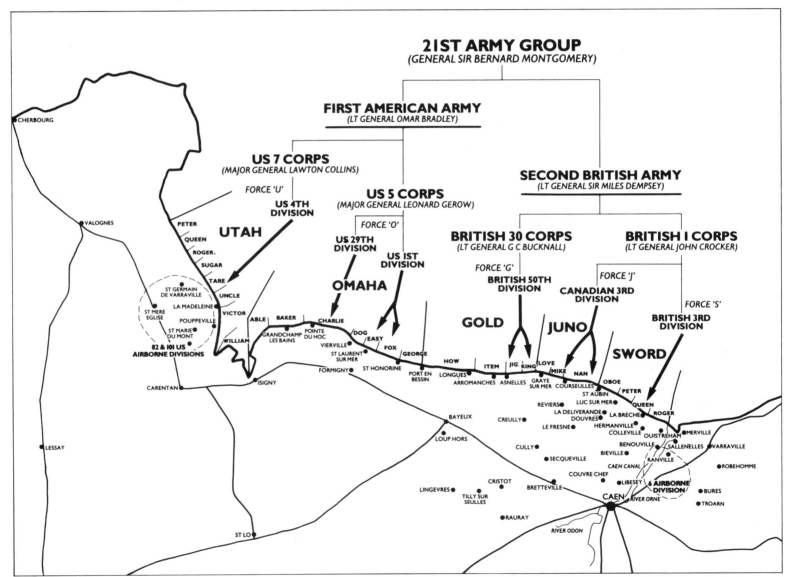

battleships and assault craft suggested that a major naval disaster was imminent, but it was pointed out that the scene should not be interpreted too literally. In the case of Panel 21, when it first came before the Embroidery Committee, 'the position of the Liberator flying so low was discussed but it was pointed out that it was symbolic only.' The point was made that the planned brochure would help to explain the symbolic significance of many things in the Embroidery.

A DRENCHING FIRE

The Naval Bombardment

On D-Day, the Allied naval bombardment force was made up of seven battleships, two monitors, 23 cruisers and 103 destroyers. The bombardment was timed for 5.30 AM and the fleet opened fire along a 50-mile front. The battleships and cruisers directed their fire so as to neutralise the danger from the long-range German shore batteries. Then the destroyers and close support craft, using both shells and rockets, produced a 'drenching fire' against the German shore machine-gun posts and strong points, to protect the assault craft as they reached the beaches. Sub-Lieutenant Sidney Montford, RNVR, Gunnery Officer of the Hunt class destroyer HMS *Eglinton*, described in a letter to his brother on 12 June 1944 how his ship had been given the task of destroying German positions in houses on the shore on D-Day:

> As soon as we sighted our target we opened up and poured several hundred shells into these blinking houses (that lasted an hour or two) rapidly reducing them to ruins. But before we had fired many rounds all hell was poppin'! The other destroyers found their targets and blazed away, while the battle wag-

gons whipped away 15-inch shells at targets further inland. At the same time the RAF planes cracked their bombs down on the shore defences, and the rocket-carrying sea-craft let off their death-dealing loads onto the beaches – the most appalling and demoralising weapon surely ever devised!

As Sidney Montford says, after the assault forces had landed on the beaches the guns of the fleet found targets further inland, disrupting the movement of German reinforcements. They continued to do so during the Normandy campaign, and Field Marshal von Rundstedt, German Commander-in-Chief West, reported to Hitler that 'the guns of most enemy warships have so powerful an effect on areas within their range that any advance into the zone dominated by fire from the sea is impossible.'

In the Embroidery, an RAF Mustang flies over the bombarding forces. The fleet initially had to rely on aircraft to report the accuracy of the fall of their shells inland. These aircraft were manned by specially trained men of the Fleet Air Arm and the Royal Air Force, together with American naval pilots, a total of some 180 in all. In the background, a Sunderland flying-boat symbolises the maritime reconnaissance and anti-submarine patrols undertaken by RAF Coastal Command to protect the Allied cross-Channel assault.

Two 'Polar Bears'

As the guns of the battleships open up, two members of a gun crew wearing their 'anti-flash' protective clothing study their orders. In his memoirs Lord Lovat recalled that as he passed HMS *Scylla* on the morning of D-Day, he observed that 'the gun crews on the cruiser's turrets wore white protective clothing, giving them a curious polar bear appearance.'

THE GERMANS IN DISARRAY

Date: D-Day Location: German defensive positions on the Normandy coast

Sandra Lawrence's brief for this panel in the Embroidery Script was, 'Assault wave approaches coast which is shown in silhouette, under air attack.' As with the scene involving a German bunker in Panel 16, she has again chosen an interior/exterior format here. The use of red, orange and yellow in the background indicates very well the effects of the heavy naval and air bombardments, and this fiery backdrop is reflected in the colour tone of the Germans' frightened faces. The glare and heat of the

flames are brought right to the front of the panel by the use of orange lacing cord and embroidery silk on the arms and helmets of the foreground figures, and on the ensnaring barbed wire.

French knots are seen for the first time in this panel, used to create a different texture at the edge of the sea, around the bunker and for the vegetation on the right. The French knots were judged to be so successful at the Royal School of Needlework that they 'almost became an

epidemic' in succeeding panels, the embroiderer Wendy Hogg later recalled.

The rather odd appearance of the central German's headgear, which appears to have earflaps, has a curious origin. The original photograph Sandra Lawrence used as the basis for her design was taken in 1940 during the German conquest of Norway. One of the soldiers had used a white cloth to camouflage his helmet in the snow. The Embroidery Committee failed to realise that Sandra Lawrence had made a mistake in transposing this particular feature to a soldier defending the Normandy coast. Indeed they were not sure what the German had on his head. The minutes of the meeting when this panel was discussed recorded that 'the peculiar headgear of the German obser-

The soldier's face and clothing and the barbed wire reflect the glare from the gun emplacement as the Allies bombard it from the sea and the air.

ver was discussed and although no reason was found for his not wearing a helmet, it was decided to leave it as it was.'

The result of basing the faces of the two soldiers in Panel 21 on the photograph of the Norwegian campaign has given rise to the comment that in this particular panel we have something too close to a 'comic-strip' caricature of the Germans. The question whether 'the enemy' are depicted in an unfavourable light in the Embroidery as a whole needs to be asked, but the answer is really a negative one. When first shown in Panel 7 the Germans appear as a purposeful, efficient, striding, competent force. In Panel 16 they are shown in a very human way, sharing a drink, needing relaxation and sleep. In this panel their faces show justifiable apprehension and fear as the immense invasion fleet opens fire. By Panel 26 some are capitulating, but the leading figure is shown as dignified and defiant, whereas the original photograph that inspired the design shows a much younger and very frightened German. Panel 29 shows them in the *bocage*, the strain of battle apparent on their faces. In Panels 31 and 33 we see them as victims of the war, while the battle continues around them. The German dead in Panel 33 are, in fact, the most affecting in the whole Embroidery, more so than any of the Allied casualties, even including the American at the water's edge in Panel 22.

THE UNEXPECTED INVASION

The View from the Bunker

As the first Allied assault waves headed for the beaches, some 160 aircraft of the American Eighth and Ninth Air Forces — Marauders, Liberators and Flying Fortresses — attacked the German coastal defences. In this panel, American B-24 Liberators are shown bombing a German gun emplacement. Many of the concrete emplacements proved capable of withstanding both the naval and air bombardments but such fortifications were relatively few in number. The stupefying effects of the assaults on the

men manning the concrete emplacements, and also the resulting boost to the morale of the troops coming in to the assault, were of great importance.

As the expressions of the German troops in this panel show, there was now no mistaking the fact that Allied landings were taking place in Normandy. A German wireless operator gave this account of what it was like to be on the receiving end of the Allied onslaught:

> One message followed the other. 'Parachutists landed here – gliders reported there', and finally 'landing craft approaching'. Some of our guns fired as best they could. In the morning a huge naval force was sighted – that was the last report our advanced observation posts could send us before they were overwhelmed. And it was the last report we received about the situation. It was no longer possible to get an idea of what was happening. Wireless communications were jammed, the cables cut and our officers had lost their grasp of the situation. Infantrymen who were streaming back told us that their positions on the coast had been overrun or that the few bunkers in our sector had either been shot up or blown to pieces.

The German High Command

The confusion at the front was matched by that of the German High Command. Was the assault on Normandy the *main* enemy invasion? In order to keep the Germans guessing, the Allied deception plan continued on D-Day itself. Naval and air forces simulated attacks in the Pas de Calais and Cap d'Antifer near Dieppe, while dummy parachute drops north of the Seine and to the south of Caen and St Lô also helped to confuse the Germans over the extent of the Allied invasion. So successful were the measures taken to convince the Germans that there was still a major Allied army poised in south-east England that Rommel wrote to his wife, on 13 June: 'We are expecting the next, perhaps even heavier, blow to fall elsewhere in a few days.' It was not until July that Hitler

allowed any troops to be transferred from the Pas de Calais to Normandy.

H-Hour: A German Version

The German propaganda version of events at H-hour on 6 June can be seen from a translation of an article in the June 1944 issue of the magazine *Luftflotte West*, produced by the German Third Air Fleet in France and now preserved at the D-Day Museum:

> With unparalleled force the German troops flung themselves against the Anglo-American invasion

An American B-21 Liberator on a bombing mission in 1944. Imperial War Museum EA 25098

German soldiers fighting in Norway in 1940. Sandra Lawrence based the two Germans in Panel 21 on this photograph, and inappropriately incorporated the snow camouflage on the soldier's helmet into her design. Bundesarchiv

army. Even if every enemy soldier knew that the assault would be no picnic, they had not expected this. An inferno struck them from all the German weapons, wielded by men every one of whom had a score to settle with the enemy . . . Death reaped a terrible harvest many times worse than the enemy had imagined. Countless attackers lost their lives in the water or were captured the moment they reached the beach. The dead lay in heaps, sacrificed to a criminally insane urge for the destruction of the European continent. The great reckoning has begun.

HITTING THE BEACHES

Date: D-Day Location: Utah, Omaha and Sword Beaches

In the double spread of these two panels, Sandra Lawrence's design captures the great contrast between the fortunes of the Americans on Utah Beach, which was almost a walkover, and those of the US 1st Division on Omaha Beach. There men are shown pinned down at the water's edge and forced to seek shelter behind Rommel's beach obstacles. Sandra Lawrence then symbolises the eventual success of the American troops, dashing headlong across the beach. On the right of Panel 23, the story of the British and Canadian assault begins as green-bereted commandos prepare to land.

The two panels are full of striking silhouetted shapes, running and crouching. The harsh, aggressive shapes of the 'hedgehog' beach obstacles divide the action and give added drama to the dead body (the first to be shown in the Embroidery), which forms an unforgettable central image. It is based on a German photograph of a dead British or Canadian soldier at Dieppe two years earlier.

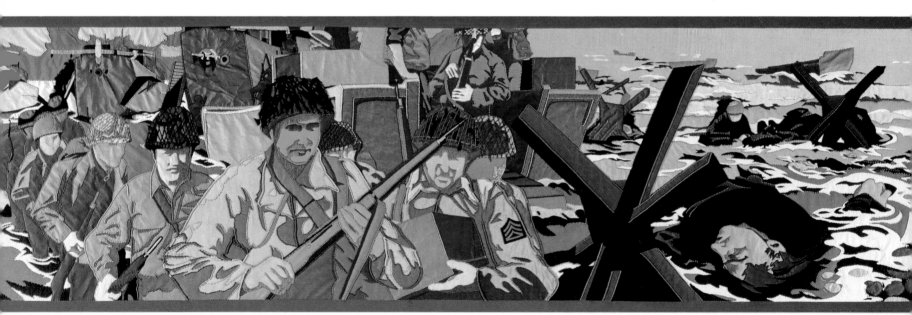

Even so, the Embroidery Committee felt that the panel should show more of the horrors of war, the dying soldiers and exploding shells. Remembering Peter Scott's comment about giving the Embroidery an anti-war message, Lord Dulverton was particularly concerned about the impression which the scenes of the landings would make on the viewer. In a letter to Air Chief Marshal Evans he wrote, 'We do not want to glorify war. Have we got the Blood, Sweat and Toil and the ghastliness across?' In this and succeeding panels, the Embroidery Committee urged Sandra Lawrence to include more visual evidence of the cost of war. She finally succeeded in creating a truly ghastly image which lingers in the memory in Panel 33 – the destruction of the German forces trapped in the Falaise Pocket.

In the panels shown here, the details of the pebbles, large and small, and the swirling water in an enormous variety of light and dark areas, make the shoreline tremendously realistic. Strategic use of net in varying shades gives the pebbles a really sea-washed appearance. As Margaret Bartlett says, it was a case of trial and error to get the right effect. But the transformation resulting from placing a certain colour of net over what had until then been a rather drab pebble had to be seen to be believed.

Other examples of embroidery technique worth noting in these two panels are the way in which the screw on the rifle of the leading American soldier in Panel 22 has been depicted in satin stitch, with a dark countersunk line to make it unmistakably the head of a screw; and, in the centre of Panel 23, the working of the green beret and shadow on the nape of the commando's neck.

FIGHTING ON THE BEACHES

Utah Beach

Because of the tides, H-Hour for the Americans was at 6.30 AM, about an hour earlier than on the British and Canadian beaches. On Utah Beach, a lucky mistake in navigation brought the leading assault craft in about a mile further south than intended, where the German defences proved to be relatively weak. Supported by 28 amphibious tanks, the seaborne forces soon established their beachhead. On D-Day, some 23,250 men landed on Utah Beach at a cost of under 350 casualties.

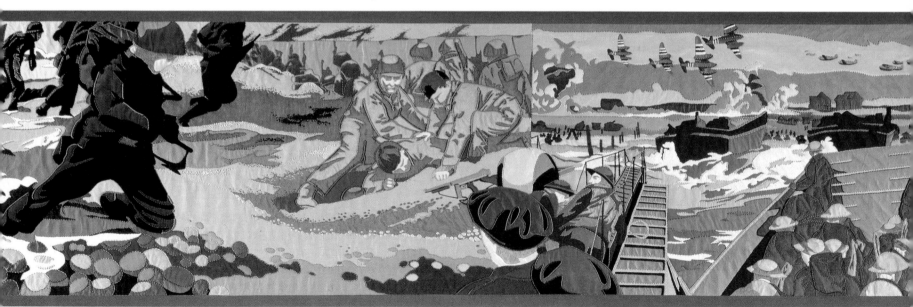

Omaha Beach

On Omaha Beach, the initial assault was a very different story and a combination of circumstances nearly spelled disaster. First, the German strong points had not been subdued by the preliminary bombardments – the 40-minute naval bombardment proved to be too short and the bombers had missed their targets. What was worse was that the defences on the rising ground commanding the beach were manned not by second-rate German troops but by front-line infantry of the 352nd Division. They had only recently been moved up to exercise in the Omaha Beach area. Many of the Americans' amphibious tanks failed to reach dry land and the offer of other specialised armoured assault vehicles had not been taken up. So, without armoured support and hampered by Rommel's shoreline obstacles, the American troops were pinned down on the beach. Soon after 9 AM the situation on Omaha Beach looked so serious that the commander of the US First Army, General Bradley, thought it might be necessary to order an evacuation.

But the courage and experience of the US 1st Division, supported by naval gunfire, in the end enabled the Americans to fight their way off Omaha Beach. The left of Panel 23 shows GIs on the move, perhaps inspired by the famous words of Colonel Taylor: 'Two kinds of people are staying on this beach, the dead and those who are going to die – now let's get the hell out of here!' Other soldiers give artificial respiration to a half-drowned comrade. Some 34,000 men were landed on Omaha Beach on D-Day, but there were more than 3000 casualties.

Even on Omaha Beach some units had lucky escapes. John C. Gearhart, of the 111th US Naval Construction Battalion, was responsible for operating Rhino ferries unloading the landing ships off Omaha Beach. He later wrote:

We had very few casualties, considering that half our outfit was in the beach area from H-Hour on. Our people found a German soldier in one of the holes from which guns had fired on our soldiers (this was

Omaha Beach on D-Day morning. The American assault falters as troops are pinned down on the seashore and take cover behind armoured vehicles and German 'hedgehogs'. Imperial War Museum AP 25726

about June 12). When he was asked why the Germans did not fire on our equipment he said, 'Ah! All dummy intended to draw our fire.'

Landing the Commandos

On the right of the panel, the Embroidery moves to the run in to the British and Canadian beaches, Gold, Juno and Sword. This half-panel and Panels 24 and 25 look at these three beaches as a whole, from the H-Hour landings to the movement inland once the German coastal defences had been pierced.

In the Embroidery, commandos wearing their green berets prepare to land, while overhead Mosquitoes and Thunderbolts keep watch for German fighters. In fact, Allied mastery of the air was so complete that on D-Day the air forces flew some 14,000 sorties, compared with only 319 by the Germans. The scene of the ramp crew waiting for touch-down is based on a photograph of

Landing Craft Infantry (Small) 519, one in the flotilla commanded by Lieutenant-Commander Rupert Curtis, RNVR, coming in on Sword Beach at about 8.40 AM. The commandos he was carrying included Brigadier Lord Lovat and Piper Millin. Half an hour later in the follow-up unit was Sub-Lieutenant Don Bonfield, RNVR, with men of 45 RM Commando in Landing Craft Infantry (Small) 518. In a letter dated 12 October 1944, he recalled his experiences that morning:

> The trip was rough for our small craft, but except for some gunfire in the west, quite uneventful. We were early when we arrived 5 miles off the beach and trod water for 10 minutes watching the bombardment. Then we formed up and set course for the beach at top speed. Everything went fine until we were a mile off and then 'Gerry' let us have all the short range

An American Rhino ferry carrying vehicles and cargo from a landing ship to the Normandy beaches. The Rhino ferries were made of steel pontoons, assembled in sections and powered by large outboard engines. D-Day Museum

The result of a direct hit by a mortar on LCT 854 on D-Day. D-Day Museum: B N Bignell

> stuff he could muster from machine guns to 88 mm shells. By the Grace of God we all reached the beach, though three were never to come off. My own craft took a direct hit just aft of the bridge from an 88 mm and massacred about 20 marines and another forward as we beached, killing five of the crew. We cleared out from the beaches eventually and set about picking up survivors and getting our wounded off. Until late afternoon events don't bear talking about.

In fact, the ramp crew of the landing craft were beheaded by the fire from the German 88 mm gun. The nature of the 'events' referred to by Don Bonfield can be judged by the tribute paid to him and another sub-lieutenant in the report by the Flotilla Officer, Lieutenant-Commander Deslandes, RNVR: 'These officers were untiring in their attentions to the seriously wounded and they inspired and encouraged seamen to carry out the disposal of badly mutilated dead.'

THE BRITISH AND CANADIAN BEACHES

Date: D-Day Location: Gold, Juno and Sword Beaches

These two panels represent the course of events on D-Day on the British and Canadian beaches: Gold, Juno and Sword. The mass of khaki humanity, bounded by the landing craft on the left and by the rising ground on the right, suggests a solid and orderly landing, though some casualties are to be seen. Permanence is given to the scene by the departure of the troops, who are seen here pushing their bicycles on towards their next encounter with the enemy.

When the Embroidery Committee studied Sandra Lawrence's thumbnail sketches for this most important double spread, they requested that 'the faces of the British troops will be made to look more grim and more purposeful.' Sandra Lawrence returned with the amended sketches for the next meeting the following month, but the 'Three Wise Men' thought that 'the general effect was still one of weakness and sadness and the British troops should be made to look more purposeful and aggressive.'

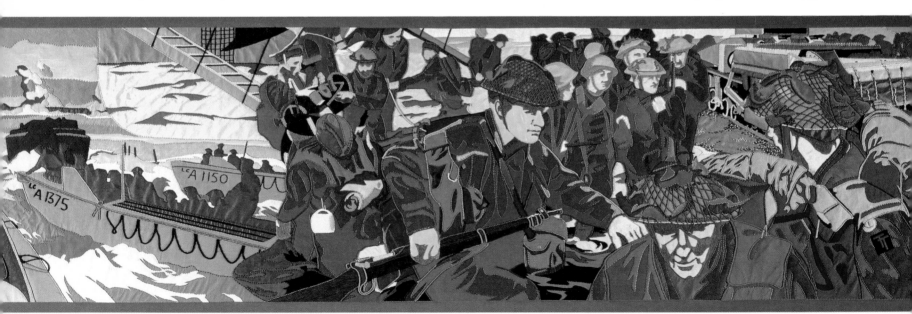

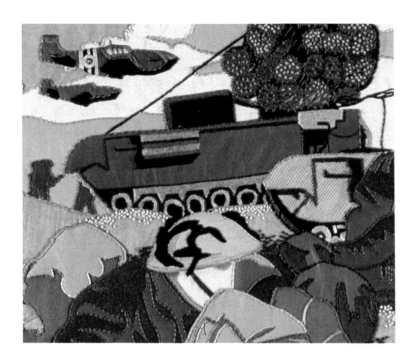

The Churchill Assault Vehicle, Royal Engineers, shown in Panel 25. French knots have been used to good effect in working the fascine which it carries. Mustangs fly overhead.

One thing in particular had been worrying General Jones. Sandra Lawrence based her sketch of the leading soldier with the rifle in Panel 24 on a photograph of a Royal Marine commando hurrying on to the beach. The man was wearing spectacles in the photograph and these were included in the sketch. As Sandra Lawrence told the story to *The Sunday Times* in 1975, General Jones was 'quite shocked – "You can't have a man going into battle wearing spectacles", he said.' The glasses were removed. Sandra Lawrence felt that this was 'a pity ... somehow they brought home the thought that most of these fighting men were just civilians in uniform.' And so that the point should not be lost sight of completely, spectacles were added to the man by the tank at the rear.

When the story of the censored spectacles appeared in *The Sunday Times*, a Mr Graham was moved to write in from Liverpool: 'May I, as an ex-bespectacled Sherman tank gunner in Normandy, 1944, offer my sincere if belated apologies to the general who was shocked at the idea of a man going into battle wearing spectacles? I did not realise at the time that I was spoiling the look of the battlefield.'

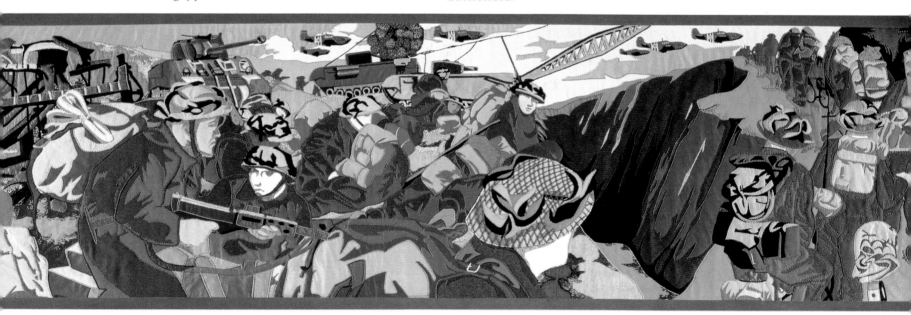

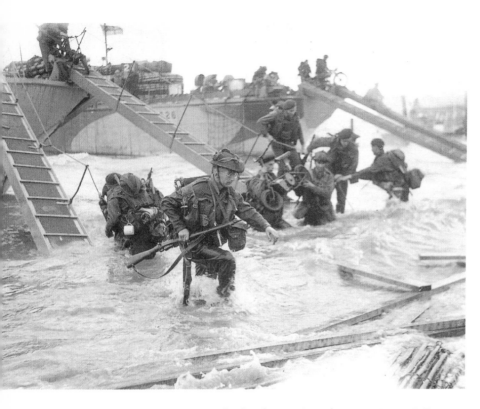

Royal Marine commandos landing at St Aubin-sur-Mer on D-Day morning. 'You can't have a man going into battle wearing spectacles,' protested General Jones when he saw Sandra Lawrence's thumbnail sketch inspired by this photograph. Imperial War Museum B 5218

A further amendment to the same soldier with the rifle was necessary after the embroidered panel had been completed. Perhaps to increase his warlike appearance once his spectacles had been removed, a bayonet was added to his rifle. Colonel Neave-Hill was asked to check the accuracy of this. In June 1972 he wrote to Major-General Brown at the Dulverton Trust, 'Regarding bayonets, I've checked several photographs and it seems that when landing in the assault on the beaches bayonets were not fixed.' Keen-eyed visitors to the Embroidery can now see the marks left by the removed bayonet.

Achieving an accurate representation of weapons often proved to be a problem in the Embroidery. At first

the rifle in Panel 24 and the Sten gun in Panel 25 were unsatisfactory. Sandra Lawrence was given a copy of a book called *British and American Infantry Weapons of World War II* by A.J. Barker, which she took to the Royal School of Needlework to see if the illustrations would help them. Eventually, in July 1972, a deputation comprising Sandra Lawrence, David Lloyd and Margaret Bartlett went to the Imperial War Museum to examine a real Sten gun and a Bren gun (for Panel 34) in order to get the embroidered versions exactly right.

The immense versatility of corduroy in all its different colours and thicknesses – from very fine to thick, broad ribbing – can be seen in Panel 25. First, note its use for the Churchill bridge-laying tank, and then again on the nearly vertical cliff face, where the ribbed effect creates a very naturalistic landscape, especially when cut with deep indentations as it is here. Placing the ribbing of the corduroy so that it runs vertically, horizontally or on the bias can all achieve different effects. Other embroidery details worth noting in these panels are the ends of the bundles of wood carried by the Churchill tank, which are worked in French knots to create a very realistic impression of the texture of timber; and the rope loops hanging from the landing craft, which are made of cord and look just as if you could grab hold of them.

LANDING CRAFT, CRABS AND BICYCLES

Touchdown

On the extreme left of Panel 24 are shown two LCAs (Landing Craft – Assault), Nos 1375 and 1150, which carried Canadian troops to Juno Beach from HMCS *Prince David*, an Infantry Landing Ship. LCA 1375 was the only one of the eight LCAs attached to the *Prince David* to survive D-Day undamaged. In the next scene, commandos are shown manhandling a small motorised bicycle down the ramp of an infantry landing craft. Another soldier moves rapidly to dry land clutching his rifle. Men help a wounded comrade to the beach, while a soldier wearing the 'double-T' formation badge of the 50th (North-

The Art of War: *the tapestry shows Marlborough's men cutting faggots and loading them on to horses to help the army's advance.* Victoria and Albert Museum

umbrian) Division urges them on. The assault divisions, west to east, were the British 50th Division on Gold Beach, the 3rd Canadian Division on Juno Beach and the British 3rd Division on Sword Beach.

Specialised Armoured Vehicles

A key part in overcoming the German defences on the British and Canadian beaches was played by the specialised armoured vehicles developed by the 79th Armoured Division. The Embroidery shows a Sherman Crab which, using a rotating chain, could flail 10-foot wide gaps in German minefields. Then, on Panel 25, are shown two Churchill AVREs (Assault Vehicles, Royal Engineers). Churchill tanks, with the gun replaced by a mortar known as a Petard, were adapted to various uses by the Royal Engineers. In the Embroidery, one is shown carrying a box-girder bridge which, when lowered into position could carry a 40-ton load across a 30-foot span or over a 15-foot wall. The other is carrying a fascine to fill in ditches and shell holes. Fascines (from the latin *fascina*, meaning 'bundle') can be traced back as far as the seventeenth century. Marlborough's forces in the tapestry *The Art of War* can be seen using horses to carry bundles of faggots for fighting over marshy ground. Fascines were particularly used by tanks involved in trench warfare on the western front in the First World War.

Success on the Beaches

As Mustangs fly overhead, the heavily laden troops move off the beaches, pushing the bicycles which it had been hoped would enable them to make rapid progress inland. German opposition and congestion on the beaches prevented them from reaching all their objectives, but a secure beachhead had been established. Some 75,000 men were landed on the British and Canadian beaches on D-Day at a cost of under 2000 casualties.

EXPANDING THE BEACHHEAD

Date: June 1944 Location: The Cotentin peninsula behind Utah Beach

The dominant feature of this panel is the German prisoner, whose eyes are impossible to avoid. He is another example of an almost larger than life character in the Embroidery. In the photograph on which Sandra Lawrence based the portrait, the German looks very young and extremely apprehensive, whilst the Embroidery seems to make him a more defiant and threatening figure.

Close study of Sandra Lawrence's original cartoon shows how skilfully the Royal School has changed the flat gouache into a three-dimensional face. The shadows are worked in satin stitch, but appliqué has been used for the hair, a much quicker method than embroidery. Attention to detail is shown in the working of the buttonholes of the German's greatcoat and the folds in his crumpled jacket.

In Sandra Lawrence's thumbnail sketch for this panel, the right-hand side originally contained an American soldier firing a bazooka and a man covering his ears.

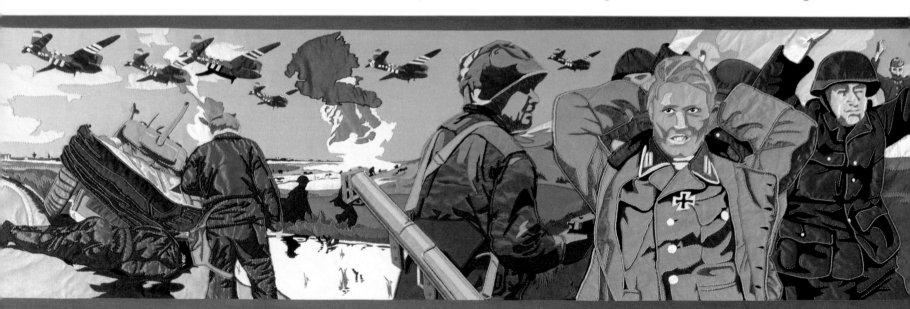

Sandra Lawrence's cartoon for Panel 26 of the Embroidery, showing her depiction of the German prisoner.

The Embroidery Committee suggested that this should be deleted and the German prisoners, who were included in the sketch for Panel 27, should be transferred to this panel. The American soldier in the centre was given a pistol so that he could appear to be covering the new arrivals. The Embroidery Committee also asked that the central figure's helmet should be made to look more clearly American.

In the Bayeux Tapestry, the artist gave all the participants in the battle of Hastings helmets which were much the same in style and construction. National distinctions there are made through hairstyles: the Normans are mostly shown clean-shaven and with short hair, whilst the English typically have moustaches and longer hair. In the Overlord Embroidery, there is an enormous variety of headwear. Germans, British and Americans can easily be identified by the different shapes of their helmets; and on the Allied side, leather flying helmets, naval caps and coloured berets give clear indications of a man's service affiliations.

EXPANSION AND BUILD-UP

A Solid Lodgement Area

In the days following the landings, the Allies expanded their beachheads into a solid lodgement area some 50 miles long and eight to twelve miles deep. Then the race began to build up men and equipment faster than the Germans could organise reinforcements and mount a major counterattack. On the left of the panel, the scene is the flooded area behind Utah Beach. In the foreground a knocked-out tank – one of the amphibious Shermans with its canvas flotation screen lowered – and the body of a GI symbolise the cost of the fighting. In the background, American troops move inland across the area flooded by the Germans and begin the battle to cut the neck of the Cotentin peninsula. Overhead, B-26 Marauders fly off to bomb German units trying to move up to the front.

Prisoners of War

On the right of the panel, an American soldier, a bazooka slung across his back, guards a group of German prisoners. Hands clasped behind his head, a young German

103

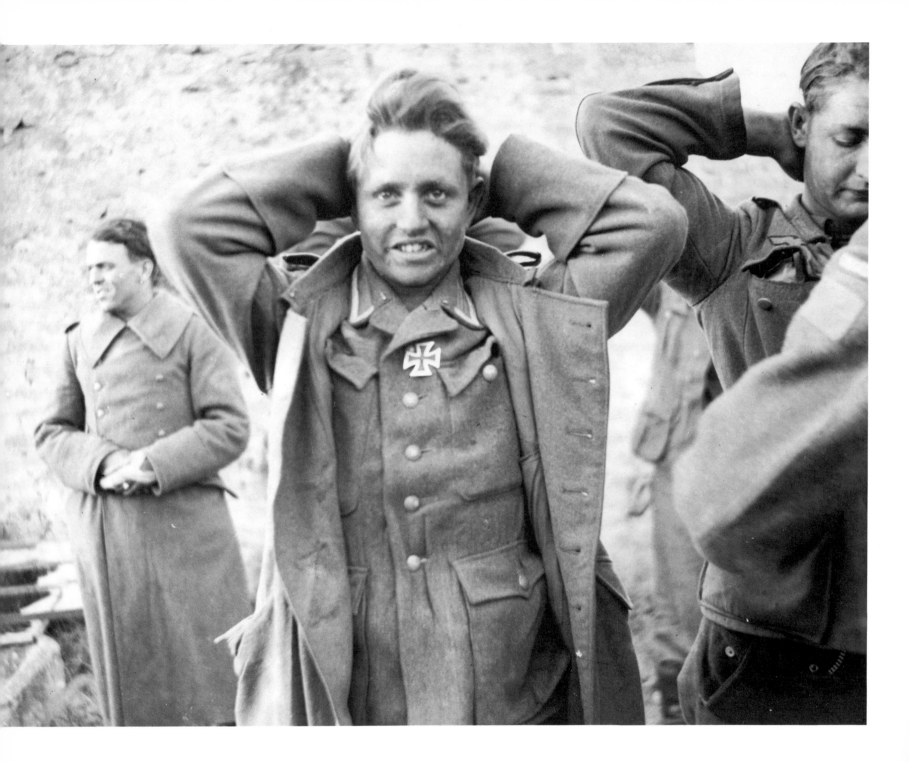

The Bayeux Tapestry: national characteristics. An English soldier, wearing a moustache, fights on foot with an axe; the Norman, clean-shaven, fights on horseback with a lance.

Prisoners-of-war, many of them 'volunteers' from Germany's conquests in central Asia, wait on a Mulberry harbour pontoon to be shipped to England. D-Day Museum: Martin Waarvick

waits to be searched. He wears an Iron Cross on his chest, perhaps awarded for bravery in recent days.

Many of the defenders of Hitler's Atlantic Wall had little stomach for a fight to the finish. 'As a guess, prisoners about 6000 so far', Montgomery wrote to a colleague at the War Office on 8 June. 'The Germans are fighting well; Russians, Poles, Japanese, and Turks run away; and if unable to do so, surrender.' For others initial shame at surrendering soon turned to relief. A German veteran

taken prisoner on D-Day recalled, 'At first I was rather depressed, of course. I, an old soldier, a prisoner of war after a few hours of invasion. But when I saw the material behind the enemy front, I could only say, "Old man, how lucky you have been!"' Great caution was needed, however, in the matter of offering and accepting surrender. A US Ranger, Alban Meccia, wrote, 'I saw a German officer shoot one of his men in the back when he started to walk over to us with his hands up ... One of our guys saw a flag of surrender, and stood up to wave to the Germans to come on over, and was shot between the eyes!'

A German prisoner waits to be searched after being captured by the Canadians at Langrune on 8 June 1944. Imperial War Museum B 5144

PHYSICAL AND SPIRITUAL CARE

Date: Summer 1944 Location: Blood transfusion unit and field dressing station in Normandy

In Sandra Lawrence's first version of this panel, German prisoners were included on the left. The Embroidery Committee suggested that they should be replaced by the blood transfusion unit so that the whole panel dealt with British field medical arrangements.

Nurses and orderlies prepare transfusions and check clean sheets and blankets so that they will be ready to take the next batch of casualties arriving at their hospital tent. On the right, a nursing corporal helps move a

wounded commando, still wearing his green beret. In the centre of the panel, a major from the Royal Army Medical Corps bandages a head wound. A sense of concern and caring is evoked by the expressions and attitudes of the figures throughout the scene.

At the insistence of Lord Dulverton, another figure was added to the central group – a regimental chaplain. Lord Dulverton felt very strongly that reference should be made in the Embroidery to the dedicated chaplains, who

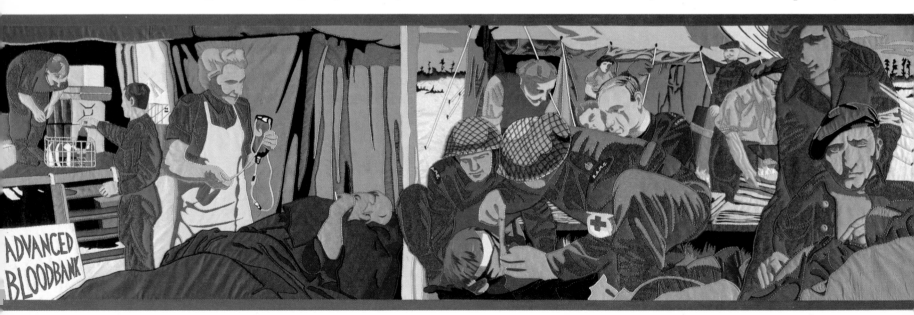

The words ADVANCED BLOODBANK are worked in reverse appliqué.

The padre, who was included at the suggestion of Lord Dulverton.

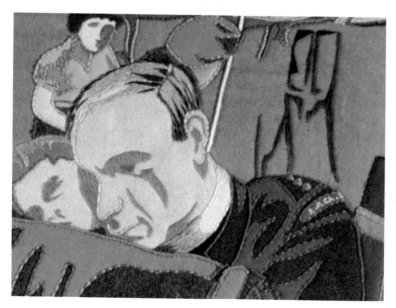

shared the dangers of combat with the troops and made an important contribution to the morale of all ranks. Although the chaplain is somewhat hidden, note the way in which his hair is extremely realistically depicted in embroidery thread. He is one of the few non-VIPs to receive such special treatment.

The panel as a whole has a sombre feel to it, but warm hair tones, the green of the beret and the red on the armbands and signboard form highlights of colour. It is fascinating to look closely at the technique used to produce the lettering of the words 'Advanced Bloodbank'. At first glance you might assume that the letters are made of red material applied to the light cream background. But look again and you will see that the exact opposite is the case. Reverse appliqué has been used because some letters, such as A and V, have very sharp points and it was found to be easier to cut the letters out of the cream material and lay it on a red background. Even then the tops of the three As needed to be worked in red embroidery silk.

Those with keen eyes may be able to see marks where the guy ropes of the tent have been altered. After it had studied the original cartoon, the Embroidery Committee requested that the layout of the tent pegs should be depicted 'more irregularly'. But when later Lord Dulverton was visiting the Royal School he noticed that the perspective of the supporting ropes was now wrong, and these had to be altered on the actual embroidery.

CLEARING UP THE HAVOC

The Medical Services in Normandy

In the build-up to D-Day, field dressing stations, casualty clearing stations and general hospitals were brought to a high state of readiness and massive quantities of blood and plasma were prepared. Early on in the Normandy campaign, casualties had to be evacuated from the beachhead as quickly as possible, either by sea or, from 13 June onwards, by air, and this required a massive organisational effort. From 6 June to 31 August, 57,426 casualties

Evacuating the wounded from Normandy by sea. D-Day Museum: J H Ellis

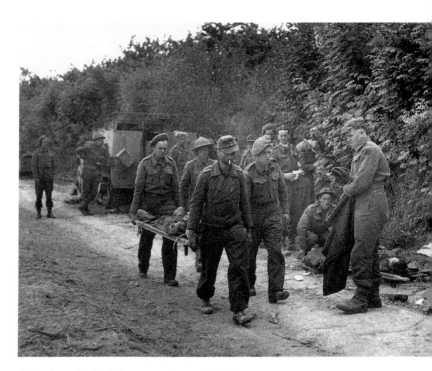

A Durham Light Infantry regimental aid post near Lingèvres treats both German and English wounded. As in Panel 27, there is a padre in the background. Imperial War Museum B 5528

were evacuated by sea and 22,646 by air from Normandy. During the campaign, advances in surgery, the development of the transfusion services and above all the use of penicillin helped save lives in great numbers. The recovery rate in medical units was 93 per cent.

Nurses at War

This is the only panel to show women on active service in Normandy. Sister Iris Ogilvie of the Princess Mary's RAF Nursing Service was one of the first to land in Normandy, late in the evening on 12 June. In her memoirs she recounts how one site where her hospital was located was close to Allied artillery:

One night was particularly noisy due to the gunfire and shelling and we were all busy dashing about. I stopped by one of the lads who was very poorly,

lapsing into periods of unconsciousness. He had the familiar intravenous infusion and in addition tubing being retained in his stomach. I noted that he was unconscious, made certain that all was well with the various tubes, then hurried off to do other things. After a little while I returned to look at him again. This time he had his eyes wide open and said in a perfectly clear voice, 'Where's your tin hat? Who do you think you are – a blinking fairy?!' I had forgotten I wasn't wearing one. Off I went to find my hat and hurriedly put it on. I returned to reassure him to find he had just died. It was an incident that shook me greatly and which I could never forget.

The Chaplain

Also shown in this particular panel, waiting near the

wounded man, is a captain from the Royal Army Chaplains Department. Chaplains were concerned with far more than the spiritual welfare of the men. Although non-combatants, chaplains acted as stretcher bearers and organised burial parties. During the campaign in north-west Europe, seventeen chaplains in 21st Army Group were killed or died of wounds. At the end of many days the chaplain had a melancholy duty to perform, as described by Reverend A.R.C. Leaney, a chaplain with the 4th Battalion of the Dorsetshire Regiment. On 28 August 1944, his battalion was engaged in a fierce fight for a French village as they advanced to the Seine. When it was over, he wrote:

We now discovered what had happened to the platoon of 'C' Company which had advanced to take the farm. Along a hedgerow lay sixteen, cruelly shattered by shells from a Tiger, firing over open sights ... We worked into the darkness making graves, clearing up the havoc. One stretcher bearer had been blown to smithereens and we buried what parts we could collect ... I had now at last time to start writing to the next of kin of those whom I had buried. It had been a hard struggle to get up-to-date the Burial Returns, but these were finished, and the much longer task now lay ahead of me. We were at Tilly for thirteen days and I tried to write about six letters per day.

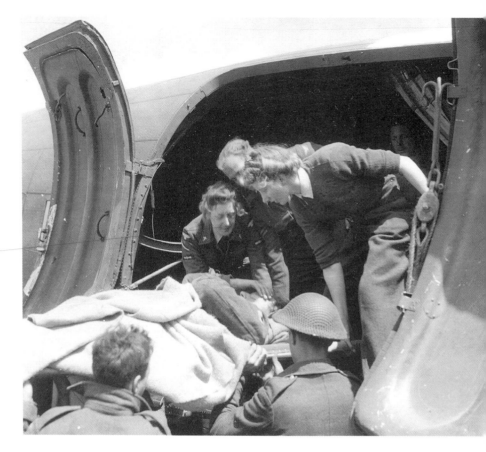

Evacuating the wounded from Normandy by air: WAAF nursing orderlies ease a soldier into a Dakota. Imperial War Museum CL 173

DISTINGUISHED VISITORS GO ASHORE

Date: June 1944 Location: The Normandy beaches

The excellent likenesses and clever grouping of the VIPs make this one of the most successful and popular panels in the Embroidery. Sandra Lawrence has used artistic licence in creating a composite in time and place, since the VIPs actually made separate visits to the beaches in the days after the Allied landings. The grouping works well as, by reading from left to right, the correct protocol is produced. First we see the King, then the Supreme Commander, General Eisenhower, with Montgomery, his ground forces commander, slightly behind him. In the background is Field Marshal Brooke, most of whose invaluable work as Chief of the Imperial General Staff went on behind the scenes. But holding the central position, of course, is the Prime Minister, Winston Churchill.

Sandra Lawrence's design proved to be an excellent way of condensing what might otherwise have necessitated several separate scenes – a thought worth remembering for anyone involved in creating a historical

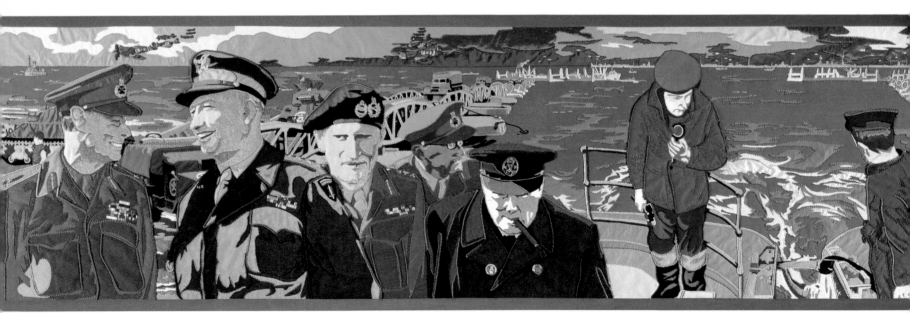

embroidery. Although none of the VIPs looks directly out at us, we feel we are there observing them on the beaches. Despite the stormy sky, rays of sun from the patches of blue above the group fall on their necks and faces, picking out their features and making them come alive.

Enormous care went into the creation of the figures in this panel. Eisenhower's likeness was not thought satisfactory at first and it was amended. Silver thread was delicately used to make an '8' on Montgomery's Africa Star ribbon and an '8' and '1' on Eisenhower's to indicate service with the First and Eighth Armies. Gold threads were used to create Montgomery's watch chain and Churchill's cap badge. The differences between the cap badges of field marshals and generals were double-checked. A pair of horn-rimmed spectacles were placed on the nose of Field Marshal Brooke, and the nose itself made to look 'more hawkish'. Marks can be seen where the Royal School were later asked to alter the shading on his nose a little more. And some ash was added to the end of the Prime Ministerial cigar.

Some uncertainty over who should be included in the VIP group arose out of discussions about the representation of various Allied countries in the Embroidery. Lord Dulverton wrote to Air Chief Marshal Evans in November 1970, 'I wonder whether we should somewhere make pictorial reference in the Embroidery to the Free French and General de Gaulle; but if we did this, I really think we would have to include the Free Norwegians, Poles, etc., etc.'

Colonel Neave-Hill examined the problem. He advised that the Poles could be included in the battle for Falaise (a Polish tank appears in Panel 33), but that it would not be easy to fit the Belgians, Dutch and Czechs into the scenes showing events leading up to the break-out from Normandy. His solution was that if the Embroidery was to end with a symbolic liberation scene, all the Allied nations could be represented there. He added one specific suggestion, however, which was that, as General de Gaulle visited the Normandy beaches on 14 June 1944, it would be valid to include him in the VIP group in Panel 28.

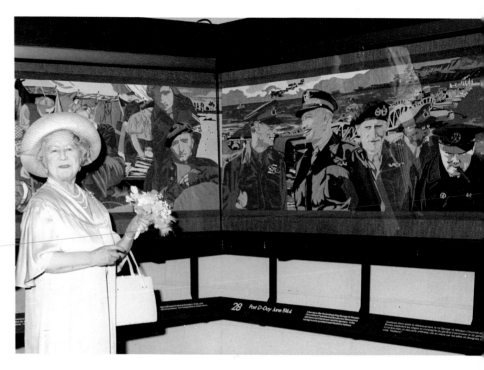

HM Queen Elizabeth The Queen Mother pauses by Panel 28 of the Embroidery on the occasion of her visit to Portsmouth to open the D-Day Museum on 3 June 1984. D-Day Museum

So Air Chief Marshal Evans asked Sandra Lawrence to sketch General de Gaulle in lightly at the back of the VIPs. His appearance there, however, was a brief one. After seeing the sketch, the Embroidery Committee decided to transfer him to the final liberation scene to join the Belgians, Dutch, Czechs, Poles, et al. Unfortunately, as is explained later, the idea of the liberation scene was subsequently rejected, so General de Gaulle disappeared without trace from the Embroidery.

As well as the VIP group, it was intended that this panel should include references to two important aspects of Allied plans for supplying the forces in Normandy. The first was the construction of two artificial 'Mulberry' harbours on the Normandy coast. One of these being used for the unloading of equipment and supplies can be seen in the background of this panel. The second feature

King George VI inspects men of the 21st Army group at the Normandy beachhead on 16 June 1944. Imperial War Museum B 5630

gineer when problems arose. The photograph itself is quite difficult to understand, and it proved much too complex to translate into a clear visual reference to PLUTO in the Embroidery.

Sandra Lawrence tried to simplify matters by removing the microphone and turning the headphones into a scarf. The Embroidery Committee, however, felt that the sailor had to be holding something, and so they suggested a wheel spanner and a hammer. But he still seemed to have a very awkward stance, and staff at the Royal School nicknamed him 'the Sloppy Sailor'.

They did their best to improve the figure, but without much success. The Royal School saw none of the photographs on which Sandra Lawrence based her designs. In this case they might have modified the sailor more radically if they had realised how his odd pose had come about. As it is the confusion remains – the headphones that became a scarf are responsible for the man's strange 'neckless' appearance, while he now issues orders through his spanner!

VIPs AND MULBERRIES

The Distinguished Visitors

Winston Churchill was the first VIP to go over to Normandy after D-Day. Only with difficulty and by the intervention of the King had the Prime Minister been dissuaded from accompanying the invasion forces on D-Day itself. He visited Montgomery's headquarters on 12 June, together with the Chief of the Imperial General Staff, Field Marshal Sir Alan Brooke (shown behind Churchill in the panel) and General Smuts, the South African Prime Minister.

Both Churchill and Brooke wrote of their feelings on this momentous occasion. Churchill described in his war memoirs how they had had lunch and then toured 'our interesting but severely restricted conquest'. He later watched the British naval bombardment and persuaded the captain of the destroyer in which he had embarked, HMS *Kelvin*, to open fire on the German positions. Two

to be included was PLUTO, the Pipeline under the Ocean, which was laid across the Channel to carry fuel to the Allied forces in Europe.

The Embroidery Committee suggested that PLUTO might be indicated by showing a ship equipped with a huge drum from which the pipe was being unwound. Sandra Lawrence found a photograph showing two sailors on board HMS *Sancroft* watching as the pipeline was paid out over rollers at the stern of the ship. The sailor on the left was wearing headphones and holding a microphone so that they could tell the ship's chief en-

days after the visit Churchill wrote to President Roosevelt, 'I had a jolly day on Monday on the beaches and inland . . . How I wish you were here.' He had written in Montgomery's autograph book, 'As it was in the beginning so may it continue to the end.' To which Smuts added, 'And so it will!'

For his part, Brooke wrote in his diary, 'About 11 AM we approached the French coast and the scene was beyond description. Everywhere the sea was covered with ships of all sizes and shapes, and a scene of continuous activity.' As he stepped on to French soil his thoughts turned to his evacuation in 1940: 'Floods of memories came back of my last trip of despair and those long four years of work and anxiety at last crowned by the success of a re-entry into France.' Also on the beaches on 12 June was General Eisenhower, acting as guide in the American sector to the US service chiefs, General Marshall, Admiral King and General Arnold. The image in the Embroidery of Eisenhower in conversation with the King is actually based on a photograph of them together outside US First Army Headquarters at Liège on 14 October 1944.

On 16 June, King George VI visited Montgomery in Normandy. With him were General Ismay, who was Churchill's Chief of Staff, and Admiral Ramsay. Ismay wrote that, during the journey cross the Channel on board HMS *Arethusa*, the King was 'the kindest and most considerate of hosts. He was so obviously happy to get away from his papers in London, and so completely in his element on the bridge of the cruiser. If "Action Stations" had been ordered he would have been happier still.' Ramsay wrote, 'I had long conversations with the King throughout the day: he is easy to talk to and likes doing a lot of it himself. He adores the Navy.'

The Mulberry Harbours

In the background of the panel can be seen one of the two artificial Mulberry harbours, the construction of which began off the Normandy coast on 7 June. The Mulberry

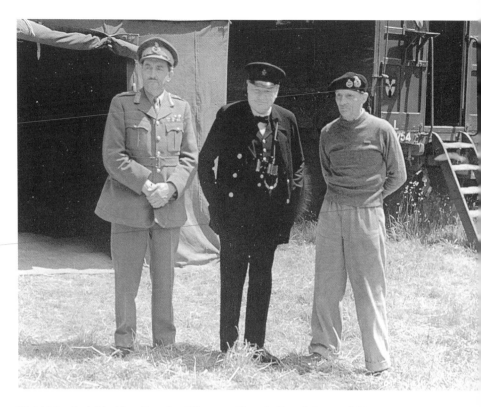

Field Marshal Sir Alan Brooke, Winston Churchill and General Sir Bernard Montgomery at 21st Army Group tactical headquarters during the Prime Minister's visit to Normandy on 12 June 1944. Imperial War Museum TR 1838

harbours, one of the great feats of wartime ingenuity and engineering, were devised in 1942–3, when it was clear that the Allies were unlikely to be able to capture a major French port intact. The harbours consisted of sunken blockships, huge concrete caissons and floating piers. One Mulberry was constructed off Omaha Beach, though this was destroyed in the great Channel storm of 19–22 June, and the other at Arromanches. Between 6 and 16 June, the Americans landed 278,000 men and 35,000 vehicles, and the British 279,000 men and 46,000 vehicles, across the beaches, the majority by way of the Mulberry harbours.

FIGHTING IN THE BOCAGE

Date: June and July 1944 Location: The Normandy countryside

This panel evokes the difficult conditions in the bocage country, with its steeply banked hedges, which the Allies had to fight through to achieve their break-out from Normandy. The panel is cleverly divided into three sections by the two stylised hedgerows of trees and scrub, so that the Germans in the centre are both trapped by and lying in wait for the British on one side and the Americans on the other. The trees form divisions in a similar way to the Celtic style trees in the Bayeux Tapestry, which established

breaks in the narrative. To create the trees here a lighter material was superimposed on the darker mass. The light green fabric indicates the trunk, branches and foliage in a most dramatic way, but it was not easy to achieve the desired effect. The lighter material was first backed with vilene and then, starting in the centre of the panel, it was *partially* cut out, so that the central branches could be attached to the background. The rest were only marked out at first but not cut out, and they were left rolled up. If the

whole tree had been cut out initially, it would inevitably have stretched and then been very difficult to lay down in the correct position without any movement. Even with the great care that was taken, some puckering has subsequently appeared on the trunks.

Sandra Lawrence has given the wounded soldier on the left red hair to add colour to an otherwise sombre panel. Light falls on the backs of the two Germans in the foreground, and the appliquéd material in greys, browns and black makes their uniforms very lifelike. In the rear, the Germans leaping from their vehicle are made to stand out in silhouette by placing them against a cloud of white smoke.

PLAYING HIDE-AND-SEEK

Fighting for the Break-out

The interior of Normandy from the Orne westwards consists of small fields, steeply banked hedges, sunken lanes and woodland, which offered countless natural defensive positions for the German forces. Towards the end of June, the Allies, their build-up delayed by the Channel storm of 19–22 June, found themselves making slow progress. The British and Canadians were stalled in front of Caen. The Americans took Cherbourg on 26 June, but met stiff opposition when they turned to push south. Fears were

The Bayeux Tapestry: trees used to separate two scenes.

(left) *The unit road signs on the left-hand side of Panel 29. On the left is the formation sign of the 6th Guards Tank Brigade, and on the right that of the 15th Scottish Division.*

(right) *The technique used for working the trees in Panel 29.*

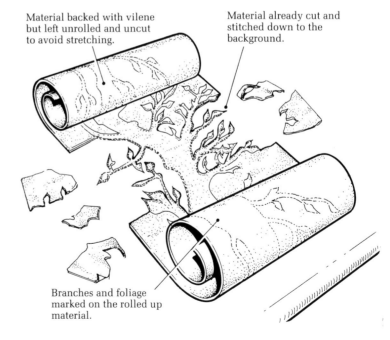

Material backed with vilene but left unrolled and uncut to avoid stretching.

Material already cut and stitched down to the background.

Branches and foliage marked on the rolled up material.

115

expressed in some quarters that a stalemate might be developing in Normandy to rival the western front thirty years before.

A Deadly Game

On the left of the panel, a British soldier becomes a casualty. The unit 'road signs' on the side of the ruined building are those of the 6th Guards Tank Brigade and the 15th Scottish Division. On the right of the panel, American troops race from one hedgerow to the next across an

(left) *Military police painting signs to direct road traffic to the rear and main headquarters of the British Second Army. Imperial War Museum B 5744*

(below) *Playing hide and seek for their lives. American troops try to flush out a German sniper in the bocage. D-Day Museum*

The great storm in the Channel in June 1944 badly damaged the artificial Mulberry harbours, delaying the unloading of supplies needed for the Allied advance. Imperial War Museum B 6062

A Sherman tank fitted with prongs for bulldozing through hedgerows; photographed near Beauvais on 31 August 1944. Imperial War Museum BU 297

exposed road. The Americans eventually devised an attachment for tanks called the 'Cullin Spike' with which they could bulldoze their way through high banks and hedgerows.

War correspondent Robert Dunnett reported on 14 July 1944:

In this country where tanks may, and do, come round corners and engage each other at point blank range with no room to manoeuvre, infantry can never make great sweeping advances. They've got to watch and stalk and crouch and wait, and play hide-and-seek for their lives.

The faces of the two German infantrymen as they wait in the hedgerow show the strain of this deadly game of hide-and-seek. Behind them, panzer grenadiers leap from their half-track as Boston light bombers fly overhead looking for targets. There was little scope for mobile warfare in the bocage but ample opportunity for ambushes by German snipers, anti-tank guns and heavily armed and armoured tanks.

THE STRUGGLE FOR CAEN

Date: 7 July 1944 Location: Caen

When the Embroidery was first completed in 1972, it consisted of 33 panels. But Lord Dulverton felt that an important aspect of the battle of Normandy had not been properly covered. In March 1973, he wrote to his historical advisers, 'I have been thinking further about the Overlord Embroidery and it occurred to me that the absence of a panel depicting the struggle for Caen is an omission that may come to be regretted.' Sandra Lawrence and the 'Three Wise Men' agreed to help, so Lord Dulverton

decided to take the plunge and commission a thirty-fourth panel.

How this took shape is a good example of the way in which the Embroidery Committee worked together, not just on matters of historical detail, but also to achieve a design which would make the greatest possible impact. Sandra Lawrence at first produced a thumbnail sketch showing troops advancing through the rubble-strewn streets of Caen. The Committee felt that this could be

improved by showing a far more desolate landscape, devoid of human life, the sky full of departing bombers and a panoramic view of Caen laid waste below. Sandra Lawrence redrew the panel along these lines and it has proved to be one of her most successful designs in the whole Embroidery.

When the Embroidery Committee considered the revised cartoon General Jones felt that the ruined city needed to be more readily identifiable as French. He suggested that there might be a shattered signpost saying 'Caen' or that on a wall there could be an advert for 'Dubonnet or *Byrrh* or whatever'. Sandra Lawrence incorporated the word *Byrrh* (French for beer) and it is a case where the addition of a single word brings instantaneous understanding and avoids any possibility of ambiguity.

Sandra Lawrence took her cartoon to the Royal School of Needlework in July 1973. By then the workroom at the Royal School had moved on to a new commission. So Wendy Hogg, one of the most experienced members of the team that had worked on the Embroidery, was made responsible for working the whole panel on her

Sandra Lawrence's first thumbnail sketch for a panel on the battle for Caen. Sandra Lawrence

own. When embroidering the small details such as the buildings on the skyline, which were not made by appliqué work because they were so small, Wendy Hogg found it was essential to set herself a target each day, otherwise

Paul Nash, We are Making a New World, *oil on canvas, 1918. Nash's ironic comment on the results of four years of conflict on the Western Front in the First World War. Imperial War Museum*

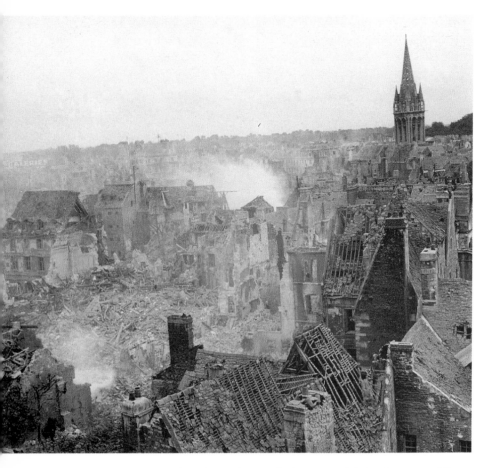

After the bombers have departed, the spire of Saint-Sauveur still stands above the ruins of Caen, ' . . . a portent of the triumph of good over evil.' Imperial War Museum B 6912

the enormity of the task would have overwhelmed her. Whenever a large piece of appliquéd fabric was laid down she found it an enormous relief, as there was a sudden sense of progress.

Finding herself under slightly less pressure of time than when the other panels of the Embroidery were being worked one after another, Wendy Hogg was able to lavish enormous care on the creation of the vegetation in this panel. Tremendously intricate pieces of appliquéd fabric can be seen forming the scorched foliage, whilst the thin,

brown remnants of the tree trunks and branches are worked in embroidery thread, couched down. Not surprisingly it was January 1974 before Wendy Hogg completed this final panel, which became number 30.

In its final form, the panel shows a scene of complete desolation, which could equally well be the aftermath of a nuclear explosion. It is empty and silent, blasted, burnt, brown and scorched and devoid of people, living or dead. Hundreds of planes, like birds of prey, darken the sky as they deposit their deadly loads, creating devastation, stifling dust and clouds of black smoke. Amongst the ruins, the church spires and towers stand firm against the horizon. It is a wasteland bringing back memories of many of the official war artist Paul Nash's First World War paintings, such as *The Menin Road* and *We are Making a New World*, which had depicted just such horror and futility.

A SINISTER MAJESTY

The Bombardment of Caen

Hopes of capturing Caen at the outset of the campaign in Normandy had been frustrated. At the beginning of July, Montgomery decided to launch a major new attack by three divisions of I Corps. A successful offensive would increase his room to manoeuvre with his forces and draw in more German divisions to the eastern end of the Allied line, making things easier for the Americans in the west. Montgomery requested massive air support to ensure the success of his assault on 8 July.

At about 9.50 PM on 7 July, more than 450 Lancasters and Halifaxes of RAF Bomber Command began their attack on Caen. The bombers initially met some anti-aircraft fire, but as the attack went on the German response ceased. In less than an hour, 2560 tons of bombs were dropped on the northern suburbs of Caen.

One eyewitness, Desmond Flower, wrote:

To those of us who watched from the ground in safety there was a sinister yet inspiring majesty ab-

out the scene. The earth was already in the shadow of night, and the sky itself was that electric blue which follows a day of cloudless heat. But the long line of bombers stretching back towards England as far as we could see was still in sunlight and their metal twinkled like fairy lights against the darkening sky.

A war correspondent who watched the attack from three miles away, John D'Arcy-Dawson, wrote that it was like a scene from 'the worst nightmare imaginable ... The bombers went off, but the pall of smoke remained until much later, when it drifted away and the ruins were mercifully hidden under the velvet night.'

Operation Charnwood

The ground assault, Operation Charnwood, began at 4.20 AM next day, preceded by a massive artillery bombardment. After two days' hard fighting, the northern part of Caen was in Allied hands, though the Germans still held the area south of the Orne. Yet this success had been achieved at the cost of terrible destruction to the city, and a survey carried out immediately of the results of the bombing raid found few German strong points in the target area. In part the bombing had been intended to prevent the Germans bringing up reinforcements, but the advancing British troops found their own progress impeded by the rubble and huge pieces of locally quarried stone which had been 'tossed like sugar lumps', choking the narrow streets.

Those who passed through Caen after the fighting had died down found it a terrible and moving experience to see such devastation. War correspondent Alan Moorehead wrote that the group he was with,

... came at once upon such a desolation that one could think only of the surface of the moon ... Row after row of immense craters. New hills and valleys wherever you looked. The very earth was reduced to its original dust ... There was a kind of anarchy in

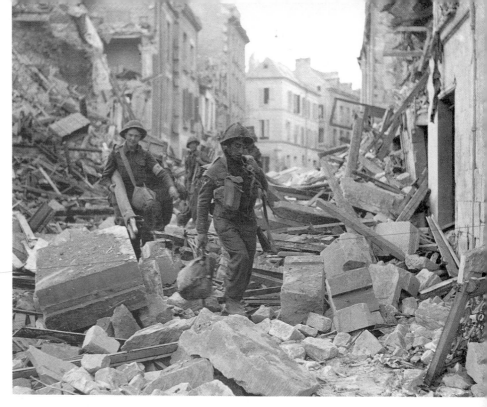

British infantry, together with a stretcher bearer, pick their way through the streets of Caen, choked with rubble after the aerial bombardment. Imperial War Museum B 6727

this waste, a thing against which the mind rebelled; an unreasoning and futile violence ... There seemed no point in going on. This was the end of the world, the end of the war, the final expression of man's desire to destroy.

Some of Caen's churches, where many of the inhabitants had taken refuge, miraculously survived the bombing. (Their spires can be seen appearing above the ruins in the Embroidery.) General Ismay, visiting Caen on 23 July, found a certain comfort in this fact: 'It was a curious sensation to walk out of the welter of destruction into that peaceful house of prayer. It seemed a portent of the triumph of good over evil.'

121

THE AMERICAN BREAK-OUT

Date: Late July 1944 Location: South of St Lô in Normandy

This panel takes us back to the American sector of the Allied bridgehead and shows the aftermath of Operation Cobra, the American break-out from the area round St Lô. American troops, together with a column of Sherman tanks, pour south past German dead. On the rear of the nearest tank the red, yellow and blue badge of the US armoured divisions forms a highlight of colour. Bombers fly at high altitude in the distance, while over the column of tanks appear the distinctive Lockhead P-38 Lightning fighters, known to the Germans as the 'two-tailed devils'. The Americans' initial attack was preceded by heavy carpet bombing of German positions, and so, at the suggestion of the Embroidery Committee, Sandra Lawrence has added bomb craters to the green fields. As in Panel 20, the clouds of smoke, this time from burning German equipment, are the most striking feature of the design. Grey, brown, black and fawn clouds billow up against a very blue sky.

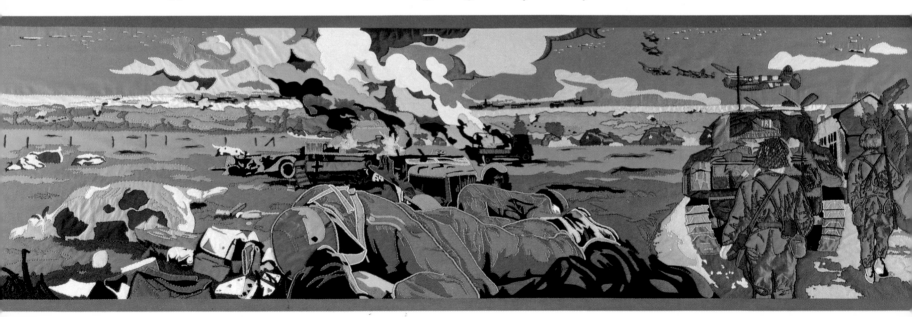

POOR DEAD PANZER

Poor dead Panzer!
It must have cost you some
to crawl through this wheat
setting it alight,
into this ditch
where swollen flies
buzz round the stiff upturned legs
of a Uccello cart-horse:
And you must have hated the stench
of which you now stink too.

Dragging your torn shoulder
through the corn, an oily smudge
on your tunic sizzling, and clutching
to your chest this evil-looking
Schmeisser machine pistol I covet,
and which sure you must have treasured
to spin round it a frothy cocoon
of brain tissues and dried blood
oozing from that hole in your forehead?

Poor old Panzer!
Your sought to protect it so,
did you not? And you felt less vulnerable
with it in your hand.
Now here I am – half jew
and victorious invader –
dispossessing you.

And as I take the butt
into my plough-hands
seeking the point of balance,
I catch a whiff of Bavarian
harvest fields and temporarily
drop it back beside you.

Melville Hardiment
Epron Cross Roads
D-Day Plus 20

From Poems of the Second World War: the Oasis Selection (J M Dent & Sons)

Comparing this panel with number 33, there is far less of a sense of involvement here for the viewer. The German body in the foreground lies face down and the Americans have their backs to us. There are no points of contact to help us understand and involve ourselves in the predicament of the fighting men. Yet Margaret Bartlett felt that the introduction of the dead animals into the scene helped to bring home the totality of pointless suffering in war. The dead cows were the accidental casualties of the American artillery and air bombardment. They lay swollen and bloated in the sun, adding to the stench of death.

Although we cannot see his face, the pack of cards spilling out of the German's knapsack adds a pathetic touch to his lifeless presence in the forefront of the panel. Note the care which has gone into the meticulous embroidery of the hearts and spades. Margaret Bartlett found that the horrors of war, as represented by scenes showing dead bodies, had a certain fascination for the staff of the workroom, perhaps because it was a subject not normally depicted in modern embroidery.

OPERATION COBRA – THE AMERICAN BREAK-OUT

While the British and Canadian attacks around Caen held the German armoured divisions at the eastern end of the Allied line, the Americans captured St Lô on 19 July. All was now set for the long awaited break-out, though bad weather delayed the start of Operation Cobra until 25 July. The American advance, led by VII Corps, was pre-

American troops advancing towards Avranches on 30 July 1944.

ceded by massive carpet bombing of the German defences. Some 2500 aircraft dropped 4000 tons of bombs. The American bombing killed some of their own men, but General Bradley later wrote, 'It had pulverised the enemy in the carpet to litter the torn fields and roads with the black hulls of burned-out tanks, the mutilated bodies of soldiers and the carcasses of bloated, stiff-legged cattle.'

A gaping breach opened in the enemy line as German resistance crumbled. Avranches fell to the American armoured spearheads on 31 July. The US Third Army, commanded by Lieutenant-General George S. Patton, was activated next day, and his forces swept into Brittany and turned east to race towards the Seine. General Bradley later described Cobra as 'the most decisive battle of our war in western Europe'.

IN RETROSPECT

As the Allies fought their way from beachhead to breakout in June, July and August 1944, they encountered place names familiar to every schoolchild who has studied the history of William the Conqueror: Falaise, his birthplace; Caen, where he was buried; and Bayeux, where the tapestry telling of his invasion of England has been preserved. For centuries, Duke William's invasion had been a symbol of success to those intent on a cross-Channel assault. Napoleon in 1803 and, reputedly, Hitler in 1940 had sought inspiration in the Bayeux Tapestry.

In 1944 it was by no means a foregone conclusion that the Allies would succeed in emulating Duke William's achievement. The chief of staff of the naval forces, Rear-Admiral Creasy, drew attention to some less happy historical parallels: 'What Philip of Spain failed to do, what Napoleon tried and failed to do and what Hitler never had the courage to try, we are about to do, and, with God's Grace, we shall.' And succeed they did, in an operation the scale and complexity of which was so immense that the idea that it could be depicted in a latter-day Bayeux Tapestry seemed completely impracticable to the historian, Fred Majdalany. In his book *The Fall of Fortress Europe*, published in 1968, he referred to the fact that it was the descendants of Duke William's men who re-crossed the Channel in 1944 and liberated Bayeux, home of the 'most famous of all tapestries':

The Bishop of Bayeux who accompanied the Conqueror is thought to have commissioned the tapestry from a workshop of Saxon weavers. Had his successor in 1944 been like-minded no weavers on earth could have been found to encompass the scope and scale of events that were to link England and Normandy in this new conquest.

Unbeknown to Fred Majdalany, Lord Dulverton, Sandra Lawrence and the Royal School of Needlework were in the process of taking up the challenge.

There are many comparisons and associations to be made between the events of 1066 and 1944. Both invasions were helped by good luck and the vagaries of the weather in the English Channel. In 1066, adverse winds delayed William's invasion until after Harald Hardraada, the King of Norway, had descended on the north of England. King Harold defeated him at Stamford Bridge,

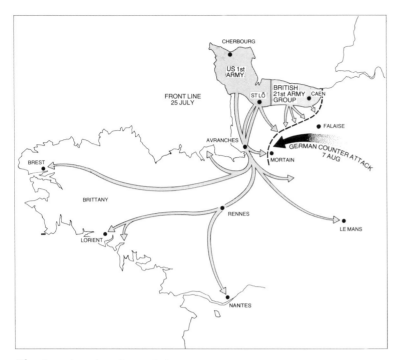

The American break-out, July 1944.

but then the wind changed and William was able to open a 'second front' by crossing to the unguarded south coast. In early June 1944, there was terrible weather in the Channel, and D-Day had to be postponed for 24 hours. But the weather also lulled the Germans into a false sense of security, which helped ensure that the Allies would achieve the vital element of surprise when they carried out their airborne and seaborne assaults on 6 June.

When battle was joined at Hastings in 1066, the Norman possession of a mixed force of foot soldiers, armoured cavalry and archers gave them the initiative against the English, immobile behind their shield-wall. In Normandy in 1944, the Germans tried first to defend the coastal strip, and then to establish a defence line inland which would pen the Allies into their beachhead. But airpower and armoured forces, in combination with infantry and artillery, enabled the Allies to create a weak point in the enemy defences so that the Americans could break through the German 'shield-wall'. Attack triumphed over defence – but only after a bloody struggle.

There was also a strong personal link between the two invasions – through the name Montgomery. The first person who bore that name to appear in England was Sir Roger de Montgomeri in 1066. His family owned large estates in the region of Caen, Falaise and Argentan. A kinsman of Duke William, he contributed 60 ships to the invasion fleet and commanded the right wing of the army at Hastings. He ended a life spent as a soldier and administrator by becoming a monk in the Benedictine order at the Abbey of St Peter and St Paul in Shrewsbury, which he himself had founded.

Nine hundred years later, it was a descendant of Sir Roger who commanded the land forces in Operation Overlord – Sir Bernard Montgomery. Monty's biographer, Nigel Hamilton, says that his character had a 'decidedly Norman quality': 'An absolute singleness of purpose still considered un-British (and certainly un-American); a passion for effective administration bordering on cruelty; a Christian conviction both simple and zealous; and a temperament not above intrigue when felt appropriate.' So perhaps it was qualities imported into the British character in 1066 which, in 1944, helped to defeat the Germans, and to show again after 900 years that the Channel could be a highway and not just an obstacle to victory.

It was at Bayeux, the first French city to be liberated by the Allies in June 1944, that the Commonwealth War Graves Commission sited the largest of the sixteen British war cemeteries in Normandy. There are 4663 men buried there, and the names of a further 1843 men who have no known grave are recorded on the Bayeux Memorial. On a frieze above the columns of the Memorial is carved a Latin inscription: *Nos a Gulielmo Victi Victoris Patriam Liberavimus*, which, freely translated, reads, 'We, once conquered by William, have now set free the Conqueror's native land.'

125

THE CANADIAN ADVANCE ON FALAISE

Date: 7 August 1944 Location: West of the Caen–Falaise road

In the original plan for the closing stages of the Embroidery this particular subject had not been included, but the Embroidery Committee thought it was impossible to depict the success of the Allied campaign without an extra panel on the Canadian advance from Caen to Falaise in August 1944. Panel 32 captures the moment late in the evening on 7 August when men of the Royal Regiment of Canada began their part in the attack (code named Totalise) southwards to the west of the Caen–Falaise road.

Sandra Lawrence's initial designs gave the Embroidery Committee plenty to get their teeth into. They pointed out that the battledress manufactured in Canada was a slightly greener shade than its British counterpart, and also that the moon was shown in the wrong phase. The Committee also felt that in the thumbnail sketch armoured cars were too much in evidence: 'Show more troop carriers. Create impression of massed tanks advancing into the darkness flanked by Bofors tracer shells.'

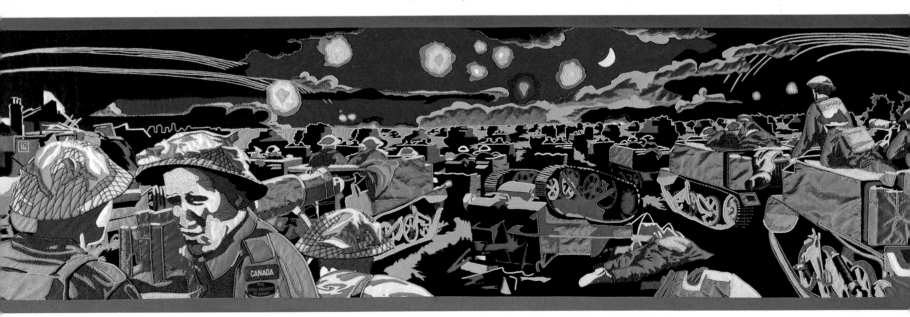

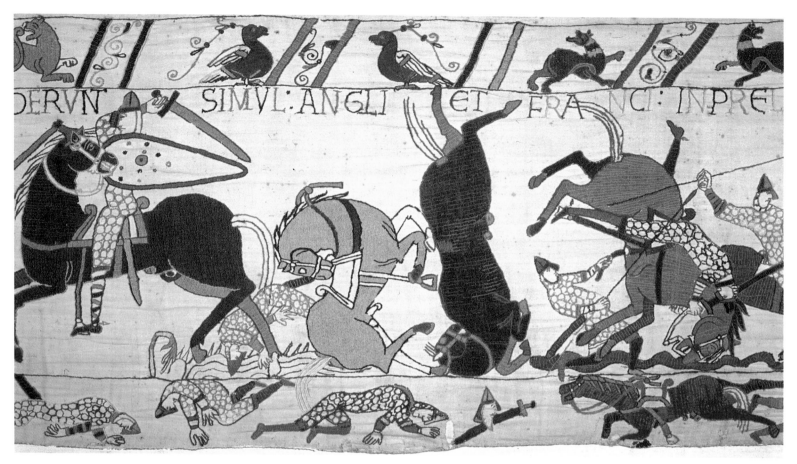

DERVNT SIMVL:ANGLI ET FRA NCI INPRE

(above) *The Bayeux Tapestry: Norman knights charge and men and horses fall together. Panel 32 of the Overlord Embroidery shows the modern counterpart of the medieval cavalry charge. Michael Holford*

(left) *The correct colour material for the Canadian soldier's uniform and details of his two badges were provided by the Canadian Defence Liaison Staff in London.*

When the Committee referred to 'troop carriers', they probably had in mind the important part played in the operation by 'unfrocked Priests' (self-propelled guns with the armament specially removed: see below). Instead, however, Sandra Lawrence incorporated more standard universal carriers into her revised draft. So at the next meeting of the Embroidery Committee she was asked to

127

Troops moving up to the start line for the attack on 7 August 1944 in 'unfrocked Priests'. Imperial War Museum B 8806

consult Colonel Neave-Hill again and rework the sketch 'to show a phalanx of the various types of armoured vehicles in their right order – Rams, Priests and Shermans.' But in the end, after a good deal more discussion, the design was executed by the Royal School more or less as it stood.

The Canadian night attack shown in this panel provided Sandra Lawrence and the Royal School with the opportunity of creating almost as dramatic a perspective scene as the Allied invasion armada in Panels 12 and 13. The embroiderers worked the dark background (with net

much in evidence across the sky), and then used white embroidery thread to silhouette the heads and shoulders of the troops and the outlines of armoured vehicles in an entirely different way from the methods used on all the other panels. It is extremely effective and quite economic in terms of time. Small pieces of appliquéd material in greys and fawn are sufficient to give solidity to some of the armoured vehicles. It is interesting to compare this with Panel 30 to see two different ways of executing a night scene in embroidery and appliqué.

The impact made by the yellow trails of the tracer shells is due to the way they are embroidered in long and short stitch, making them stand out very clearly. The

bursts of the coloured marker shells and the moon (finally shown 'five days beyond the full') show up well against the inky blue of the sky.

The face of the Canadian soldier on the left, part worked in appliqué and part in long and short stitch, helps us to become involved in the action of the panel. The neat embroidery used for the words 'Canada' and 'The Royal Regiment of Canada' gives instant recognition, as did the word 'Byrrh' in Panel 30. Work on the panel was suspended for a time while Colonel Neave-Hill obtained battledress material of the correct shade of green for Canadian soldiers through the Canadian Defence Liaison Staff in London.

UNFROCKED PRIESTS

The object of Operation Totalise in August 1944 was the capture of Falaise. In planning their offensive, the Canadians faced the problem that their line of advance could hardly be disguised and the enemy defences were well prepared. So Lieutenant-General Guy Simonds, commanding the Canadian II Corps, devised some tactical surprises for the Germans.

General Simonds's first innovation was that the attack was timed to begin at 11 PM and continue through the night. Secondly, despite the darkness, heavy bombers were to attack in close support of the advancing troops. At about 11 PM on 7 August, 1000 Allied bombers and fighter-bombers began to deliver 5000 tons of bombs on to the German positions. Artillery also opened fire, including some guns using coloured marker shells to guide the bombers. The ground attack then began, at 11.30 PM, with tanks moving forward close behind the artillery barrage, four abreast in eight columns, led by flail tanks to clear the German minefields. Anti-aircraft guns fired tracer shells, which, together with coloured smoke and radio beams, were used to help the columns keep on course in the dark.

Wendy Hogg matching material against Sandra Lawrence's cartoon for Panel 32 at the Royal School of Needlework. Fox Photos

Simonds's third and most interesting innovation was the fact that the leading infantry were carried through the enemy's forward fire zone in improvised armoured personnel carriers. These were made by removing the armament from American self-propelled 105 mm howitzers (nicknamed 'Priests' because of their pulpit-like machine-gun mounting). Beginning on 3 August, an advanced workshop detachment, 250 strong, began the task of removing guns and welding on extra armour. By 6 August, 76 vehicles had been converted into 'unfrocked Priests' or 'holy rollers', each capable of carrying ten men into action in Operation Totalise. Thanks to these new methods of attack, the Canadian operation met with considerable initial success. Then the advance on Falaise became bogged down again, and it was not until 16 August that the town fell.

THE DESTRUCTION OF THE GERMAN ARMY

Date: 20 August 1944 Location: The Falaise Pocket

The destruction of the German forces trapped in the Falaise Pocket provided Sandra Lawrence with the opportunity to create a memorable panel which truly conveys what Lord Dulverton called the 'ghastliness' of war. The Embroidery Committee urged her to give the greatest possible 'impression of distance, destruction and death'. When they looked at her initial design, they felt there should be more burning German equipment, including evidence of horse-drawn transport, and that the Typhoons in the sky above might be shown firing their rockets. The main impact of the completed panel undoubtedly comes from the depiction of the corpses in the foreground. On the left there is a haunting quality about the German soldier's face, bloody and contorted, with open mouth and staring eyes. The bodies in this panel are the first in the Embroidery where blood is shown. Sandra Lawrence based the image of the German on the left on a Russian photograph taken in the Ukraine in 1944; the inspiration for the pile of bodies on the right was a German

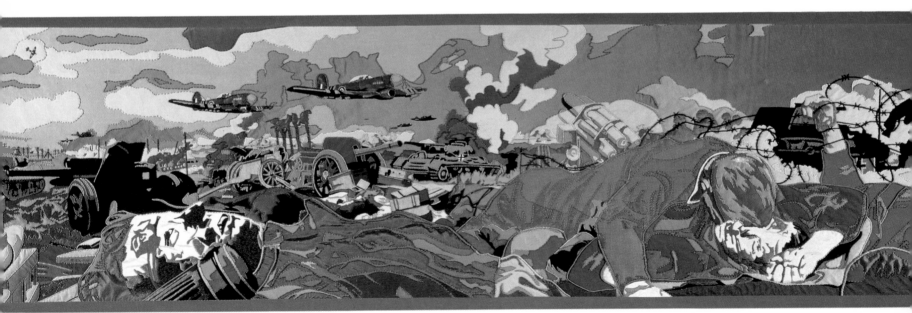

The Hastings Embroidery: the Great Fire of London. This suggested the use of light, coloured netting to create the smoke haze in Panel 33 of the Overlord Embroidery. Hastings Borough Council

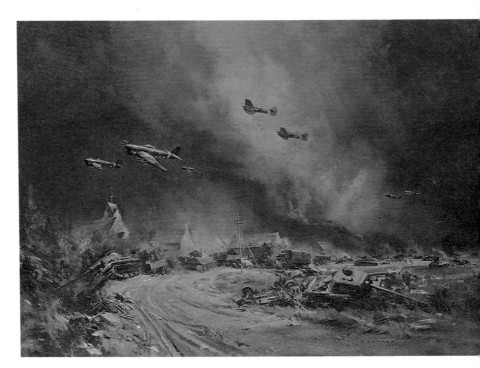

Frank Wootton, Rocket-Firing Typhoons at the Falaise Gap, Normandy 1944, oil on canvas. Imperial War Museum

THE SMELL OF DEATH

The Falaise Pocket

photograph of Allied dead at Dieppe. In the latter group, a man's arm is entangled in strands of barbed wire – its jagged spikes created by large stitches – symbolising the fate shared by many in both world wars.

The yellow noses of the Typhoons, the flames and the golden-brown hair of the dead German provide highlights in this panel, where grey, in many different tones, predominates. The scene includes one of the most subtle depictions of smoke in the whole Embroidery. Net of a lighter colour than the material it covers is laid over parts of the German multi-barrelled mortar and the dead German's jacket. Margaret Bartlett had successfully achieved a hazy smoke effect in this way when depicting the Great Fire of London in the Hastings Embroidery.

Soon after midnight on 7 August, the Germans launched a major counter-offensive against American forces around Mortain, with the object of breaking through to the sea at Avranches. The attack failed. Far from halting the Allied advance, it pushed the German Seventh Army deeper into a trap. As the British and Canadians attacked from the north, the Americans swung round to press in from the south. By 16 August, 100,000 Germans were all but surrounded in a rapidly shrinking pocket. Their escape route lay through the 15-mile gap between Falaise and Argentan.

Max Hastings, in his book *Overlord*, has described the ensuing struggle as 'one of the great nightmares of military history'. The panel represents the scene of car-

131

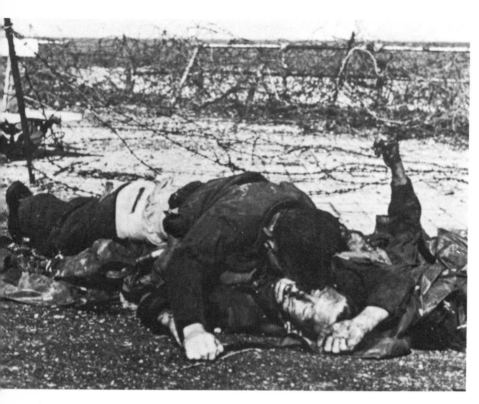

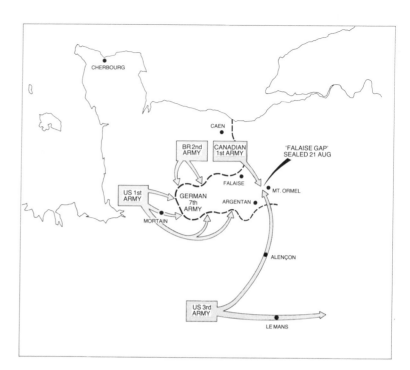

The Falaise pocket, August 1944.

The photograph of Allied dead at Dieppe in Purnell's History of the Second World War *which inspired Sandra Lawrence's design for the right-hand side of Panel 33.* Bundesarchiv

nage and destruction in the last hours of the German withdrawal from the pocket, after Allied artillery and airpower had done their work. Fighter-bombers, such as the rocket-firing Typhoons shown in the Embroidery, flew more than 2000 sorties a day. When the Allies finally closed the gap in strength on 21 August, the Germans had lost in the pocket 10,000 men killed and 50,000 captured, as well as vast quantities of equipment.

The devastation in the pocket when the fighting subsided left an awful impression on those who witnessed it. Some had to don gas masks to keep out the smell of death.

A Typhoon pilot Group Captain Desmond Scott described a scene much like that portrayed in Panel 33:

The insignia of the 1st Polish Armoured Division, which is depicted in black and orange on the back of the Sherman tank on the extreme left of Panel 33

The battle of Hastings, 1066: English soldiers behind their shield wall made a good target for Norman archers firing high in the air.

The battle of Normandy, 1944: German armoured fighting vehicles were a good target for Allied fighter-bombers. D-Day Museum

The roads were choked with wreckage and the swollen bodies of men and horses. Bits of uniform were plastered to shattered tanks and trucks and human remains hung in grotesque shapes on the blackened hedgerows. Corpses lay in pools of dried blood, staring into space and as if their eyes were being forced from their sockets.

The Polish Contribution

The Sherman tank on the left of the panel bears the 1st Polish Armoured Division's insignia, which represented the leather falcon wings worn by Polish cavalry in the seventeenth century. A Polish badge was brought into the Royal School of Needlework in June 1972 to enable the correct colour to be selected. The inclusion of the tank symbolises the gallantry of the Polish division, which was cut off for three days on Mount Ormel as it tried to block the path of the escaping Germans. Though short of ammunition and fuel, the Poles beat off a counterattack by II SS Panzer Corps trying to keep open the gap on 20 August. Over 300 Poles died in the battle.

THE BEGINNING OF THE END

Date: August 1944 Location: Liberated France

In the very early stages of planning the Embroidery, Colonel Neave-Hill had suggested that it might show the Allied progress across Europe right up to VE Day in 1945. But Lord Dulverton felt that this would be trying to cover too much. The most natural conclusion to the story of Overlord was the Allied break-out from Normandy and the liberation of France. When the question was discussed by the 'Three Wise Men', they agreed with Lord Dulverton and concluded that 'the final cartoon on liberation must emphasise the success of the battle and should not depict the story much beyond Falaise.' It was agreed that there was no necessity to depict a definite operation such as the liberation of Brussels or the crossing of the Seine. 'Success can be shown by the victorious forces fanning out and being met by the inhabitants greeting the troops, hanging out flags of welcome, and a general air of jubilation.'

Sandra Lawrence produced a thumbnail sketch along these lines, but when she presented it to the Embroidery

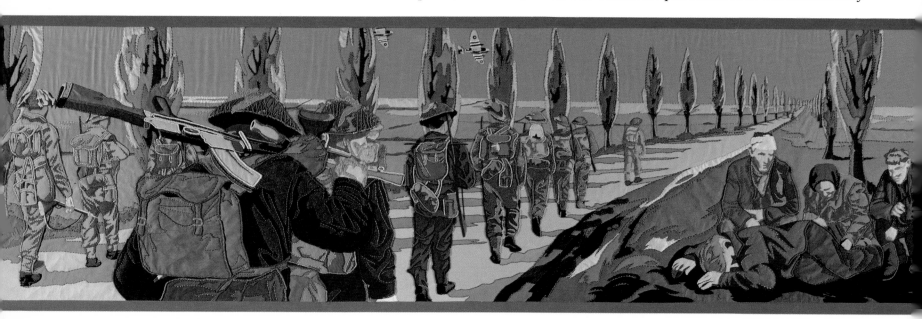

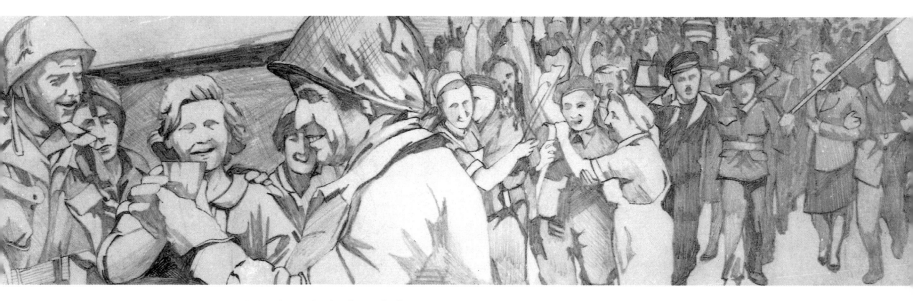

Sandra Lawrence's original thumbnail sketch for the final panel of the Embroidery. It was rejected by the Embroidery Committee because they did not want to give the impression that victory in Normandy meant that the war was over. Sandra Lawrence

Committee they realised that it might give the wrong message. 'In discussion it was agreed that Liberation should not give the impression of a jamboree and that the campaign was over, as a great deal lay ahead.' At the Committee's next meeting, Lord Dulverton stressed that he did not want the final panel to give rise to any idea that the end of the Embroidery's story was the end of the war. So Sandra Lawrence was asked to produce a new sketch showing British infantry marching 'out of the story' towards Germany, together with 'ghost figures' depicting some of their civilian occupations.

Sandra Lawrence duly had another shot at the design for the last panel. The revised thumbnail sketch included a fascinating dream-like sequence in which infantrymen seem to be thinking wistfully of their civilian days. A city office worker and a farmer appear, shown against their home backgrounds. There is also a clever double image of a miner wearing his mining helmet with its lamp, and, slightly behind, the same face with an army steel helmet.

The Embroidery Committee were also concerned whether the part played by the French Resistance in the Battle of Normandy had been sufficiently represented, so a group of French civilians mourning a dead Maquisard was added to the scene.

Lord Dulverton, however, was not very taken with the daydreaming sequence. He therefore produced a rough sketch of his own, simply showing an infantry platoon advancing through the French countryside. It was a scene with which he himself was very familiar. Lord Dulverton had been commissioned in 1935 into the Lovat Scouts, a Highland regiment originally raised during the Boer War, and mobilised with them in 1939. In 1943 he was instructed by the War Office to set up a 'Fieldcraft, Observation and Sniping School'. With some 'stalkers' from the Lovat Scouts and some personnel from the Small Arms School, this school was established first at Llanberis, in north Wales, and then at Bisley, in Surrey. Its role was to train officers and NCO instructors for the infantry battalions of 21st Army Group preparing for the invasion of north-west Europe. Lord Dulverton visited Normandy after D-Day to assess the training needs of the troops there.

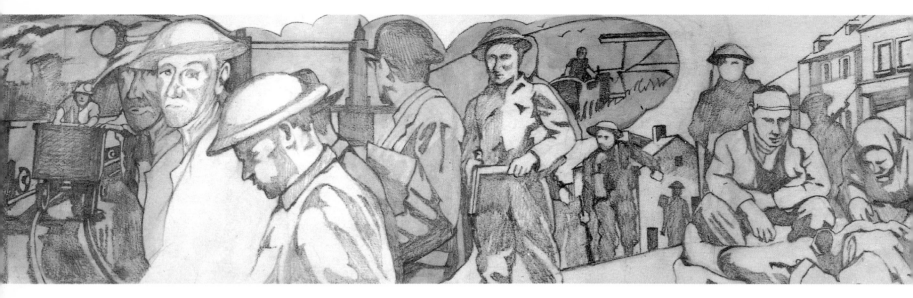

Sandra Lawrence's second thumbnail sketch. It was rejected because Lord Dulverton was unhappy with the 'ghost figures' on the left of the design. Sandra Lawrence

In producing his sketch, for Panel 34, he was prompted by the fact that 'the PBI ("Poor Bloody Infantry") had not had much of a look in' up until then in the Embroidery, and this was the last chance to put that right. Sandra Lawrence was asked to produce yet another version of the panel, this time showing the infantry platoon 'moving in file on either side of the road through unspoilt countryside.'

Sandra Lawrence painted a cartoon along these lines very rapidly, as the target date for the unveiling of the Embroidery to family and friends at Batsford, on 28 July 1972, was close at hand. When the Embroidery Committee examined the cartoon on 23 June, they said it was very important that 'the leading file of the marching troops should be shown closer to the verge, possibly by moving the verge nearer to the men.' Infantry would have always hugged the edge of the road in case they needed to dive for cover. Admiral Madden suggested that poppies might be added as symbolism and to add interest to what was becoming a rather large verge.

Sandra Lawrence took the cartoon and tracing to the Royal School on 3 July in the hope that the panel might be ready for the party at the end of the month. But this did not allow enough time for the embroidery work to be completed, so the cartoon was used at Batsford instead. When Lord Dulverton saw it he was still unhappy about the position of the infantrymen, so the following month he went back to the Royal School and explained how he wanted them to enlarge the roadside even further. It proved to be no easy matter and it was not until November that Lord Dulverton was satisfied with the 'road improvements' undertaken for historical accuracy.

The figures of the infantrymen also gave a few problems. Lord Dulverton was not happy for some time about the appearance of the third soldier down on the right. His stance was altered and his hair tidied up, lest he should become the 'sloppy soldier' to match the 'sloppy sailor' in Panel 28. The Bren gun carried by the nearest soldier was also not very convincing at first, and a visit to the Imperial War Museum to examine one was necessary before it could be improved. Now the gun and the soldier's pack are both extremely realistic, and the choice of green to highlight the khaki pack is an inspiration.

The panel as finally completed in January 1973 is evocative of the 'long way still ahead', whilst freedom at last returns to the French countryside. The price of freedom is symbolised by the red poppies and the group of figures on the right. The sunlit road sweeps our eyes on towards the horizon, aided by the avenue of trees. A pair of Spitfires fly overhead in a clear blue sky. The scene is both purposeful and hopeful, but it also brings the sadness of war home poignantly to the observer.

THE PRICE OF VICTORY

A British infantry platoon advances through France in pursuit of the fleeing Germans. Paris was liberated on 25 August 1944 and the Allied armies were soon in Brussels. But a considerable price had been paid for victory in Normandy. Between 6 June and 31 August 1944, 21st Army Group lost 16,000 men killed and 59,000 wounded; American casualties numbered 21,000 killed and 95,000 wounded.

The people of France, too, paid dearly for their freedom. War correspondent Frank Gillard recorded what was told to him of the last days of the German occupation of Caen when he entered the city in July:

As we went down the roads, crowds gathered round us. They spoke of the savagery of the SS troops in the last few days of the German occupation: of their wholesale looting; of the shooting of French civilians who were political prisoners in the jails; of the wanton burning by the Germans of the gendarmerie, of the theatre and of many private houses and shops

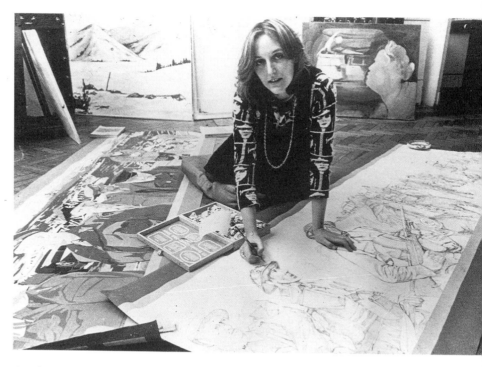

Sandra Lawrence at work on the last panel of the Embroidery in 1972. D-Day Museum

into which enemy troops had tossed hand grenades as they left Caen.

Yet despite all this and the terrible destruction wrought by the Allied bombing, Frank Gillard found the reaction of the people of Caen extremely moving – 'Not a word of reproach: not a word of self-pity.'

PART III
IN PERSPECTIVE

No Place Like Home

During the very early stages of planning the creation of the Overlord Embroidery, the question of where it should eventually be displayed was naturally discussed. Various possibilities were raised – a proposed extension to Portsmouth Cathedral, Guildford Cathedral and even London Airport. The extension to Portsmouth Cathedral looked particularly promising, as it was to be built as a memorial to D-Day. In 1967, plans were even drawn up for a 'Tapestry Court' for the Embroidery, designed in the shape of a Mulberry harbour. But there were problems over space and funds at Portsmouth Cathedral, so other sites were considered, including the Queen's Gallery at Buckingham Palace, the new building at the House of Commons and Westminster Hall. The plan for Westminster Hall was to hang the Embroidery round it six feet off the ground, but it was decided that the ancient hall, built by William Rufus, should keep its walls bare.

It was in the summer of 1968 that the association between the Overlord Embroidery and the Imperial War Museum began. In July the Secretary of the Dulverton Trust, Sir Walter Coutts, wrote to both the Imperial War Museum and the National Maritime Museum asking if they would be interested in displaying the finished work:

> We have already progressed some way towards the creation of the tapestry and we are now concerned about where it should be hung. We feel that although Portsmouth Cathedral is to be specifically earmarked for a D-Day memorial, the tapestry ought to be in London where it can be seen, not only by our own people, but by Americans and tourists of all other nations.

Lord Dulverton himself was still undecided about the Imperial War Museum at this stage, owing to his overall conception of the Embroidery's role. As he later explained in a letter to the Director of the Imperial War Museum, Dr Noble Frankland, the most important thing about the Embroidery was its portrayal of 'national teamwork' in wartime Britain, with civilians playing their part every bit as much as the services:

> Whether or not we have successfully got this message across, it was, as you know, always uppermost in my mind that this should be the purpose of the embroidery rather than a 'war relic' in the normal accepted sense, and was the reason for my demurring for a while over making your splendid institution the ultimate recipient of the work. I can see that it is not going to be easy to spell this message out, but it was the essence of the whole undertaking, and I feel most anxious that we should make a considerable effort to get the message spelt out, particularly as it is to go to a War Museum rather than a Civic Institution as I had originally contemplated.

In 1969, Major-General Douglas Brown, who had recently taken over as Secretary of the Dulverton Trust, wrote to Dr Frankland suggesting a meeting to discuss the future of the Embroidery. In September, Air Chief Marshal Sir Donald Evans, together with Major-General Brown, visited the Imperial War Museum, and then Dr Frankland and his colleagues went to the Royal School of Needlework to view the completed panels of the Embroidery.

After due deliberation, the Trustees of the Imperial War Museum accepted without reservation Lord Dulverton's offer to present them with the Embroidery. As the Museum, like the Embroidery, deals with the impact of war in the twentieth century on the lives of all members

of the community, clearly it was a most appropriate home for the work. In 1970, the Trustees of the Imperial War Museum established the Overlord Embroidery Trust. Lord Dulverton formally handed the completed work over to the care of the Overlord Embroidery Trust in December 1972.

There was an important proviso to the Trustees' acceptance of Lord Dulverton's generous offer. They felt that the scale of the Embroidery and its subject matter meant that any attempt to display it in the Museum's existing galleries would not do justice to the work itself and might upset the historical balance of the main permanent exhibitions. The Imperial War Museum therefore asked the distinguished architects, R. Seifert and Partners, to design a new gallery, to be located in the park next to the west wing of the existing building.

The Overlord Embroidery on display at the Pension Building in Washington during its tour of North America. Dulverton Trust

In their final form, the designs for the Overlord Gallery, as it was to have been called, proposed an attractive circular building of two storeys connected to the main museum building by an enclosed bridge. These plans were unveiled at a press conference at the Imperial War Museum in May 1972. They were approved by all the statutory bodies concerned, including the London Borough of Southwark, the Greater London Council and the Royal Fine Art Commission. But there were also some objections, principally from those who did not wish to see any encroachment on the open space provided by the Geraldine Mary Harmsworth Park surrounding the Museum. The Trustees' application for planning permission, which had been granted by the local authority, was consequently referred to the Secretary of State for the Environment, Geoffrey Rippon. A public inquiry was held in June 1973 and, to the dismay of the Museum and the Overlord Embroidery Trust, the Secretary of State, whilst recognising the national importance of the proposed display, decided to withdraw the planning permission.

Among those shocked by this news was Lord Mountbatten, who wrote to Dr Frankland in October 1973, characteristically proposing a radical solution of his own to the problem:

I am absolutely horror-struck at the decision of the Secretary of State for the Environment that you can't have the Overlord Gallery built in the park. The exhibition of the Embroidery in Canada is already attracting great excitement and it is inconceivable to me that this valuable thing should not be displayed. ... I recently visited the Bayeux Tapestry. The large, long room has no windows – only electric day-light lamps. Could you not dig out a long gallery below ground – re-cover it with turf and so get round current objections?

But encroaching on – or beneath – the surrounding park was effectively ruled out. The Imperial War Museum and the Overlord Embroidery Trust embarked on a lengthy

search for an alternative home for the Embroidery, but this proved fruitless.

While these events were taking place, the Overlord Embroidery had started on a long travelling tour on the other side of the Atlantic. It went first to the Pension Building in Washington, in October 1972, where it was hung high between the pillars as once Bishop Odo's tapestry was displayed at Bayeux Cathedral. From there it travelled to Canada, visiting all seven provinces in the following twelve months before it returned to England.

In July and August 1975, it went on display for a month in the old library of the Guildhall. The main aim of this particular exhibition was to publicise the fact that the Embroidery had no permanent home and 'to gauge public, and hopefully governmental departmental, reactions.' One press report bore the headline 'Homeless' and described the Embroidery as 'squatting' in the Guildhall: 'Can anyone give a good home to a remarkable piece of embroidery 3 feet 6 inches high and 272 feet long depicting the Normandy Landings of 1944 – comparable some say with the eleventh-century Bayeux Tapestry? If you have room to spare and can handle large numbers of sightseers, Lord Dulverton would be pleased to hear from you. . . There must be a spare wall somewhere in London?'

This cry for help came to the ears of David Bradshaw, who had worked for Whitbread's Brewery since 1972 and was involved in the development of their Chiswell Street site in London. Through his initiative, a proposal was made for the display of the Overlord Embroidery at Whitbread's Porter Tun Room. David Bradshaw felt that the Overlord Embroidery would make a marvellous focal point for the site. The Embroidery was displayed at the Royal Scottish Museum 1976–7, but then in June 1978 it went on view in a specially designed gallery in the upper Porter Tun Room.

In light of the changed circumstances, it was decided that the Imperial War Museum should stand down from its leading role in the custodianship of the Embroidery. In the autumn of 1977, when the move to the Porter Tun Room was certain, the Overlord Embroidery Trust was therefore reconstituted without the Imperial War Museum representation, thus ending links begun nearly a decade before. But visitor figures at the Porter Tun Room were comparatively disappointing – some 20,000 a year – and by 1983 the Overlord Embroidery Trust was taking soundings about finding another, more permanent, home for the Embroidery.

In July 1983, Portsmouth, which had already discussed the possibility of acquiring the Embroidery with Lord Dulverton in the mid-1970s, put in a new bid to make a home for it. The city had been planning to mount a D-Day anniversary display in 1984 and now, with the possibility of acquiring the Embroidery as a spur, the decision was taken to create a new purpose-built museum. Whitbread's gave their blessing to Portsmouth's venture and the Overlord Embroidery Trust decided that the D-Day Museum should be the Embroidery's new home.

The opening ceremony was performed by Her Majesty Queen Elizabeth the Queen Mother on 3 June 1984. This was the fourth setting in which the Queen Mother had seen the Embroidery. As far back as 1 June 1970, she and Princess Alice had been to see seven panels, together with nine cartoons and thumbnail sketches, when they were first exhibited for a day at the Banqueting House in Whitehall. Two years later, the Queen Mother attended the centenary celebrations of the Royal School of Needlework, at which two panels (28 and 29) were displayed as examples of the School's work. On 6 June 1978, it was the Queen Mother who inaugurated the display of the Embroidery at the Porter Tun Room. With her opening of the D-Day Museum in 1984, the Overlord Embroidery had finally found a permanent and worthy home.

Conservation and Display

Considering the conditions which are now thought to be essential for textile conservation, the story of the survival of the Bayeux Tapestry makes remarkable reading. When it first appears in history in the fifteenth century, it is described as being brought out annually and hung round the nave of Bayeux Cathedral, with all the attendant strain on the fabric that means, not to mention the notoriously cold and damp conditions typical of medieval churches. During the French Revolution, the Tapestry was nearly cut up twice, first to be used as waggon covers and later to decorate a float during a public holiday. It was kept wound on two cylinders to make inspection easier and this caused further damage to the edges and ends. Only in 1842 was it placed on display behind glass for the first time. It is remarkable that it should have survived at all, let alone in such good condition.

Fortunately the Overlord Embroidery, though it has had its difficult times, has experienced nothing like this, nor is it ever likely to do so. While it was being made, each finished panel was placed in a specially constructed wooden crate. As there was insufficient space at the Royal School of Needlework, the panels were stored in the vaults of Coutts Bank. However, particularly during its 'homeless' years, even with the best possible care, the Embroidery must have been subjected to a certain amount of wear and tear. The panels had to be manhandled into position for exhibition at least 30 times, causing stress and strain on the battens and the textiles themselves. The Embroidery travelled more than 9000 miles in the course of its North American tour, in part by aeroplane. The Canadian Air Force was responsible for flying it across the Atlantic, and one can imagine the changes of temperature that it must have been subjected to on this journey. At one point in its early history, the Embroidery actually became damp while awaiting transport.

The first time the Embroidery was displayed protected by glass was at Whitbread's Porter Tun Room in 1978. Two schemes for the display were discussed in January of that year. The first involved the use of perspex cases, which would have given the panels the appearance of 'floating in space'. This was rejected in favour of a more conventional use of glass with tungsten lighting. This provided a sympathetic illumination, highlighting the colours of the Embroidery as well as the relief effect of the needlework.

Before being displayed, the panels were re-mounted on new wooden stretchers made of Siberian deal. The existing ones had warped, causing an uneven strain on the material so that the borders varied in width. The old stretchers had also not been hollowed on the front face, so marks were left on the Embroidery; some panels had become stained and net had been pulled and caught. Whitbread's generously agreed to pay for the necessary repairs. After this conservation work, the Embroidery was installed in its newly designed display cases, where it remained for the next six years.

By early April 1984, the construction of the D-Day Museum was sufficiently advanced to consider removing the Embroidery to Portsmouth in preparation for its subsequent installation. The removal from Whitbread's in Chiswell Street was a major operation, involving Wendy Hogg of the Royal School of Needlework, conservation staff from Portsmouth City Museums, carpenters, glaziers and a specialist fine art shipping company. As each panel was removed, every single aspect of its condition was noted and marked up on photographic images for future reference. Each panel was then wrapped in inert materials which were to help buffer it against severe changes in temperature and humidity – a major threat to the preservation of textiles – and replaced in its original wooden

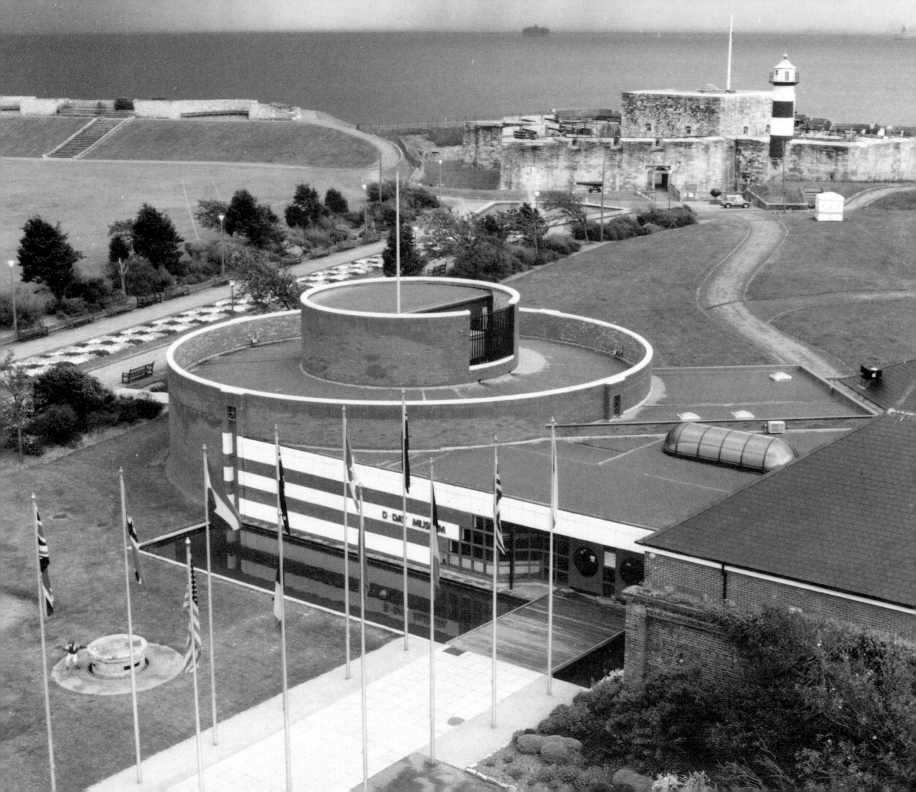

crate. The slow, meticulous process took two weeks to complete.

On arrival in Portsmouth, the Embroidery panels were stored temporarily in the basement of the City Council's Civic Offices. Each was unpacked and Wendy Hogg undertook repairs and other conservation work, using the marked up reference photographs as a guide. The Embroidery was then re-photographed in detail to give an absolute record of its condition, before being sealed into display cases in its new home. Once again the panels were repacked, and transported the one and a half miles to the Museum, where they were stored for two weeks in the Overlord Embroidery Gallery to allow them to acclimatise in the new atmospheric conditions. The Gallery had to be sealed to make sure that changes in temperature and humidity caused no problems and that the dust gradually enveloping the rest of the building as it neared completion was kept at bay.

Whitbread's had kindly offered the existing display cases to Portsmouth, but they were unsuitable, and a new design was conceived by the City Architect, working closely with the City Museum's curators and conservators. Great care was taken with both the layout and the environmental conditions. It was decided once again that the Embroidery would be displayed to best effect as if it were 'floating in space'. Rather than being mounted flat against the walls of the circular Gallery, it would be arranged in bays, which would help to articulate the space and link those adjacent panels which form one continuous scene (such as the crossing sequence in Panels 12, 13 and 14 or the landing beaches in Panels 22 to 25). To accommodate this, the framework of each panel had to be altered by chamfering the edges to bolt them together satisfactorily. The border material was unpicked, the

The D-Day Museum, Portsmouth, showing the circular gallery which houses the Overlord Embroidery, with Henry VIII's Southsea Castle in the background.

frame edges planed down and the border resewn. Fortunately, Wendy Hogg was able to find just enough of the original material left over from the installation at Whitbread's to link the panels at the end of each bay.

The display case design was critical as it had to maintain the Embroidery at a constant temperature (plus or minus two degrees) and humidity (plus or minus 3 per cent), with very low, evenly spread lighting levels to prevent the material fading. To avoid the complexity of air conditioning the cases themselves, it was decided to condition the environment of the entire Gallery from a central plant-room. In the event of an emergency, provision was made in the back of cases for inserting packs of conditioned silica gel, a material which can maintain humidity levels by absorbing moisture from the air or giving it out again as the prevailing conditions demand. This emergency back-up has never been needed, which is something of a relief, as well over one ton of silica gel is required to condition the atmosphere in the cases.

Lighting the cases proved to be more of a problem. Several designs were tried and tested as models until the most satisfactory solution was developed. A number of factors were important. The lighting should not generate much heat or the temperature in the cases would rise. It had to be screened to cut out any ultra-violet radiation, which both fades fabric and damages the material's structure. It had to cast an even intensity of light across the Embroidery's full height, but be raked so that the lacing cords and other details would be highlighted. This was eventually achieved by using cold cathode tubes (similar to moonlight) above the case in a separately ventilated box, with precision-moulded prismatic panels at the top and mirrors at the bottom of each case to illuminate it evenly and at an acceptably low level. Indeed, the lighting levels are so low that it was necessary to darken the rest of the Gallery to give the Embroidery the appearance of being brightly lit and maintain the illusion of 'floating in space'. The final detail needed to complete the effect was the angling of the glazed case fronts at 15° to ensure that distracting reflection was kept to a minimum.

145

Conclusion

In commissioning the Overlord Embroidery Lord Dulverton created a magnificent tribute and memorial to the men and women who took part in Operation Overlord. But because of the scale and importance of the Embroidery, he also hoped to ensure that there would be a museum created on this side of the Channel to record and explain for future generations the operation which marked 'the beginning of the end of World War II.'

One has only to join a group of visitors in the D-Day Museum to feel their enthusiasm and, yes, their surprise that an embroidery can convey so much. Over the years the Overlord Embroidery has featured in many newspapers and journals – the *Legion* magazine in Canada, *Women's Weekly* in Australia, *Soldier* in the United States, and *Country Life*, the *Lady* and the *Flying Needle* in England. The VIP group in Panel 28 was used as the cover illustration for Richard Lamb's best-selling book *Montgomery in Europe 1943–45*, and James Quinn, a former director of the British Film Institute, made a moving film entitled *Tribute: The Overlord Embroidery*. It must be said, however, that there are still many people who are unaware of the excellence of the Overlord Embroidery. Only when seen in its entirety in the ideal setting of the D-Day Museum does the full impact of colour, design and textile quality really become apparent. It is a truly great successor to its inspirational ancestor. the Bayeux Tapestry.

Standing listening to a group of middle-aged embroidery enthusiasts looking at the Embroidery, one hears them say, 'Oh, I remember when the barrage balloons went up. We knew we were in for it then', or 'You see, that's why we couldn't go and see Aunt Amy at the coast in May 1944.' Memories come flooding back, memories sometimes deliberately suppressed at the end of the war when many people did not want to think about the dangers, distress, disasters and disappointments they had experienced. But now, in the 1980s, nearly 50 years have elapsed, sufficient time for older people to look back objectively when grandchildren ask, 'What was life really like in the war?' What better place to relive wartime experiences and see the war years in historical perspective than at the D-Day Museum?

Once inside the Overlord Embroidery gallery, in the slightly darkened and tranquil atmosphere, the Embroidery positively glows in its richness of colour and texture. Gradually one appreciates the skill with which the lighting and layout of the panels have been arranged. If one pauses to reflect on the homeless state of the Embroidery in its early years, such considerable advances in the techniques of museum display have taken place since then that the long 'wandering in the wilderness' may have benefited it in the end.

There is a timeless quality in the design and execution of the Overlord Embroidery. Even after two decades it has not become dated (although no doubt in 900 years time someone will say, 'Oh, that's so typical of the second half of the twentieth century'). Most important of all is the fact that the message of the Embroidery has relevance today and for the foreseeable future. It pays tribute to the efforts and sacrifices of the Allies in the Second World War, but it also stands as a reminder to us all, young and old, of the futility and waste – in Lord Dulverton's words, of the 'blood, sweat and toil and the ghastliness' – of war.

APPENDIX I
The Draft Embroidery Script

The draft script for the Overlord Embroidery prepared by Colonel Neave-Hill, Mr Jacketts and Rear-Admiral Buckley for the first meeting of the Overlord Embroidery Committee in September 1968:

THE DULVERTON TAPESTRY

THE BELEAGUERED ISLAND AND FORTRESS

I 1 The Beleaguered Island
 The factories, Air Raids and ARP, firemen and Merchant Navy, barrage balloons, radar
 2 The Americans land in UK
 Factories turning out war materials – convoys bringing it in
 3 Planning
II 4 Preliminary operations
 Air reconnaissance
 Air attack on Europe? France?
 Reconnaissance from the sea
 Action of SOE and wireless reports
 5 Softening up by air attack
 Material from the factories
III 6 The issue of orders at St Paul's
 7 The assembly
 Inspection by HM King George VI
 8 The plan in diagrammatic form showing routes to the Continent, and outline enemy deployment

CROSS CHANNEL ASSAULT

IV 9 The commanders meet to confirm D-Day
 10 Postponement due to bad weather
 11 The decision taken
V 12 The armada sails with air cover

13 Clearing the minefields
14 The parachute troops emplane
15 Radio diversion points to Calais
16 The submarines mark the beaches
17 The enemy sleeps
18 The paratroops land
19 The convoys approach the coast
20 Landing craft and DD tanks are launched

VI 21 Assault wave approaches coast which is shown in silhouette, under air attack
 22 The fleet opens fire
 23 Attack goes in (depict episode beach by beach?)
 24 Situation at nightfall
VII 25 Landings successful – Ike, Churchill, Roosevelt and the King, 6th June 1944
 26 Prisoners
 27 The Services
 28 Landing of supplies, ammunition, POL (petrol/oil/lubricants) etc.

LIBERATION AND VICTORY

VIII 29 Mulberry and Pluto?
 The advance across Europe, the welcome to the liberators by the people: French; Belgians (Brussels); Dutch
 Antwerp under V1 and V2
 Crossing the Rhine – the great airborne assault – AFVs and bridges – Churchill and Brooke at the crossing
 Death of Roosevelt?
 Surrender at Luneberg Heath
 VE Day and final victory over Nazis

APPENDIX II
The Final Embroidery Script

The final Embroidery Script, after revisions had been made in the light of comments by the Embroidery Committee in September 1968, was distributed at the first meeting of the Historical Subcommittee in October. It is given below.

THE DULVERTON TAPESTRY

THE BELEAGUERED ISLAND AND FORTRESS (32 feet)
1 The Beleaguered Island
 The factories, Air Raids and ARP, firemen and Merchant Navy, barrage balloons, radar
2 The Americans land in UK
 Factories turning out war materials – convoys bringing it in
3 Planning

CROSS-CHANNEL ASSAULT (184 feet)
4 Preliminary operations
 Air reconnaissance
 Air attack on Europe? France?
 Reconnaissance from the sea
 Action of SOE and wireless reports
5 Softening up by air attack
 Material from the factories
6 The issue of orders at St Paul's
7 The assembly
 Inspection by HM King George VI
8 The plan in diagrammatic form showing routes to the Continent and outline enemy deployment
9 The commanders meet to confirm D-Day
10 Postponement due to bad weather
11 The decision taken
12 The armada sails with air cover
13 Clearing the minefields
14 The parachute troops emplane
15 Radio diversion points to Calais
16 The submarines mark the beaches
17 The enemy sleeps
18 The paratroops land
19 The convoys approach the coast
20 Landing craft and DD tanks are launched
21 Assault wave approaches coast which is shown in silhouette, under air attack
22 The fleet opens fire
23 Attack goes in (depict episode beach by beach?)
24 Situation at nightfall
25 Landings successful – Ike, Churchill, Roosevelt and the King
26 Prisoners
27 The Services
28 Landing of supplies, ammunition, POL (petrol/oil/lubricants), etc.

BREAK-OUT AND VICTORY (24 feet)
29 The build-up
30 Drawing the enemy, particularly the enemy armour, to the eastern flank
31 The break-out
32 Falaise

A renumbering of the later panels of the Embroidery was agreed by the Embroidery Committee in October 1970.

SOURCES

Illustrations Many of the illustrations in this book have been made available by kind permission of the Trustees of the Imperial War Museum. Prints of numbered photographs credited to the Imperial War Museum are for sale on application to its Department of Photographs, Lambeth Road, London SE1 6HZ, where the Visitors' Room is also open to the public by appointment.

Text The following references to the sources of quotations in the text are identified by the page number and the first words of the extract.

3, *I think the broad answer*: letter from Lord Dulverton to Sir Walter Coutts, 12 April 1967. Dulverton Trust.

4, *To produce a tapestry*: minutes of the Dulverton Tapestry Committee meeting held at the Imperial Defence College on 10 September 1968. Dulverton Trust.

5, *Attempting far too much*: letter from Lord Dulverton to Sir Walter Coutts, 26 July 1968. Dulverton Trust.

5, *I am only sorry*: letter from Air Chief Marshal Evans to Colonel Neave-Hill, 11 September 1968. Neave-Hill papers.

6, *Contain enough horror*: letter from Michael Garside to Sir Walter Coutts, 17 August 1967. Dulverton Trust.

6, *Never forgive herself*: this and other quotations from Sandra Lawrence in this chapter are from interviews with Eve Eckstein in 1987, except where otherwise indicated in the text.

7, *I do hope*: letter from Sandra Lawrence to Sir Walter Coutts, 29 December 1967. Dulverton Trust.

7, *One particular panel*: letter from Sir Walter Coutts to Sandra Lawrence, 18 January 1968. Dulverton Trust.

7, *I think Lord Dulverton*: letter from Sir Walter Coutts to David Lloyd, 7 February 1968. Dulverton Trust.

7, *I really am very thrilled*: letter from Sandra Lawrence to Sir Walter Coutts, 28 May 1968. Dulverton Trust.

9, *I would like*: letter from David Lloyd to Sir Walter Coutts, 20 January 1969. Dulverton Trust.

17, *With all the setbacks*: Lord Dulverton in his comments to the authors on the first draft of this book in September 1988.

21, *Men and women toiled*: Winston Churchill, THE SECOND WORLD WAR, Vol. II, p. 146 (Cassell 1949).

25, *This young, sun-tanned*: LAND AT WAR, p. 88 (HMSO 1945).

25, *As an old soldier*: ROOF OVER BRITAIN, p. 60 (HMSO 1945).

25, *We took our seats*: Winston Churchill, THE SECOND WORLD WAR, Vol. II, p. 293 (Cassell 1949).

32, *If Britons sit*: A SHORT GUIDE TO GREAT BRITAIN (War and Navy Departments, Washington DC, 1942). D-Day Museum.

33, *When I woke up*: Leonard Rapport and Arthur Northwood, RENDEZVOUS WITH DESTINY: A HISTORY OF THE 101ST AIRBORNE DIVISION, p. 41 (Infantry Journal Press 1948).

37, *The success of the attack*: BOMBER COMMAND, p. 89 (HMSO 1941).

39, *Both Donald and I*: letter from Major-General Brown to Lord Dulverton, 11 August 1970. Dulverton Trust.

41, *We wish to tell you*: Winston Churchill, THE SECOND WORLD WAR, Vol. VI, p. 12 (Cassell 1954).

44, *Rommel got up early*: Desmond Young, ROMMEL, p. 192 (Collins 1950).

45, *The war will be won*: Cornelius Ryan, THE LONGEST DAY, p. 23 (New English Library edition 1969).

45, *It's quite amazing*: B H Liddell Hart, THE ROMMEL PAPERS, p. 464 (Collins 1953).

49, *In all airborne operations*: General Sir Richard Gale, WITH THE 6TH AIRBORNE DIVISION IN NORMANDY, p. 70 (Sampson Low 1948).

49, *Well it looks*: letter from Ernie Brewer to his mother, 28 May 1944. D-Day Museum.

56, *Officers busied themselves*: Lord Lovat, MARCH PAST, p. 300 (Weidenfeld and Nicolson 1978).

57, *The men must know*: Montgomery Papers, diary notes July–August 1943, BLM 41/5. Department of Documents, Imperial War Museum.

57, *My general theme*: Montgomery Papers, diary notes January–March 1944, BLM 72. Department of Documents, Imperial War Museum.

57, *It has been my privilege*: quoted in Denis Judd, KING GEORGE VI (Michael Joseph 1982).

59, *By this time*: letter from Lieutenant H T Bone to his mother, 4 July 1944. Department of Documents, Imperial War Museum.

59, *This book*: France, guide book for the expeditionary forces. D-Day Museum.

60, *To foster pride*: Major L F Ellis, VICTORY IN THE WEST, Vol. I, p. 132 (HMSO 1962).

61, *Saved thousands*: letter from General Eisenhower to Sir Stewart Menzies, July 1945, quoted in F W Winterbotham, THE ULTRA SECRET, p. 2 (Weidenfeld and Nicolson 1974).

64, *One can honestly say*: letter of 8 June quoted in Rear-Admiral W S Chalmers, FULL CYCLE, p. 233 (Hodder and Stoughton 1959).

65, *It was the most:* letter from Sub-lieutenant D Bonfield to Mrs P Lancaster, 12 October 1944. D-Day Museum.

65, *We learned:* letter from Lieutenant H T Bone to his mother, 4 July 1944. Department of Documents, Imperial War Museum.

69, *At 2 o'clock:* diary of Joseph Newbold. D-Day Museum.

71, *We saw hundreds:* Captain Harry C Butcher, THREE YEARS WITH EISENHOWER, p. 485 (William Heinemann 1946).

72, *He was not a stranger:* Leonard Rapport and Arthur Northwood, RENDEZVOUS WITH DESTINY: A HISTORY OF THE 101ST AIRBORNE DIVISION, p. 83 (Infantry Journal Press 1948).

77, *The weather had proved:* Jock Haswell, THE INTELLIGENCE AND DECEPTION OF THE D-DAY LANDINGS, p. 174 (Batsford 1979).

81, *I remember that one lot:* letter from Captain Gerald Ritchie to his sister, Muriel, 1944. Department of Documents, Imperial War Museum.

81, *Several other ranks:* Lord Lovat, MARCH PAST, p. 322 (Weidenfeld and Nicolson 1978).

81, *A grim battle:* General Sir Richard Gale, WITH THE 6TH AIRBORNE DIVISION IN NORMANDY, p. 85 (Sampson Low 1948).

84, *As I felt it settle:* quoted in Alan D Wiener, 'The First Wave', typescript, p. 239. D-Day Museum.

87, *It dawned on me:* letter from Air Chief Marshal Evans to Dr Frankland, 7 July 1971. Central files, Imperial War Museum.

89, *As soon as:* letter from Sub-lieutenant Sidney Montford to his brother, Dr Tom Montford, 12 June 1944. Department of Documents, Imperial War Museum.

89, *The gun crews:* Lord Lovat, MARCH PAST, p. 308 (Weidenfeld and Nicolson 1978).

92, *One message:* Henning Krabbe, VOICES FROM BRITAIN: BROADCAST HISTORY 1939–45, p. 215 (Allen and Unwin 1947).

92, *We are expecting:* B H Liddell Hart, THE ROMMEL PAPERS, p. 491 (Collins 1953).

95, *We do not want:* letter from Lord Dulverton to Air Chief Marshal Evans, 1 December 1969. Dulverton Trust.

96, *We had very few casualties:* letter from John C Gearhart to Eve Eckstein, 3 November 1987.

97, *The trip was rough:* letter from Sub-lieutenant D Bonfield to Mrs P Lancaster, 12 October 1944. D-Day Museum.

97, *These Officers:* quoted in lecture 'I Remember D-Day' by Commander Rupert Curtis, DSC, RNVR. D-Day Museum.

100, *Regarding bayonets:* letter from Colonel Neave-Hill to Major-General Brown, 1 June 1972. Dulverton Trust.

105, *As a guess:* letter from General Montgomery to Major-General Frank Simpson, 8 June 1944. Department of Documents, Imperial War Museum.

105, *At first I was rather depressed:* Henning Krabbe, VOICES FROM BRITAIN: BROADCAST HISTORY 1939–45, p. 216 (Allen and Unwin 1947).

105, *I saw a German:* Warren Tute, D-DAY, p. 92 (Sidgwick and Jackson 1974).

108, *One night:* memoirs of Sister Iris Ogilvie, unpublished typescript. D-Day Museum.

109, *We now discovered:* papers of Reverend Professor A R C Leaney. Department of Documents, Imperial War Museum.

111, *I wonder whether:* letter from Lord Dulverton to Air Chief Marshal Evans, 11 November 1970. Dulverton Trust.

112, *Our restricted conquest:* Winston Churchill, THE SECOND WORLD WAR, Vol. VI, pp. 11–13 (Cassell 1954).

113, *About 11am:* Arthur Bryant, TRIUMPH IN THE WEST, p. 172 (Collins 1959).

113, *The kindest of hosts:* Lord Ismay, THE MEMOIRS OF GENERAL THE LORD ISMAY, p. 358 (William Heinemann 1960).

113, *I had long conversations:* Rear-Admiral W S Chalmers, FULL CYCLE, p. 237 (Hodder and Stoughton 1959).

117, *In this country:* Desmond Hawkins, WAR REPORT: D-DAY TO VE-DAY, p. 120 (Ariel Books 1985).

120, *To those of us:* Desmond Flower, HISTORY OF THE ARGYLL AND SUTHERLAND HIGHLANDERS 1939–45, p. 131 (Nelson 1950).

121, *The worst nightmare:* John D'Arcy-Dawson, EUROPEAN VICTORY, p. 83 (Macdonald 1945).

121, *Came at once upon:* Alan Moorehead, ECLIPSE, p. 121 (Hamish Hamilton 1945).

121, *It was a curious sensation:* Lord Ismay, THE MEMOIRS OF GENERAL THE LORD ISMAY, p. 361 (William Heinemann 1960).

124, *It had pulverised:* General Omar Bradley, A SOLDIER'S STORY, p. 358 (Eyre and Spottiswoode 1951).

124, *The Bishop of Bayeux:* Fred Majdalany, THE FALL OF FORTRESS EUROPE, p. 358 (Hodder and Stoughton 1968).

125, *An absolute singleness:* Nigel Hamilton, MONTY, Vol. I, p. 10 (Hamish Hamilton 1981).

133, *The roads were choked:* Group Captain Desmond Scott, TYPHOON PILOT, p. 129 (Arrow Books 1987).

137, *As we went down:* Desmond Hawkins, WAR REPORT: D-DAY TO VE-DAY, p. 116–7 (Ariel Books 1985).

140, *We have already progressed:* letter from Sir Walter Coutts to Dr Frankland, 22 July 1968. Dulverton Trust.

140, *Whether or not:* letter from Lord Dulverton to Dr Frankland, 8 May 1972. Central files, Imperial War Museum.

141, *I am absolutely horror-struck:* letter from Lord Mountbatten to Dr Frankland, 5 October 1973. Central files, Imperial War Museum.

BIBLIOGRAPHY

Belchem, David *Victory in Normandy* (London 1981)

Belfield, Eversley and Essame, Hubert *The Battle for Normandy* (London 1965)

Bennett, Ralph *Ultra in the West* (London 1979)

Bernstein, David J. *The Mystery of the Bayeux Tapestry* (London 1986)

Bradley, Omar N. *A Soldier's Story* (London 1951)

Bruce, George *Second Front Now!* (London 1979)

Butcher, Harry C. *Three Years with Eisenhower* (London 1946)

Butler, Denis *1066: The Story of a Year* (London 1966)

Calder, Angus *The People's War* (London 1969)

Chalmers, W.S. *Full Cycle* (London 1959)

Churchill, Winston *The Second World War*, Vols V and VI (London 1952/4)

Clabburn, Pamela *The Needleworker's Dictionary* (London 1976)

Colby, Averil *Quilting* (London 1972)

Crookenden, Napier *Dropzone Normandy* (London 1976)

Cruickshank, Charles *Deception in World War II* (London 1979)

D'Arcy-Dawson, John *European Victory* (London 1945)

De Guingand, Francis *Operation Victory* (London 1947)

D'Este, Carlo *Decision in Normandy* (London 1983)

Edwards, Joan *Crewel Embroidery in England* (London 1975)

Edwards, Kenneth *Operation Neptune* (London 1946)

Eisenhower, Dwight D. *Crusade in Europe* (London 1948)

Ellis, L.F. *Victory in the West* Vol I (London 1962)

Ellsberg, Edward *The Far Shore* (London 1961)

Gale, Richard *With the 6th Airborne Division in Normandy* (London 1948)

Hamilton, Nigel *Monty: Master of the Battlefield 1942–44* (London 1983)

Harries, Meirion and Susie *The War Artists* (London 1983)

Harrison G.A. *Cross-Channel Attack* (Washington 1951)

Hastings, Max *Overlord* (London 1984)

Haswell, Jock *The Intelligence and Deception of the D-Day Landings* (London 1979)

How, J.J. *Normandy: the British Breakout* (London 1981)

Howarth, David *Dawn of D-Day* (London 1959)

Hoyt, Edwin P. *The Invasion before Normandy* (London 1987)

Ismay, Lord *Memoirs* (London 1960)

Jackson, William *Overlord* (London 1978)

Jewell, Brian *Conquest and Overlord* (Tunbridge Wells 1981)

Johnson, G. and Dunphie, C. *Brightly Shone the Dawn* (London 1980)

Keegan, John *Six Armies in Normandy* (London 1982)

Lamb, Richard *Montgomery in Europe 1943–45* (London 1983)

Lewin, Ronald *Ultra goes to War* (London 1978)

Liddell Hart, Basil *The Rommel Papers* (London 1953)

Lloyd, Alan *The Year of the Conqueror* (London 1966)

Longmate, Norman *How We Lived Then* (London 1971)

Lovat, Lord *March Past* (London 1978)

Loyn, H.R. *The Norman Conquest* (London 1965)

McDougall, Murdoch C. *Swiftly They Struck* (London 1954)

McKee, Alexander *Caen: Anvil of Victory* (London 1964)

Majdalany, Fred *The Fall of Fortress Europe* (London 1969)

Montgomery, Viscount *Normandy to the Baltic* (London 1947)

Montgomery, Viscount *Memoirs* (London 1958)

Moorehead, Alan *Eclipse* (London 1945)

Morgan, Frederick *Overture to Overlord* (London 1950)

Ruge, Friedrich *Rommel in Normandy* (London 1979)

Ryan, Cornelius *The Longest Day* (London 1960)

Saunders, Hilary *The Red Beret* (London 1950)

Shulman, Milton *Defeat in the West* (London 1947)

Speidel, Hans *We Defended Normandy* (London 1951)

Stagg, J.M. *Forecast for Overlord* (London 1971)

Scott, Desmond *Typhoon Pilot* (London 1982)

Stenton, Frank *The Bayeux Tapestry* (London 1957)

Thompson, R.W. *D-Day* (London 1968)

Thomson, Francis *Tapestry: Mirror of History* (Newton Abbot 1980)

Tute, Warren *D-Day* (London 1974)

Westphal, Siegfried *The German Army in the West* (London 1951)

Wheldon, Huw *Red Berets into Normandy* (Norwich 1982)

Wilmot, Chester *The Struggle for Europe* (London 1952)

Winterbotham, F.W. *The Ultra Secret* (London 1974).

INDEX

The following abbreviations have been used throughout the index: Margaret Bartlett, M.B.; Bayeux Tapestry, B.T.; Sandra Lawrence, S.L.; Operation Overlord, O.O.; Overlord Embroidery, O.E.

153